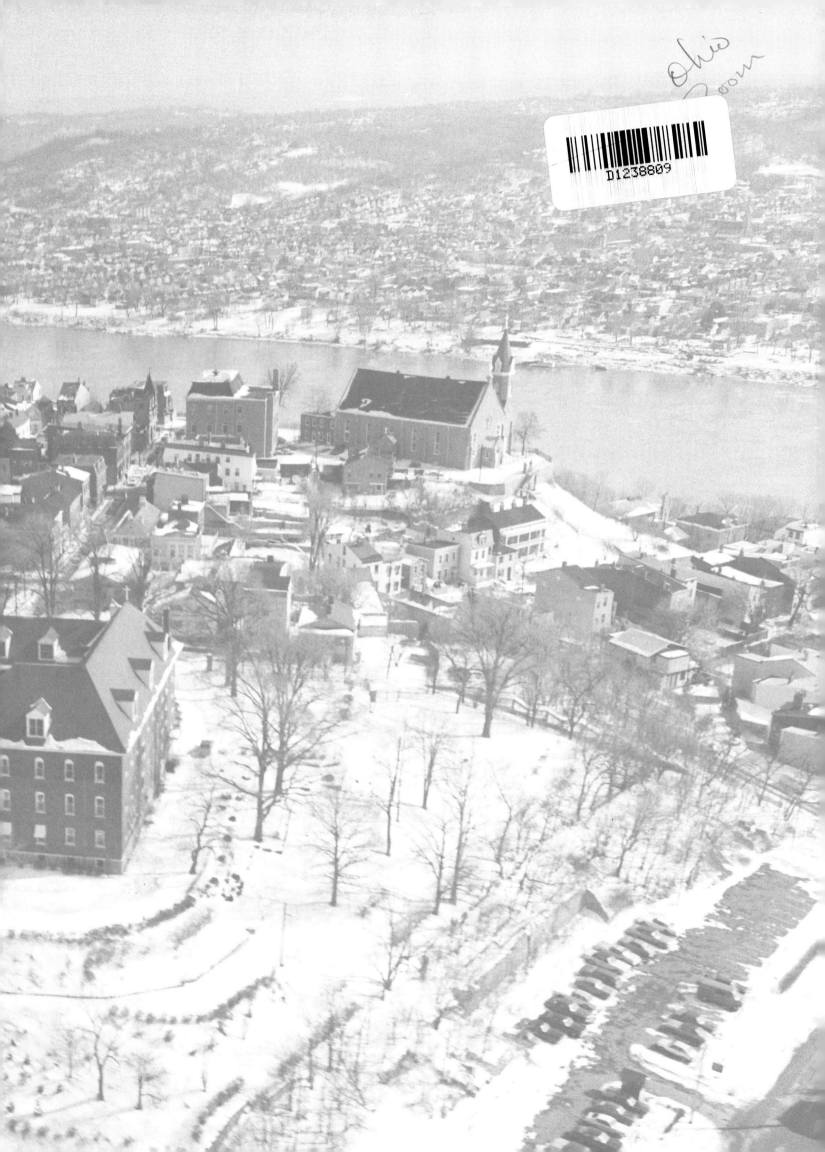

Mid-Century City

CINCINNATI AT THE APEX

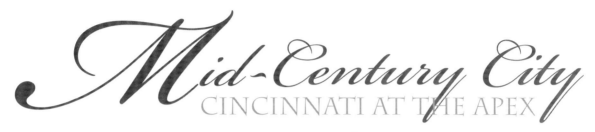

Mid-Century City
CINCINNATI AT THE APEX

photographs by Sarge Marsh

text by John Fleischman

ISBN 1-933197-04-8

Additional copies of *Mid-Century City: Cincinnati at the Apex* may be ordered directly from:
Orange Frazer Press
P.O. Box 214, Wilmington, OH 45177
Telephone 1.800.852.9332 for price and shipping information.
www.orangefrazer.com
Or:
Visual History Gallery
2709 Observatory Avenue, Cincinnati, Ohio 45208
513/871-6065
www.visualhistorygallery.com

cover design John Baskin & Jeff Fulwiler
interior design and photo editing John Baskin, with assistance from Barb Smith at Lamson Design
and Chad DeBoard
technical assistance Chad DeBoard

Library of Congress Cataloging-in-Publication Data

Marsh, Sarge, 1916-2003.

 Mid-century city: Cincinnati at the apex: the photographs of Sarge Marsh / text by John Fleischman.
 p. cm.
 ISBN 1-933197-04-8

1. Documentary photography--Ohio--Cincinnati--History--20th century. 2. Cincinnati (Ohio)--History--20th
century--Pictorial works. 3. Marsh, Sarge, 1916-2003. I. Fleischman, John, 1948- II. Title.

 TR820.5.M37135 2006
 779'.9977178--dc22

 2006046634

Printed in Canada

Dedicated to Sargent J. Marsh

With grateful acknowledgement to Patrick McKenrick;
Michael and Nancy O'Connor, publishers of *Cincinnati Express*;
and Paul Sittenfeld

The proceeds from the sale of this book will be donated
to the Research Fund of the Blood and Marrow Transplant Program
at The Jewish Hospital, Cincinnati, Ohio.

Table of contents

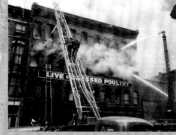
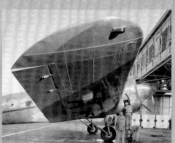

MODERN
LIMITED

TRAIN **9 57** TIME

ARRIVING TRAINS

LISTEN TO PUBLIC ADDRESS SYSTEM FOR CHANGE IN TRACK ASSIGNMENT

RAILROAD	NO.	DEPART	NO.	DESTINATION

CUT 1933-1972

DIED YOUNG

Foreword

His name was Sargent J. Marsh. A distinctive name, for sure, but I'll always remember him as Sarge. Behind his camera lens, Sarge Marsh was a "professional's professional," a photographer with a nose for news, an eye for composition, and—as time would amply prove—a sense of history.

Just think about it. Sarge was there during Cincinnati's Great Flood of 1937, snapping photos for the daily newspaper. Sixty-six years later, he was still chronicling our City's history as ground was broken along the Ohio River for the Freedom Center. Even in his final years, in fact, Sarge embraced modern technology. He loved to tinker with computers and Photoshop techniques and was amazed at the ease with which he could manipulate photos, processes that would have taken hours in the darkroom. Yet he wryly remarked that his era was strictly "B.C."—Before Computers.

All the more lucky for us, because Visual History Gallery has preserved and archived hundreds of Sarge's original negatives. We feel privileged to carry on his legacy, and to help new generations appreciate his work, and our City's rich past, through this book. The photos, with their "you-are-there" quality, impart to the subjects a sense of immediacy and perspective that is unfiltered by modern interpretation or viewpoints. What you see is what Sarge saw through his lens. No more. No less.

I trust you will enjoy *Mid-Century City: Cincinnati at the Apex* as thoroughly as we've enjoyed compiling it. And I'm confident that its pages will convey to you Sarge's enduring spirit, his wit, and his natural talent. And he would be proud to know that the book's proceeds support the Jewish Hospital Blood Disorder Research Center.

But, enough of this. Sarge wouldn't have approved of all the eulogizing. He'd tell us, just let the photos do the talking. OK, Sarge. Start talking!

Michael Wilger,
Visual History Gallery owner and proprietor

The prince of prints: Sarge belonged to the darkroom wizard school of photography. Here he is working through a stack of his familiar, oversized prints.

Addenda: The images in this book, and all the Sarge Marsh photographs that we make available at Visual History Gallery, are printed from the original negatives. They are not prints made from prints. The original negatives ensure the essential integrity. There are tens of hundreds of photos to choose from and a wide variety of subjects, such as Reds' baseball, Crosley Field, famous players, landmark buildings, and the downtown, as well as six decades of businesses, educational venues, car dealerships, aerials, and much more. Print sizes are available in 8x10, 11x14, 16x20, 20x24, and mural-sized.

Visual History Gallery is located at 2709 Observatory Avenue, near Hyde Park Square. Visit us in person, at *visualhistorygallery.com*, or call 513-871-6065.

Preface

I once drove to Tijuana, Mexico, with a friend from Los Angeles who'd heard that there was a great flea market down there for old hand tools. My friend was in the market for an adze. An adze is a peculiar kind of axe with a horizontal blade making it ideal for stripping bark off felled trees and squaring up beams. What my friend wanted with an adze in Los Angeles, land of the palm tree and the parking lot, I can't remember. I do remember what a great time we had looking for one.

In Tijuana, we saw acres of rusty hammers, carpenter's squares, augurs, awls, and handsaws of every description but not a single adze. We were hampered by our ignorance of the Spanish word for "adze." It's a word that you either have in your vocabulary or you're lost. We played charades, pantomiming the felling of mighty oaks and the efficient removal of their bark with an adze. Not a single Tijuana tool dealer was able to guess the magic word. Adze-less, my friend returned to Los Angeles. I came home with a marvelous discovery: the best way to find one thing is to look for another.

My next encounter with adzes took place roughly thirty-five years later in the Rare Book Room of the Public Library in Cincinnati. I was looking for a lost city. The adzes led me straight to it. I'd been sent to the Library by Sarge Marsh (1916-2003), a Cincinnati commercial photographer and sometime photographic newshound. I'd just had a quick look through an archive of his images. Quickness was the only possible strategy. The archive has 12,000 prints, negatives, and envelopes stuffed with strips of yet uncounted negatives. Marsh shot nearly all of them between 1937 and 1984 for clients in and around Cincinnati. Many showed prominent locations and yet, at times, I barely recognized the place.

The dateable pictures start with the Flood of 1937, the year that the Ohio River poured into Cincinnati and Sarge Marsh got fired. The worst flood of the century knocked out the city's water and power, left the central business district an island, and devastated the oldest and lowest-lying sections of town. For the *Cincinnati Post's* youngest photographer, a great flood was a great chance.

Marsh took his camera through the city's streets by rowboat, along crumbling levees on foot, and over the wide devastation by small plane. For his heroic efforts, surely the paper's most dashing photographer deserved a raise. The Photo Editor thought not. The youngest photographer insisted. The Photo Editor showed him the door. And so Marsh went into commercial photography. He prospered in the business for the next fifty plus years. He supposedly retired in 1984, although friends say that Marsh was still cooking up assignments a few months before his death in February 2003. Having a January birthday, Sarge Marsh lived a full 87 years.

But Marsh had already taken care of his archive, selling his entire collection of negatives in 2000 to Mike Wilger, the owner of a Cincinnati fine art and photography gallery. Previously, Wilger had been selling prints from Marsh's extensive sports archive of local heroes, legendary teams, and lost arenas. There was a steady market for Marsh's vintage images—particularly of long-gone Reds, Royals, and college teams. Finally, Marsh offered Wilger the whole shooting match.

Fourth Street was Cincinnati's signature retail street when Sarge moved his ambitious studio operation there in the early 1940s. Photography was still a walk-in retail business and Sarge personally designed the show window displays to grab passers-by in mid-stride.

Delivered, the "archive" was a forest of metal filing cabinets in a thicket of overflowing cardboard boxes. Marsh offered to help with identifications and captions but after his death, Wilger was on his own. Culling out the sports stuff was easy. Wilger immediately recognized the ready appeal of pictures showing Cincinnati's trademark sights—Fountain Square in various incarnations, Union Terminal, and Crosley Field. There was also the pure nostalgia of generational landmarks like the Wheel Cafeteria, the Albee Theater, the Sinton Hotel, and Lunken Field, back when it was still Cincinnati's commercial airport.

Beyond that, the Sarge Marsh archives were pretty much an uncharted wilderness. Wilger set about clearing, mapping, and then showing off his discoveries to photography and local history buffs. That's how I was drawn to Wilger's gallery. He gave me the tour of his ongoing Marsh exhibit and then the chance to browse through the backroom volumes of Sarge Marsh images. Wilger had sorted them out into broad categories—transportation, sports, theatres, manufacturing, construction, street scenes, personalities, and so on. Dates or names were often lacking. Drawing on my general knowledge of the city's history, I thought I would have some idea of what I was looking at. Several volumes of Sarge Marsh later, I realized that I had no idea.

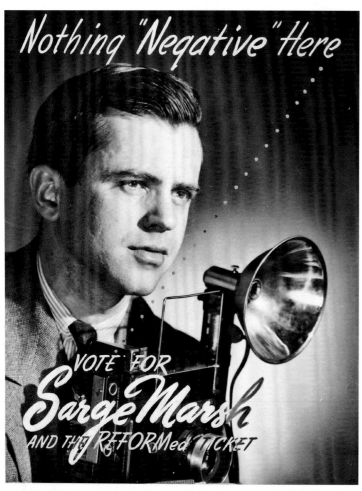

Sarge was the master of the "doctored" photo and the gag set-up. His April Fool's masterpiece was a faked panorama of the nuclear submarine, USS Nautilus, sailing past the Cincinnati riverfront. And, no, Sarge never ran for anything on the Reform Ticket.

The adzes set me straight. I went to the downtown Library in search of city directories, phone books, commercial registers, newspaper microfilms, or anything that would help me pin down some of Marsh's older images. Many of the buildings he'd photographed were long gone by my time and even scenes I knew from other sources looked different through Marsh's lens. It was a city I didn't recognize. Perhaps I could pin Marsh down by studying his pictures of the Cincinnati riverfront. That's known territory. It's been photographed steadily since 1848 and later images are dateable by the appearance (and disappearance) of various bridges over the Ohio. Throughout his career, Marsh shot a lot of film of the Cincinnati riverfront. His pictures from the 1940s showed the Public Landing as it was before the interstate highway was rammed through the "Rows," the old river-facing business district, behind it. The 1937 Flood severely damaged the Rows. But they are still standing in Marsh pictures from the 1940s. The highway wouldn't get them for another twenty years. In these early Marsh pictures, the Public Landing still has commercial wharf boats, floating docks that rose and fell with the Ohio's water levels, allowing freight and passengers to come ashore dryshod. I knew that the largest and the last of the Cincinnati wharfboats to go from the Public Landing had belonged to Greene Line Steamers. Their wharfboat with the name painted on the roof had survived into the 1960s, running day excursions on the Island Queen upriver to the Coney Island amusement park and overnight inland river cruises downriver on the Delta Queen. Looking at Marsh's photos of the Greene wharfboat, I wondered, when was the last time you could ship something by river from Cincinnati?

It was a river city from the start. Settlers' baggage floated in from upstream and whiskey floated out downstream on flatboats. From the late 1830s onward, Cincinnati steamboats carried on a lively trade in freight before the railroads and then motor trucks undercut the freight business. I studied Marsh's 1940s riverfront panorama more closely. Shipping freight by river must have come to an end sometime in the mid-20th century but when?

By freight, I didn't mean shipping 1,500 tons of coal by barge. You can still do that from Cincinnati, chartering delivery by the barge-load on diesel-pushed "towboats." Nor did I mean shipping yourself and your spouse on a ten-fun-filled-days river cruise to New Orleans. You can still do that, at least in warm weather. But when was the last time that anyone could take a crate down to the Public Landing and have it shipped on the next scheduled packet boat to Louisville?

I knew where to find out. The Library's Rare Book Room is home to the "Inland Rivers Collection," the country's largest archive of riverboat history. I took my question to the Rare Book Room Librarian, Sylvia Metzinger. She studied her computer screen, clicking the keys thoughtfully before disappearing into the vaults. She came out with an archival box. Metzinger said that this appeared to be the most recent and thus the last of its kind but that she would check other sources for a final date. Inside the box was a rough mimeographed leaflet, entitled Joint Motor-Water Class and Commodity Rates issued by Chris B. Greene, agent for Greene Line Steamers, Inc., Foot of Main Street, Cincinnati, Ohio, October 10, 1942.

It was the published freight tariff required in those long-ago days of closer federal regulation by the Interstate Commerce Commission. It was an encyclopedia of all commodities that Greene could conceivably accept for shipment, coded by classification ("See Sections 3 and 6.") with tables that matched codes to destinations ("For rates, see Section 6, except as noted.") and revealed the actual rate. The first commodity on the list was "Adzes."

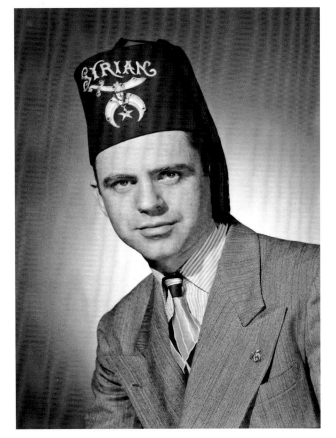

Portrait of the Artist
as a Young Shriner.

I read down the column:

Adzes
Air Cleaners, Coolers, Heaters, Humidifiers, Washers and Blowers and Fans combined
Alcoholic Liquors, Alfalfa
Almanacs (advertising)
Ammonia Compound, Animal Fat (Inedible)
Animal Feed, Animal Tails (dry)
Apples Waste, Apricot Kernels, Axes

I blinked. Then I read on, skipping to:
Bladders, Blood (dried), Bottles (glass), Brine (sauerkraut)
Broom Corn, Broths, Bush Hooks

The list enumerated:
Capers, Catalogs, Catsup, Caustic potash
Chaff, Chatts, Cherts, Chili con carne
Chowders, Cider, Circulars (newsprint)
Clam juice, Clay

Under "Fruits," it sang of:
Muscadines, Muskmelons
Nectarines, Oranges, Peaches, Pears
Quinces, Scuppernogs

By the letter "H," it was a chorus:
Hammers, Hatchets, Hay
Hides, Pelts or Skins (or pieces thereof)

High wines, Hominy (canned)
Honey, Hoofs and Animal Horns, Hops
Hooks (grass or bush), Horseradish (prepared)

Then it dawned on me. This was a found poem. It was written for Commerce (interstate!) and not Art, yet "Greene's Commodity Rates" had fallen through time into a new age where there were no steamboats carrying:
Pickles
Pimentos
Pipe Hangers
Pith, viz. dehydrated sugar cane pith, in bales or bags

Covered in chatts, cherts, and scuppernogs, "Greene's Commodity Rates" landed in the early 21st century, transformed into a poem. It was written in plain, no-nonsense, and hold-the-flowery-stuff blank verse, but it was poetry, by any name. I read the last lines with a sigh:
Wine
Wine, high
Wool and mohair
Wool clips, flocks, noils (wool combings, tags and tops).

"Greene's Commodity Rates," the found poem, threw a new light on Sarge Marsh, the picture trove. Mentally, I quickly rearranged the pictures in Wilger's volumes. It was a rough shuffle but when I was done, I could see what we have in hand.

We're holding a found portrait of a mid-sized American "center city" at its mid-20th century apex. The mid-century city was more than a "downtown" or an "urban core" around which the US Census nowadays hangs a "metropolitan statistical area." In an older parlance, it was a regional capital, the center point for a large and loosely-defined hinterland. A center city was the sun that powered its own financial, retail, cultural, entertainment and media solar system.

True center cities are a rare breed in America today and this particular specimen, Cincinnati, is a shadow of its former self. But photographs have always preserved shadows and the photographs of Sarge Marsh are a preserved likeness of Cincinnati as a thriving center city. It is a portrait of Cincinnati at the height of its World War Two power, vitality and population. It is a found portrait, because no one noticed that this was the apex, least of all Sarge Marsh. He was not an urban historian. He was a photographic businessman who made these pictures in the service of Commerce, not Art. But fallen through time, Marsh's "commercial" archive lands at our feet like a crate full of adzes.

Inside is the Mid-Century City. Trains come here. So do streetcars. So do shoppers. So do office and assembly workers. So does money. Squadrons of "office girls" process checks for the Federal Reserve Bank on high-tech sorting machines the size of small cars. Switchboards are manned by women, rows of them, elbow to elbow, waving fists full of plugs. Movie stars come on tour and gladly pose for gag shots. The downtown movie palaces seat 1,500. There are theatres downtown that just show newsreels. The sidewalks are thronged, day and night. Soldiers and sailors come looking for a good time. The myopic come for corrective lenses. The center city has tailors who know fashion, dentists who know dentures and trade schools that can make you into a legal stenographer or a watchmaker.

The airport, on the east side, is served by shiny, propeller-driven DC-3s and DC-4s. People dress formally to fly. The airport ballyhoos a new service: you can rent a car. You can also ship cargo from the Greene Line wharfboat on scheduled "river packets" (but only until 1950). There are other relics visible. Cincinnati's "inclines" are still running. These 19th century mechanical marvels were cog-railroads that lifted streetcars up Cincinnati's steep hillsides and

opened the suburban hinterlands to commuters. Like steamboat packets and electric street-cars, Cincinnati's inclines are gone by 1960. People come to this center city for complicated surgery, to hear an oratorio sung, or to announce that they are running for president. When Robert Taft announces his candidacy in 1952, the senator comes by train.

The Mid-Century City makes things. It sends out sausages, drugs, bagged flour, bottled water, radio programs, and fire engines. It sends out orders to manufacturing plants for steel, whiskey, and soap. The Mid-Century City is the realm of the Home Office that issues directives, summons branch managers, receives sales reps, and dispatches its own. Mid-century offices are up-to-date but stark. Office floor plans are open—one worker, one plain wooden desk, one black telephone, as far as the eye can see. The office cubicle has yet to strike. In summer, electric fans perch atop filing cabinets. Men take off their jackets, draping them over their hard wooden seat backs. Office workers, floorwalkers, and midday shoppers grab lunch in thunderously noisy cafeterias.

Marsh portrayed Cincinnati, but many of these images could stand for half a dozen Midwestern cities at mid-century—St. Louis, Detroit, Dayton, Pittsburgh, Cleveland, or Milwaukee. Like Cincinnati, they provided much of the industrial muscle for World War Two and the broad economic base for the post-war "American Century." Like Cincinnati in 1950, they radiated economic power and a brash post-war American style that seemed to be spreading around the globe. Like Cincinnati, the mid-century was their apex.

In Cincinnati, it was precisely 1950. The city of Cincinnati hit its all-time population high that year. The 1950 Census counted 503,998 residents, an increase of nearly 11 percent since 1940. In 1960, the Census counted 502,550 city residents. Statistically, the loss was insignificant but it was a portent. In 1970, the city's population fell by 50,026 or 10 percent. In 1980, the drop was 67,067 or 15 percent. At the end of the 20th century, the 2000 population of the city was 317,361, slightly below what it had been in 1900. The turbulent 20th century was a demographic zero sum game.

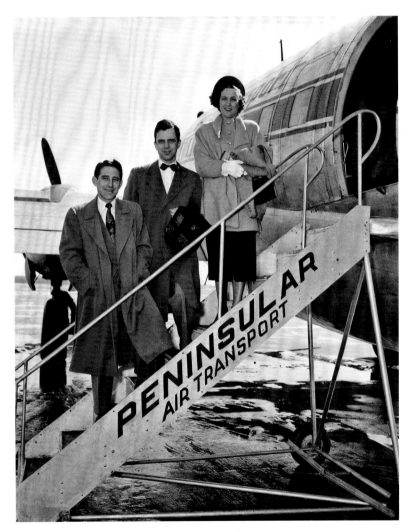

The man in the middle with the dapper bowtie and big view camera is Sarge Marsh.

The numbers are misleading. Cincinnati certainly supplied its share of Sunbelt refugees but much of the lost population simply spilled out beyond the city limits, spreading out in new subdivisions, shopping malls, and school districts. They and their children are still here. They just don't look back. The sprawling Greater Cincinnati MSA—which is heading for the horizon in three states—no longer faces center. It never will. Much money and more words have been spilled over "revitalizing" the Cincinnati downtown but its "centrality" is gone forever, along with regular freight steamboats to Louisville.

Sarge Marsh was ideally placed to capture the Mid-Century City. Sarge was his given name, that is, Sargent J. Marsh, after his father. The senior Sargent Marsh was a lieutenant in the Cincinnati Police Department; his mother, Margaret, was a "homemaker." They were Cincinnati people and their only child, born January 11, 1916, grew up in a succession of Cincinnati east side neighborhoods. From childhood, Marsh liked to draw and by high school, his

ambition was to become a cartoonist. He took his first photograph for the Withrow High School yearbook and processed the film at home in the family fruit cellar, using his mother's soup bowls for chemicals. Marsh was ever after a darkroom man. He once told an interviewer, "A lousy negative can be printed up beautiful if you have a good darkroom technique. A good negative can be the predecessor of a lousy print if you're not watching what you're doing."

Marsh also quickly learned that a good snowfall and a bright morning after created an instant demand among his neighbors for snow-covered house portraits at $1 a house. Marsh graduated from high school in 1934 and took a mill job to save up money for his own camera, a 3¼"x4" Graphic. All his life, Marsh could rattle off the brands, formats, and peculiarities of virtually every camera he'd ever used. The Graphic enabled him to "hobby around," he remembered, earning a buck here and there while pestering newspaper photo editors for a job. The *Post* took him on in 1936. Marsh went right out and bought a 4"x5" Speed Graphic, the standard newspaper camera of the day.

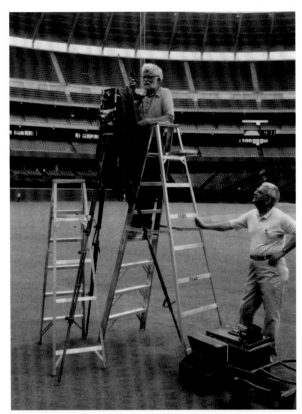

The old man and the view camera. The white hair and the Ernest Hemingway white beard were Sarge's trademarks in later years. Here he is at Riverfront Stadium taking the Reds' official team picture. The man holding the ladder is the man who took over Sarge's construction photography business in the 1980s, Pat McKenrick.

In 1937 came the great flood and, in its wake, the great firing. Marsh, however, was undismayed. He'd already been shooting commercial jobs for the *Post's* ad sales department. Advertisers in those days had to write their own copy and supply their own art. A young man with a camera who could grab a picture and have it ready within hours could make a few dollars. Over time, the young man had a string of clients. Marsh also cultivated new contacts in the Cincinnati newspaper business and caught on as a regular freelance with the Associated Press and Times World Photos. Later he shot newsreels for Warner-Pathe and Fox Movietone. The business grew as fast as he could shoot.

By 1938, Marsh was looking for office space and office help. There was no question about where an ambitious commercial photography studio had to be—in the center. He found space first in the Building Industries Building on Broadway. Then just before the war, he moved "Marsh Photography, Inc.," to a big-time, street-level location on Fourth Street, the premium retail location in Cincinnati. Marsh had a hand in everything from camera work to the window displays that rapidly became a favorite for Fourth Street window shoppers.

Marsh Photography did well on Fourth Street but by the mid-1950s, he was casting around for a new business strategy and a new location. The downtown department stores all had high-volume portrait studios. Home photography was eating into everyone's volume. In 1955, Marsh repositioned his business, leasing four floors of an office building on Ninth Street. He would concentrate on quality work, especially corporate or advertising commissions, with the slogan, *Creative Thinking. Creative Photography*. Marsh Photography also offered "Color Illustration, Quality Color Prints, Commercial, Industrial, Stereo (Color) Slides, Aerial, Convention Coverage, Banquets, News Style Publicity Photos."

His newest camera was evidence of his commitment to "Fine Photography Exclusively." It was a very expensive Hasselblad, a single lens reflex camera with a 2¼"x2¼" frame. By the mid-1950s, the compact Hasselblad and the even smaller 35mm SLR cameras were the standard in New York ad shops. In Cincinnati, they were considered "Brownie cameras" and toys. The first time Marsh took his Hasselblad on a job at Xavier University, his client, Father Steiner, wanted to know if Marsh "expected to make any serious pictures with that little gadget."

At its height, Marsh Photography, Inc., was quite an operation with thirty employees manning studios, darkroom suites, a set-building shop for advertising shoots, and "a multi-state

sales program." In 1964, Marsh bailed out. Advertising was increasingly national. Chains were eating up the portrait business. People and companies were taking their own pictures. Managing the big studio was too much for him. He sold his downtown interests to an associate and moved to the suburbs, setting up in his own basement as a one-man shop. His new business would focus on a niche market that he'd built up over the years—documenting big building projects for big construction companies.

Marsh continued his construction photography business for another twenty years but his inadvertent portrait of the Mid-Century City ends with the completion of Riverfront Stadium in 1970. Marsh was fascinated by Riverfront and he documented it every step of the way. Riverfront was to be Cincinnati's grandest statement or restatement of its centrality. For Marsh, Riverfront tied back to earlier pictures of the Public Landing and all the way back to his aerial pictures of the great flood of 1937. In 1969, he was airborne again, flying his camera over Riverfront as its massive skeleton came out of the ground. Between the river and the city, there is nothing but concrete in 1969. The drowned city of 1937 has been completely swept away by interstate highway, connector ramps, and parking lots. The Public Landing has been rolled up and pushed to the far corner of the construction zone. The Mid-Century City is gone. Decades later, this lost portrait turned up in the camera of Sarge Marsh.

That is one way to look at these pictures. There is another, especially for the people who lived in and around Cincinnati in mid-century. For them, Sarge Marsh offers a deeply satisfying glimpse at once-familiar places and lost pleasures. For their children, they offer new images to go with old stories. They show a city served by trains, steamboats, and shiny propeller-driven airplanes. They show a downtown jammed with stores, shops, theatres, eateries, streetcars, and people on foot. They were called "pedestrians."

These pedestrians walked about the streets. They shopped in stores. They went to the movies, ordered the meatloaf special, and wore hats year-round. They came downtown to see and to be seen. Mid-century, they were at the heart of the center city.

Other guides to the Mid-Century City:

Clubbe, John, *Cincinnati Observed, Architecture and History*, Ohio State University Press, Columbus, Ohio, 1992.

Giglierano, Geoffrey, *The Bicentennial Guide to Greater Cincinnati; A Portrait of Two Hundred Years*, Cincinnati Historical Society, 1988.

Ware, Jane, *Building Ohio, Volume One, A Traveler's Guide to Ohio's Urban Architecture*, Orange Frazer Press, Wilmington, Ohio, 2001.

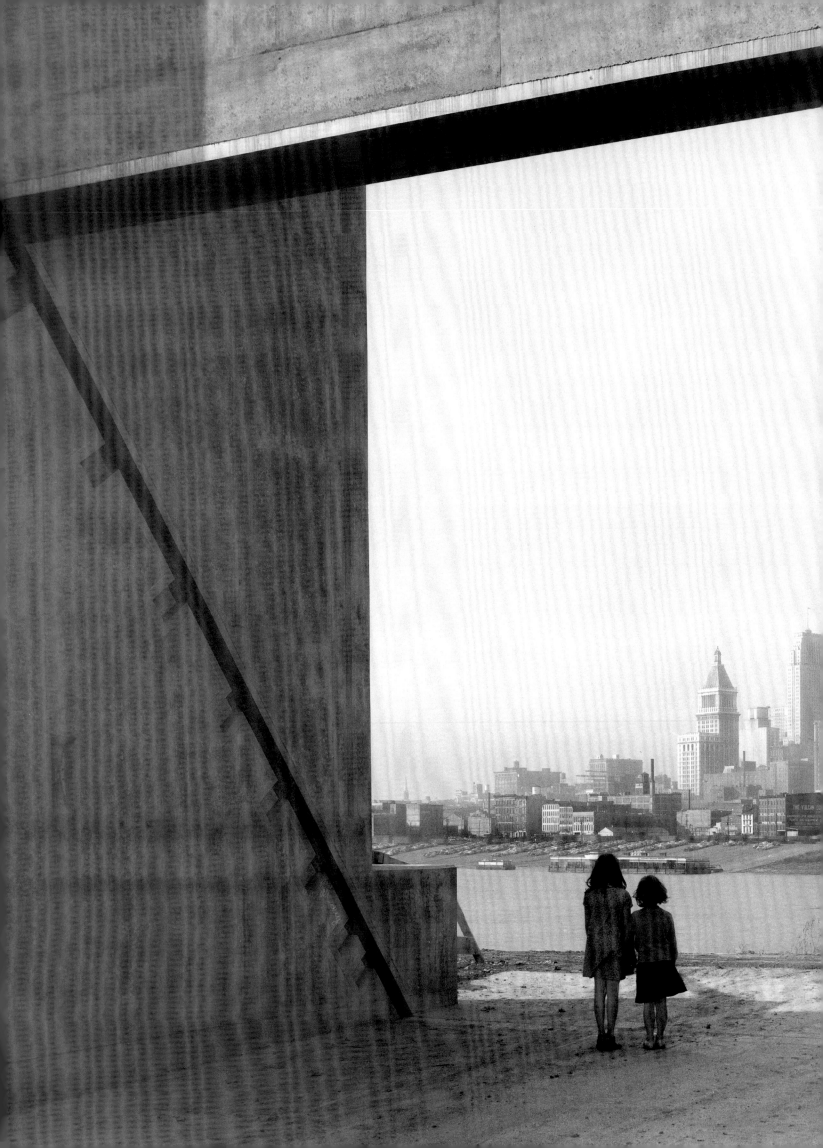

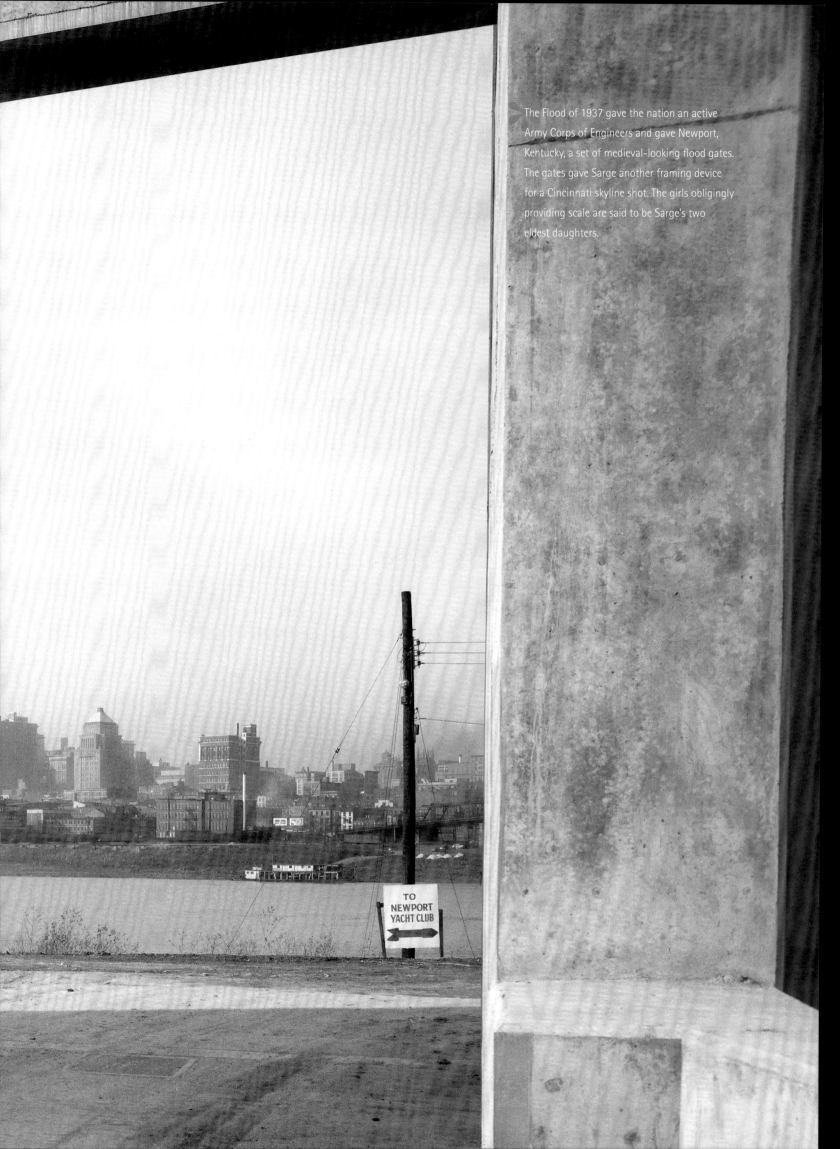

The Flood of 1937 gave the nation an active
Army Corps of Engineers and gave Newport,
Kentucky, a set of medieval-looking flood gates.
The gates gave Sarge another framing device
for a Cincinnati skyline shot. The girls obligingly
providing scale are said to be Sarge's two
eldest daughters.

TO
NEWPORT
YACHT CLUB

Mid-Century City
CINCINNATI AT THE APEX

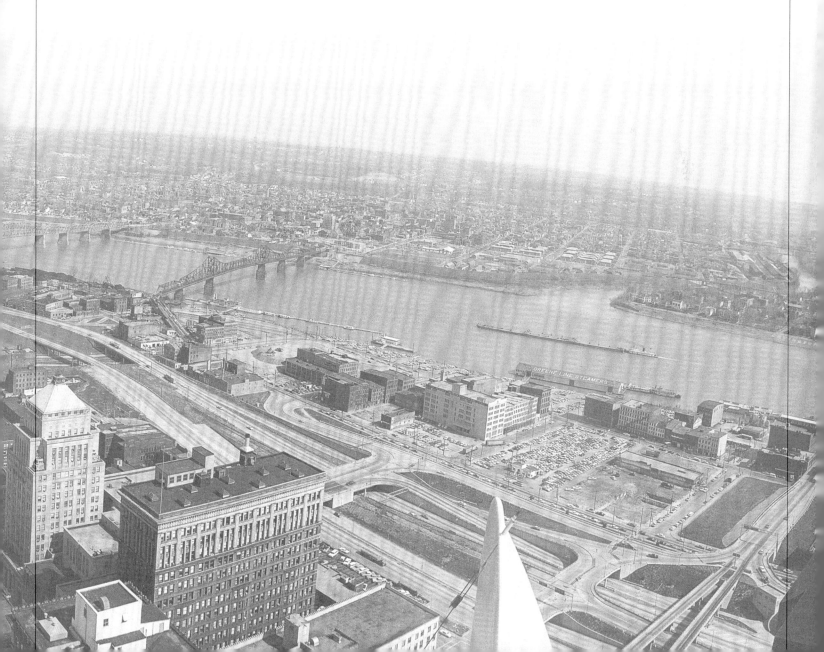

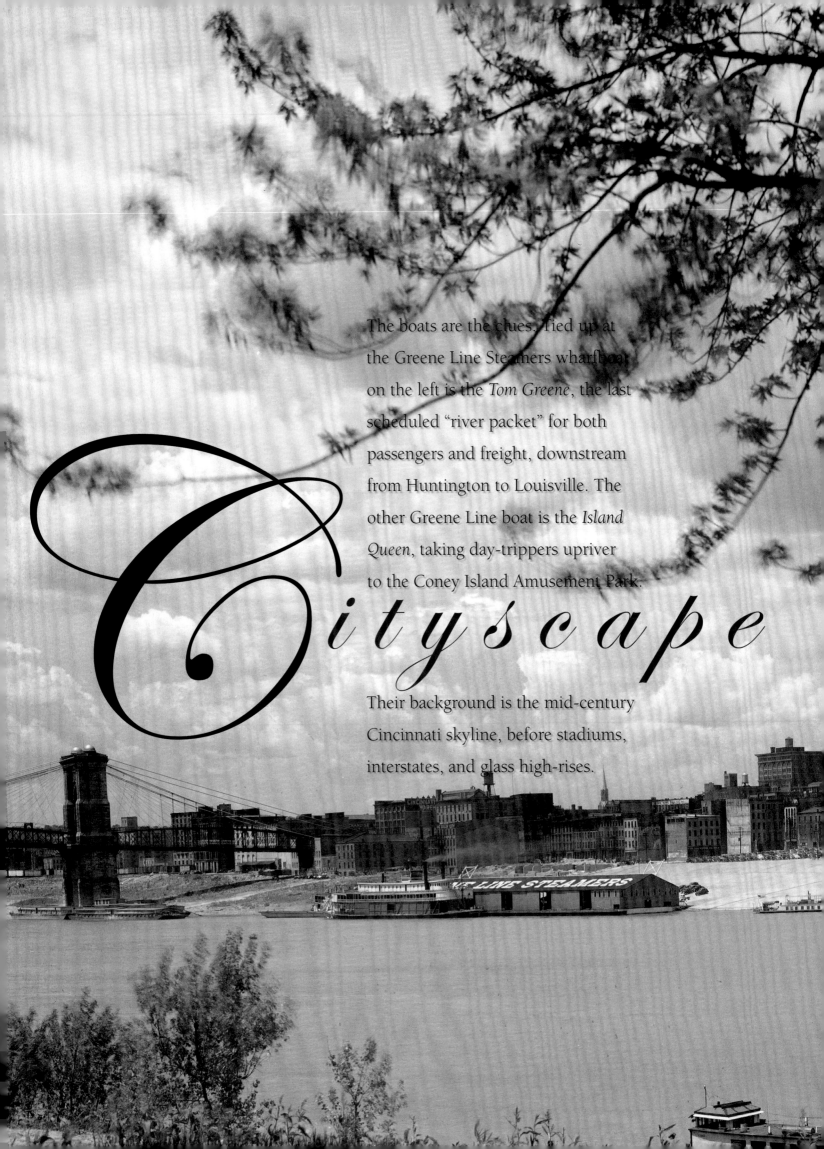

The boats are the clues. Tied up at
the Greene Line Steamers wharfboat
on the left is the *Tom Greene*, the last
scheduled "river packet" for both
passengers and freight, downstream
from Huntington to Louisville. The
other Greene Line boat is the *Island
Queen*, taking day-trippers upriver
to the Coney Island Amusement Park.

Cityscape

Their background is the mid-century
Cincinnati skyline, before stadiums,
interstates, and glass high-rises.

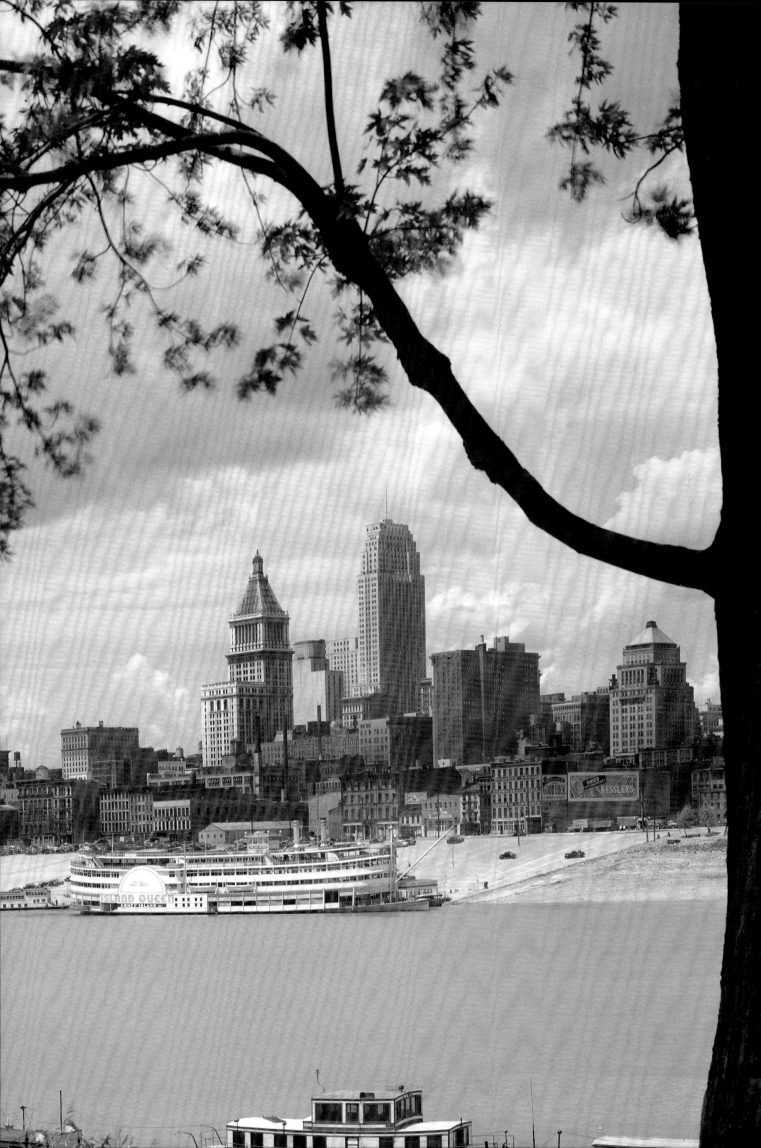

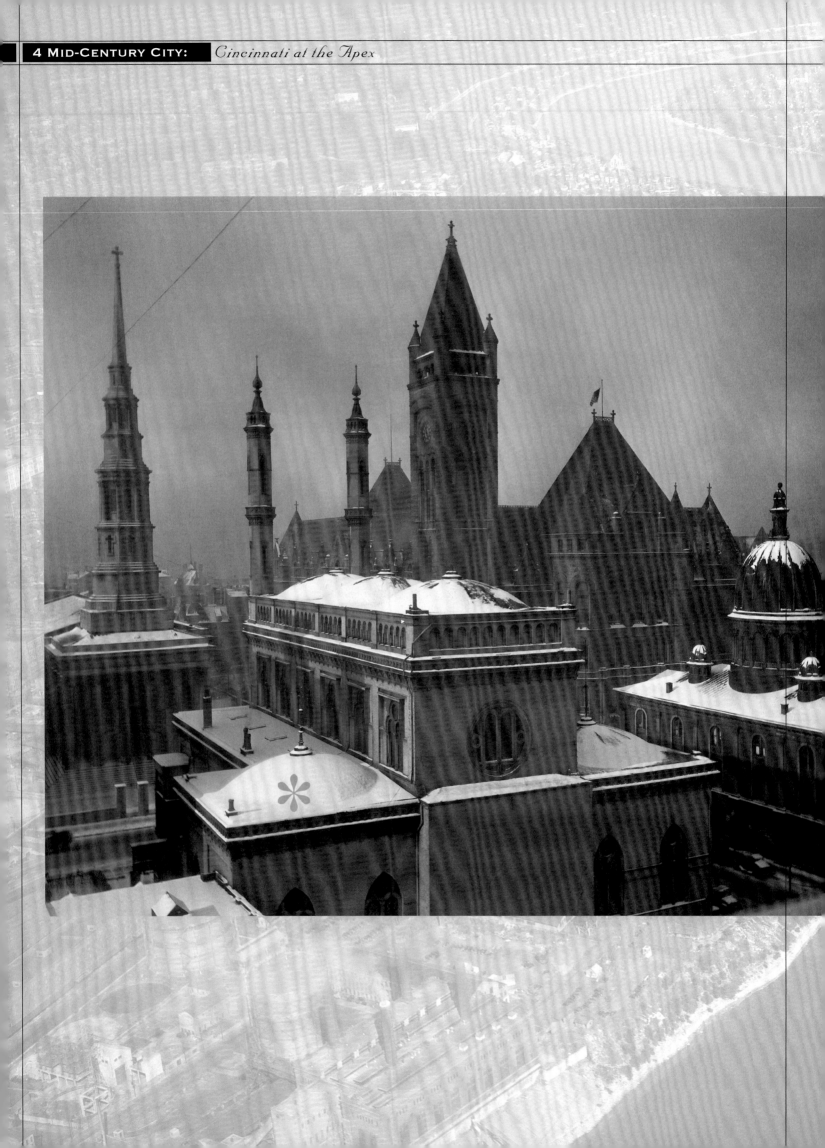

Eighth and Plum downtown was the four-cornered apotheosis of Civic and Moral Authority in Cincinnati. Three of the four are still there—the Catholic cathedral of St. Peter in Chains, at left, the "Moorish" minarets of the Jewish Plum Street Temple in the middle, and the massive tower and brownstone bulk of City Hall behind them. But the fourth corner is a mystery in modern times, occupied by a modest one-story repair garage. Sarge, showing a large domed structure on the right, lifts the mystery. This was the First Congregational Unitarian Church, which moved to the suburbs in 1887 and the old church was converted to commercial space. It came down in 1945. In Sarge's picture below, you can just make out the pre-1939 dome of downtown's "lost" Unitarian Church, which helps date this picture of Garfield Place.

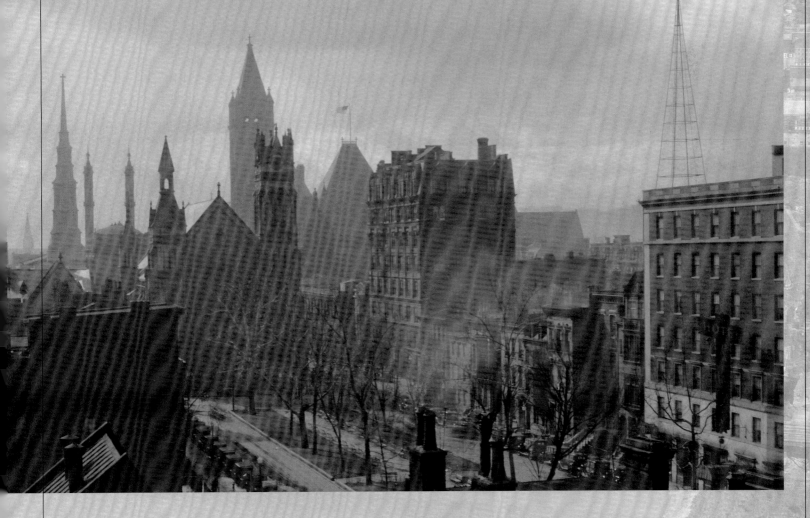

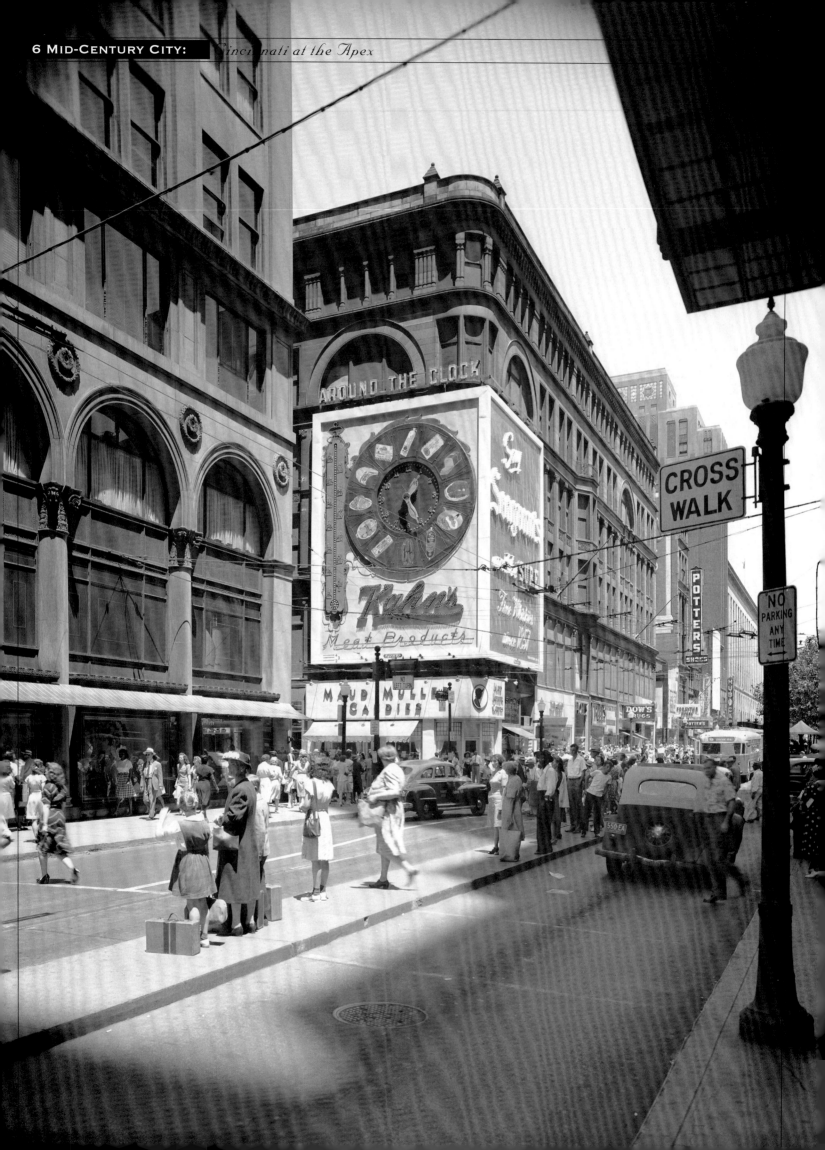

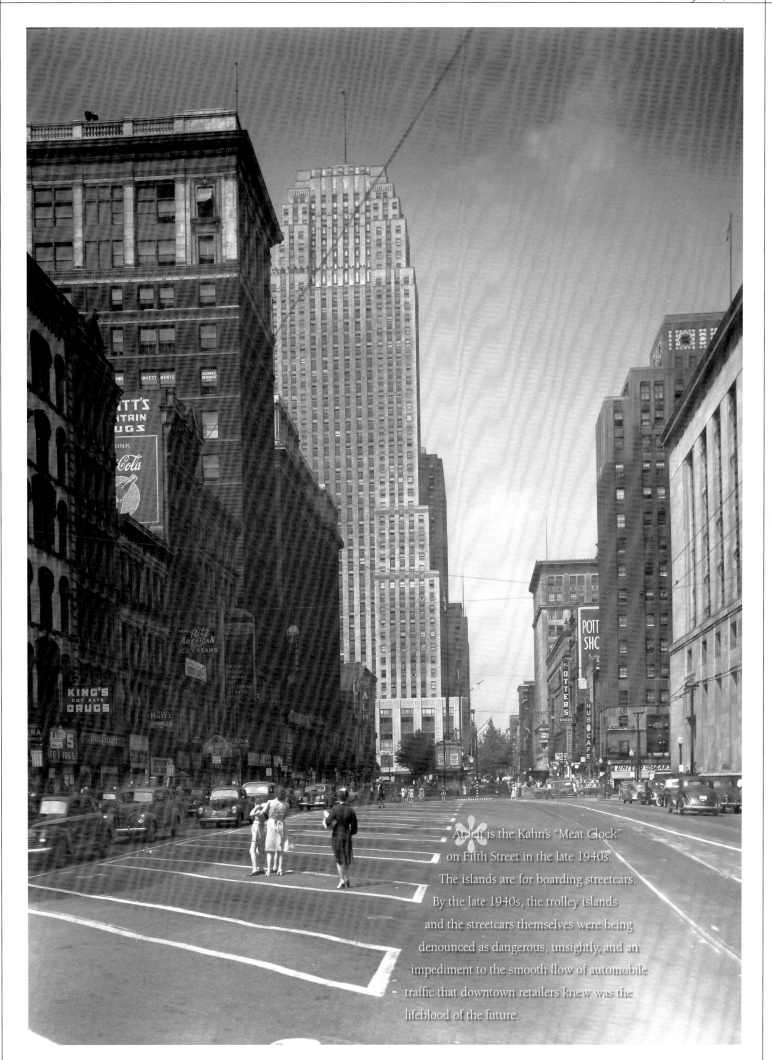

At left is the Kahn's "Meat Clock" on Fifth Street in the late 1940s. The islands are for boarding streetcars. By the late 1940s, the trolley islands and the streetcars themselves were being denounced as dangerous, unsightly, and an impediment to the smooth flow of automobile traffic that downtown retailers knew was the lifeblood of the future.

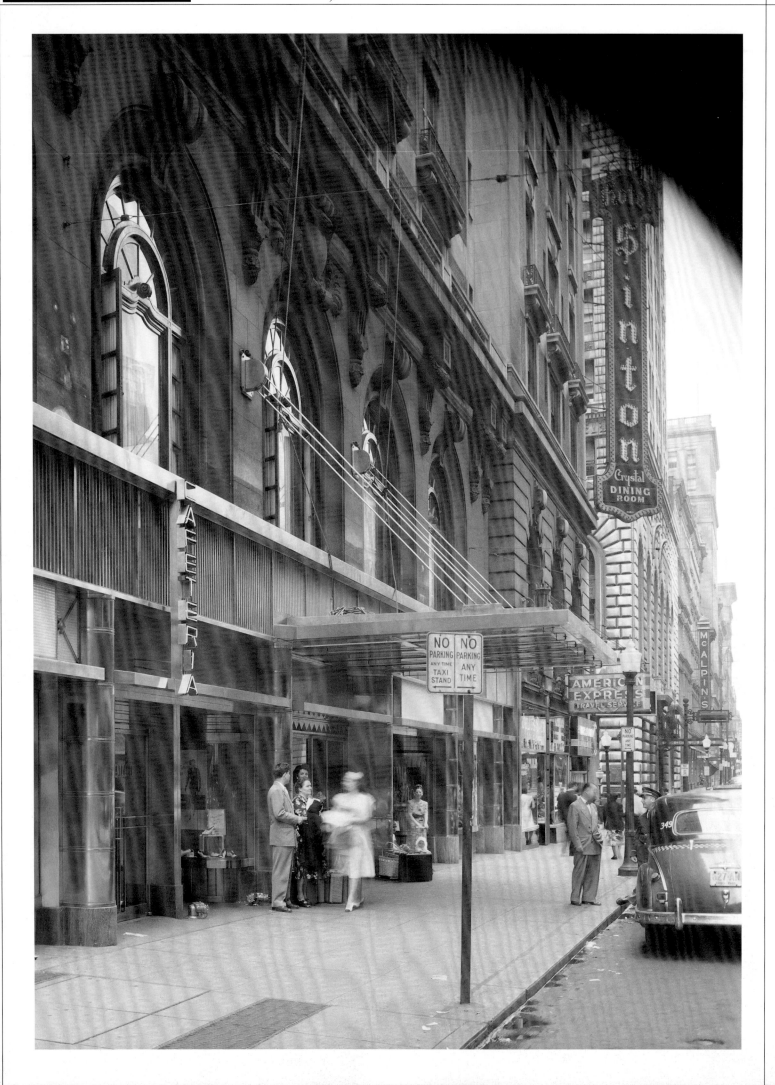

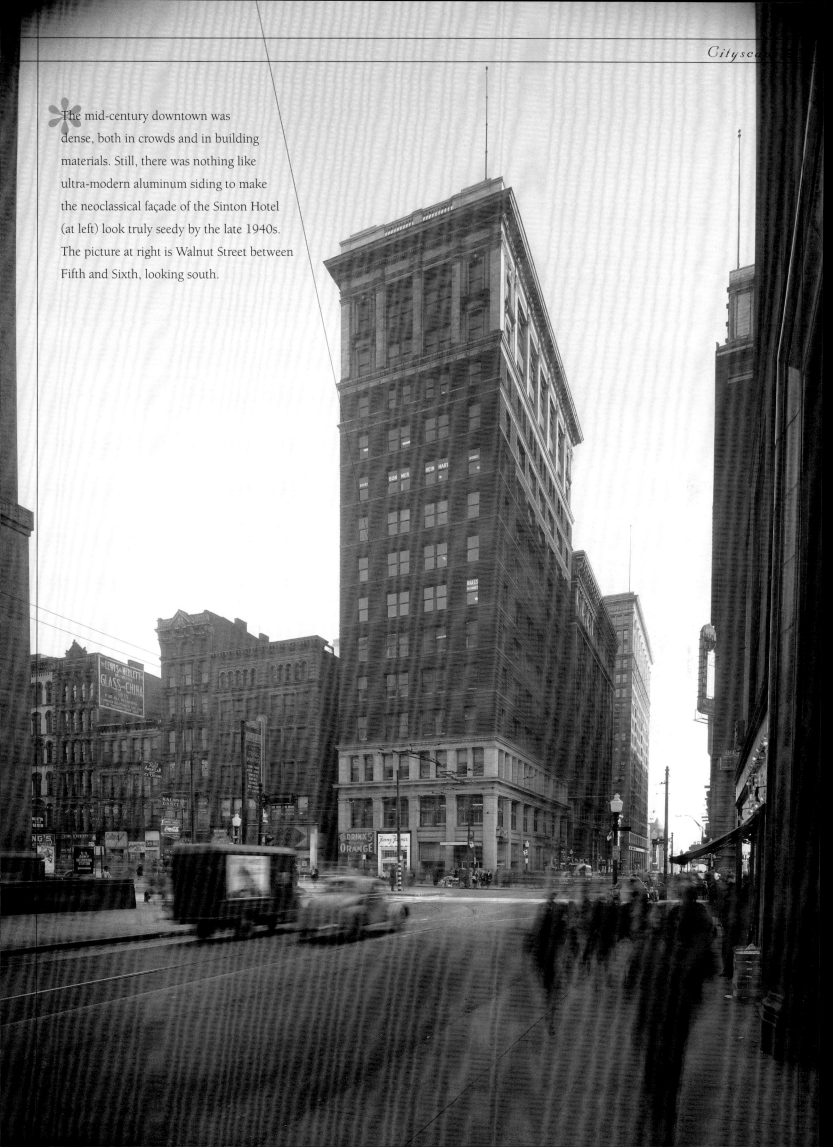

The mid-century downtown was dense, both in crowds and in building materials. Still, there was nothing like ultra-modern aluminum siding to make the neoclassical façade of the Sinton Hotel (at left) look truly seedy by the late 1940s. The picture at right is Walnut Street between Fifth and Sixth, looking south.

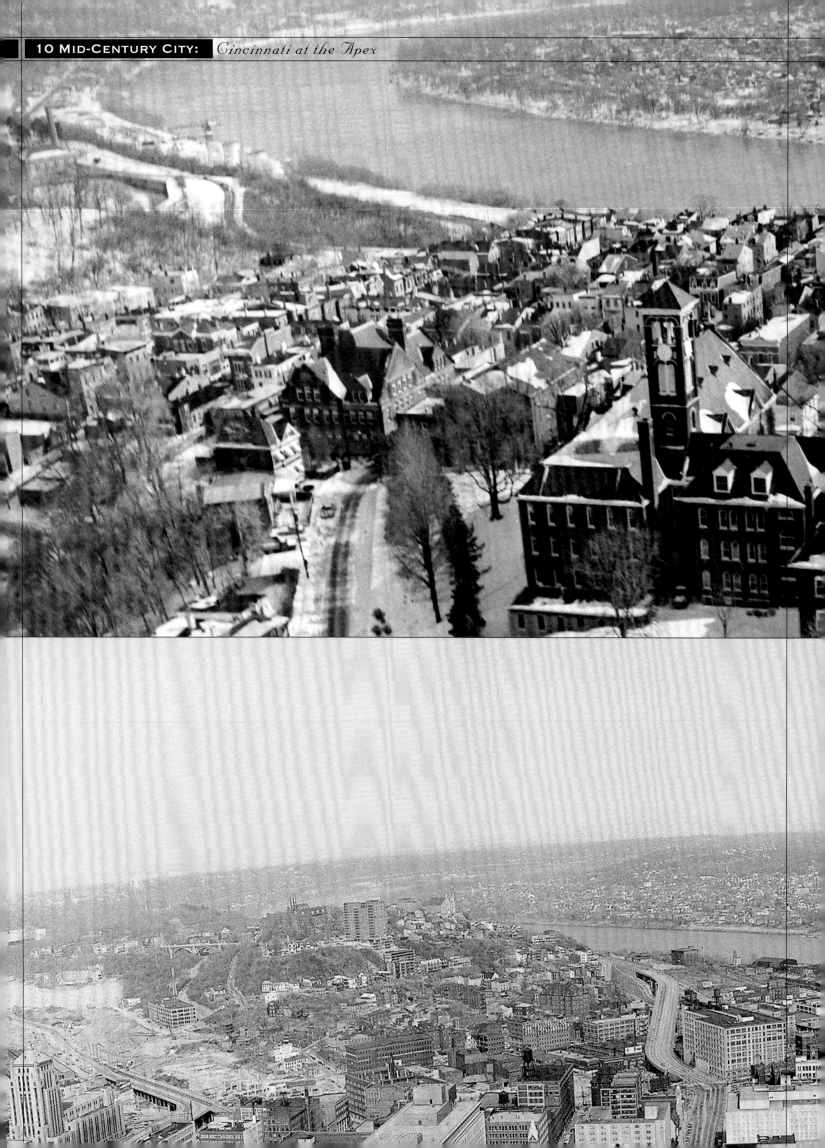

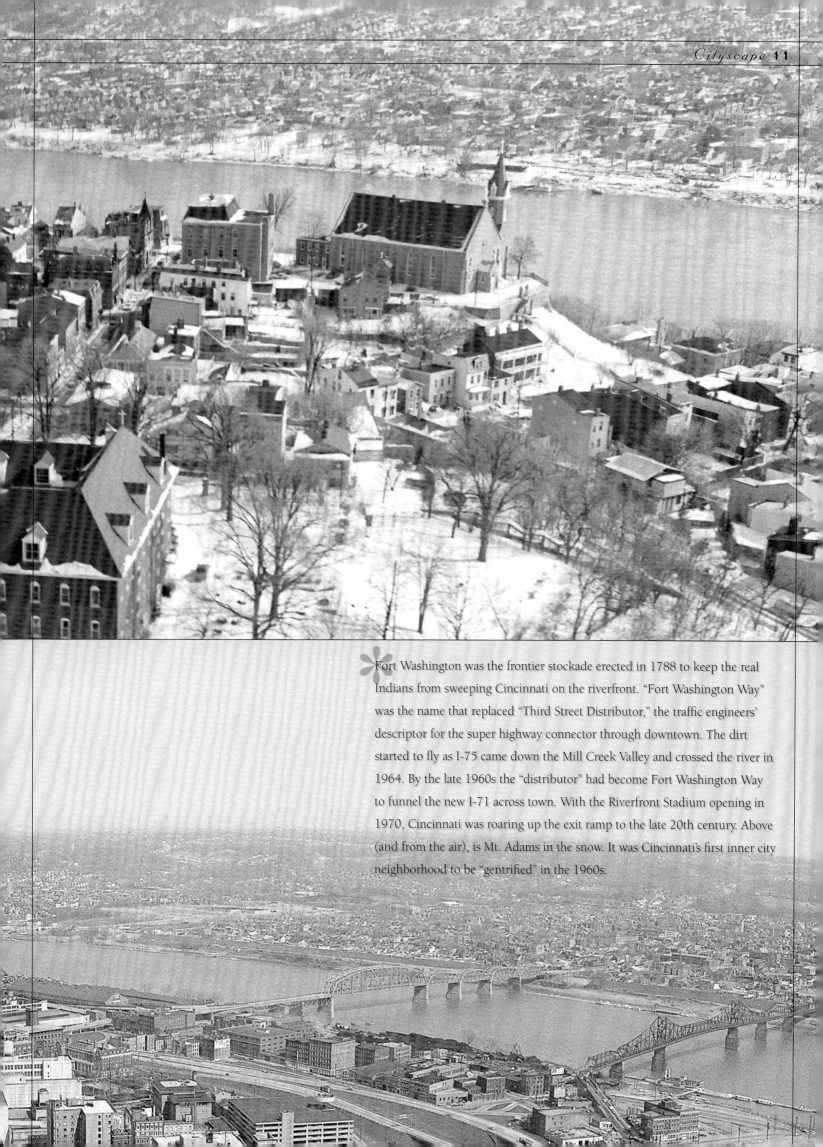

Fort Washington was the frontier stockade erected in 1788 to keep the real Indians from sweeping Cincinnati on the riverfront. "Fort Washington Way" was the name that replaced "Third Street Distributor," the traffic engineers' descriptor for the super highway connector through downtown. The dirt started to fly as I-75 came down the Mill Creek Valley and crossed the river in 1964. By the late 1960s the "distributor" had become Fort Washington Way to funnel the new I-71 across town. With the Riverfront Stadium opening in 1970, Cincinnati was roaring up the exit ramp to the late 20th century. Above (and from the air), is Mt. Adams in the snow. It was Cincinnati's first inner city neighborhood to be "gentrified" in the 1960s.

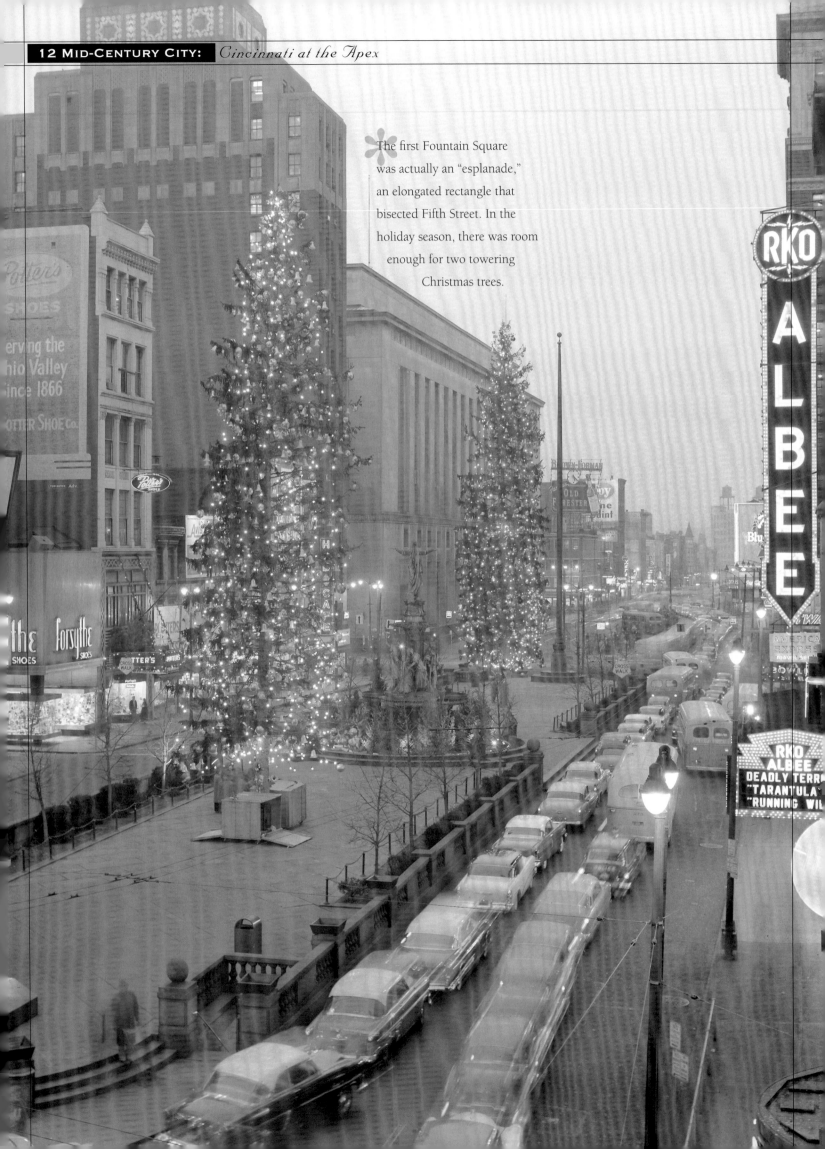

The first Fountain Square
was actually an "esplanade,"
an elongated rectangle that
bisected Fifth Street. In the
holiday season, there was room
enough for two towering
Christmas trees.

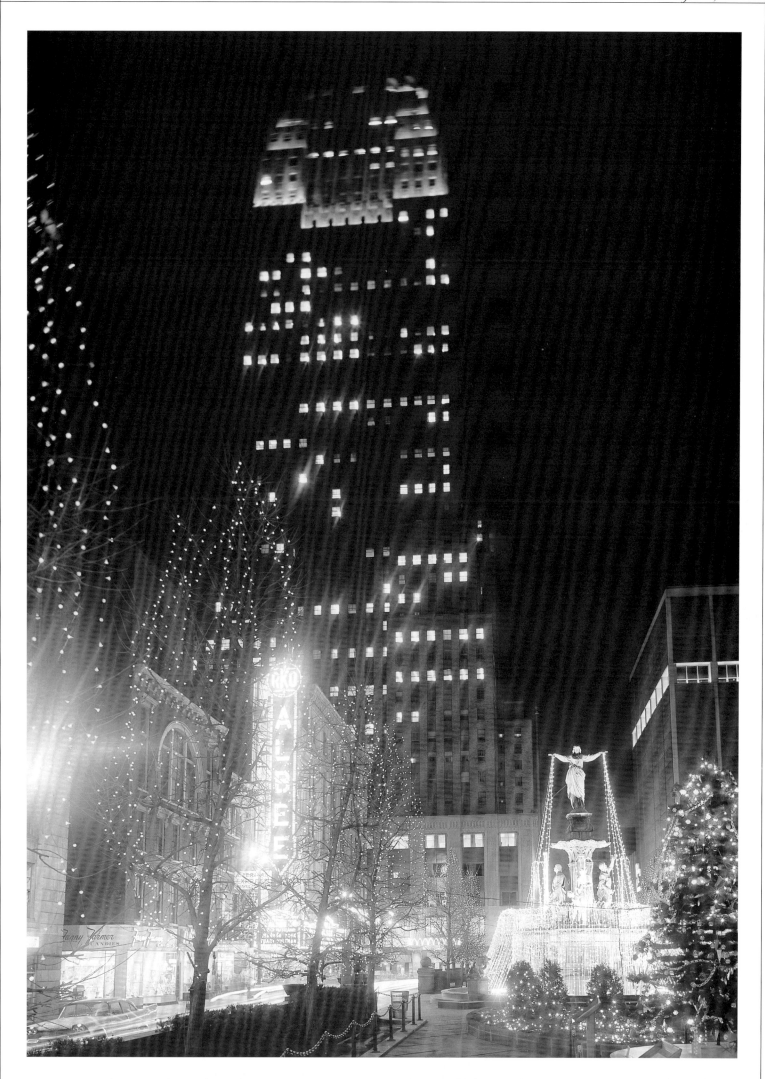

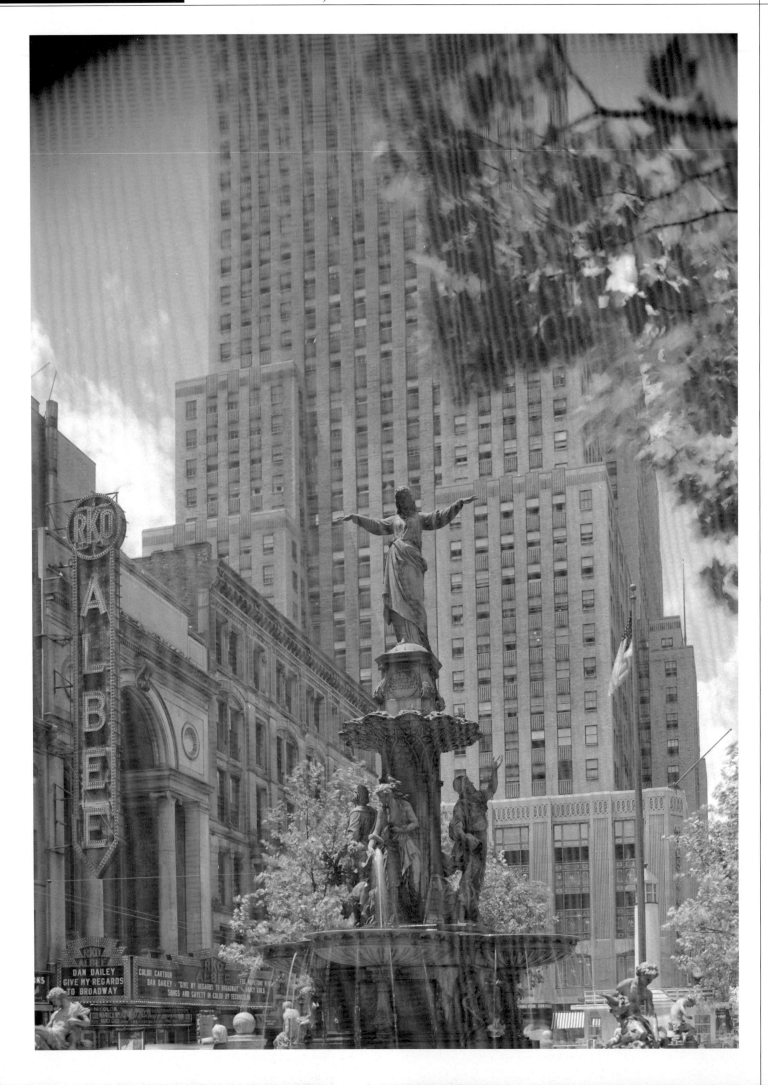

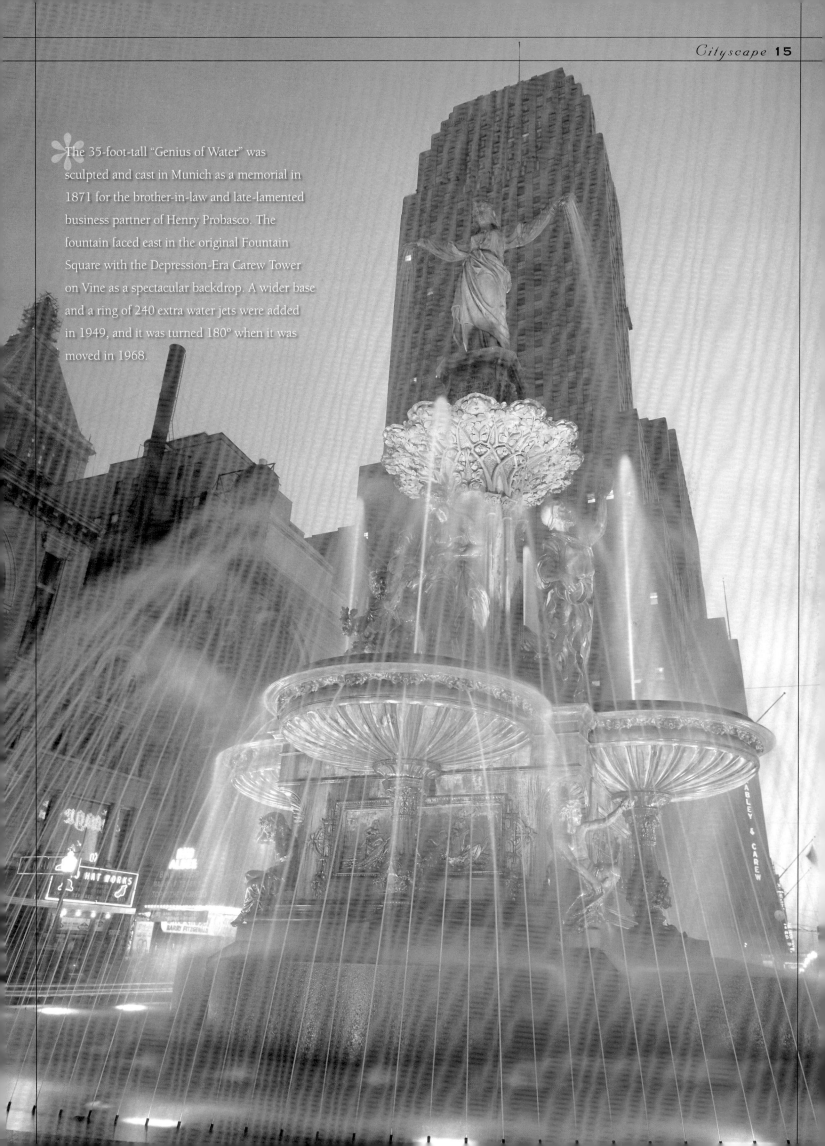

The 35-foot-tall "Genius of Water" was sculpted and cast in Munich as a memorial in 1871 for the brother-in-law and late-lamented business partner of Henry Probasco. The fountain faced east in the original Fountain Square with the Depression-Era Carew Tower on Vine as a spectacular backdrop. A wider base and a ring of 240 extra water jets were added in 1949, and it was turned 180° when it was moved in 1968.

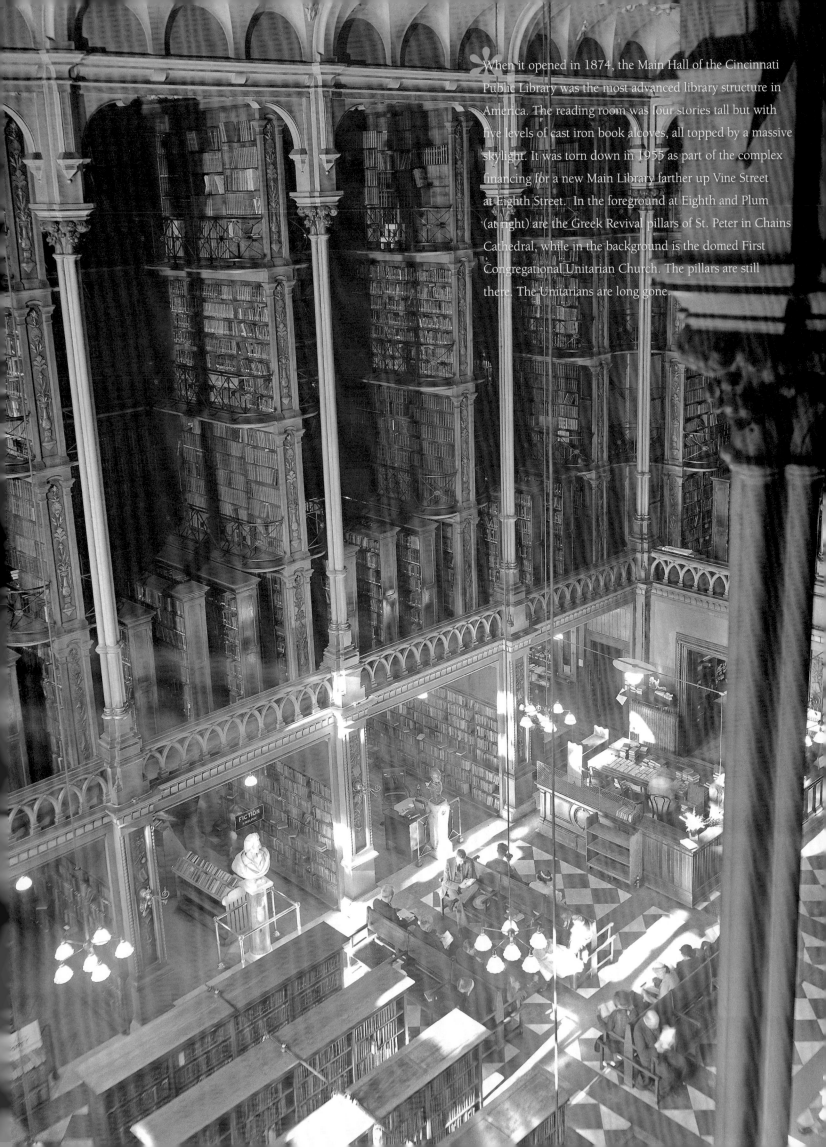

When it opened in 1874, the Main Hall of the Cincinnati Public Library was the most advanced library structure in America. The reading room was four stories tall but with five levels of cast iron book alcoves, all topped by a massive skylight. It was torn down in 1955 as part of the complex financing for a new Main Library farther up Vine Street at Eighth Street. In the foreground at Eighth and Plum (at right) are the Greek Revival pillars of St. Peter in Chains Cathedral, while in the background is the domed First Congregational Unitarian Church. The pillars are still there. The Unitarians are long gone.

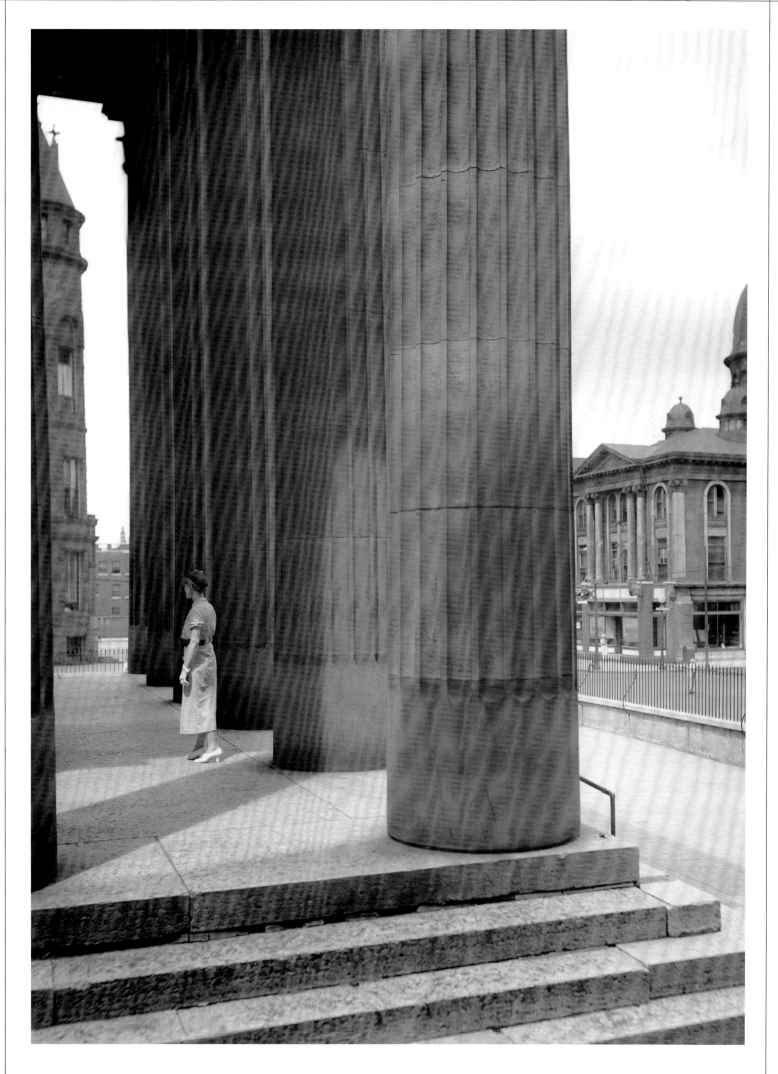

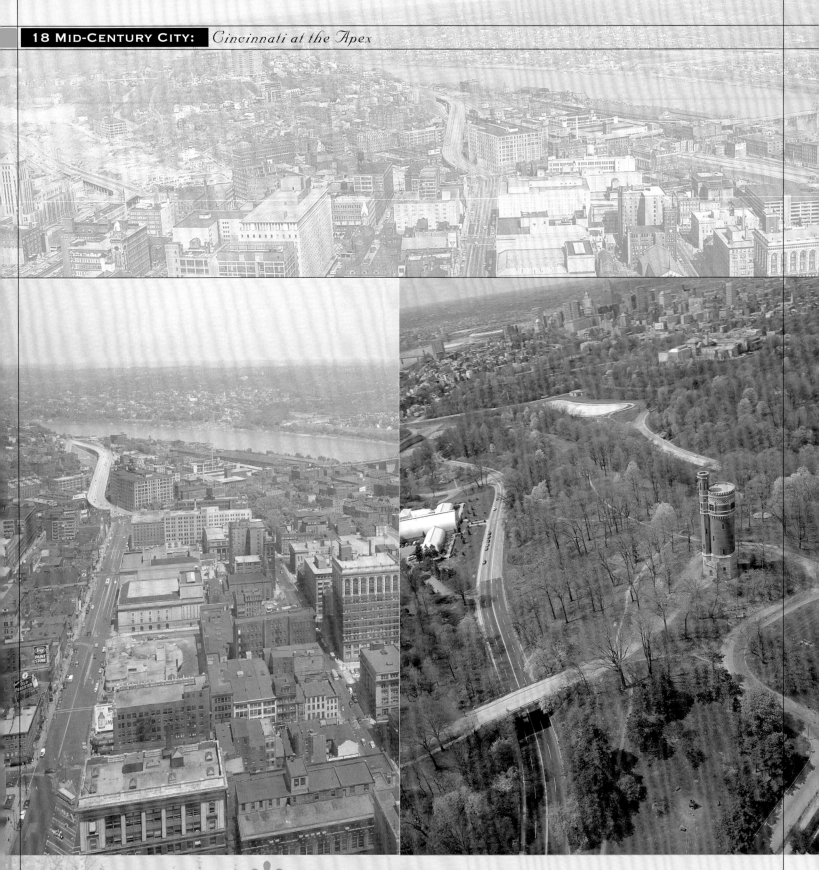

At left, Sarge's bird's-eye shot from the Carew Tower looks
into Columbia Parkway where soon an interstate would
curve into the bottom of the city. With the Riverfront Stadium
opening in 1970, Cincinnati was roaring up the exit ramp
to the late 20th century. At right: Eden Park was shaped by the
needs of the Water Department and in 1894 it needed a
172-foot-tall water tower to keep up the municipal pressure.
The architects dressed it up as a medieval castle keep. Until
1912, you could pay a nickel for an elevator ride to the top.
Sarge had to charter a plane for this view.

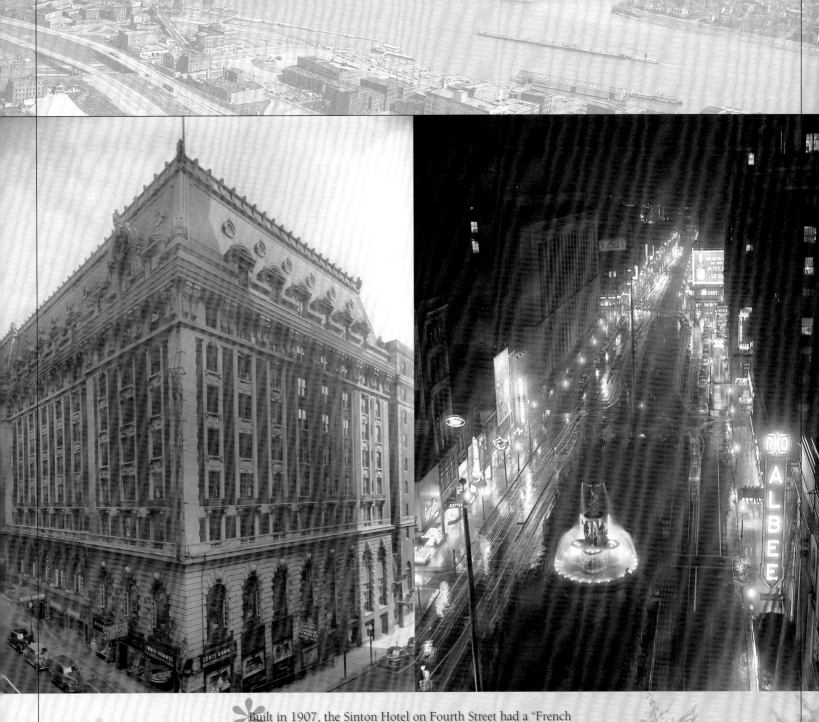

Built in 1907, the Sinton Hotel on Fourth Street had a "French Second Empire" façade and an American reinforced concrete skeleton. "The Sinton was, for a generation, the city's most stylish hotel," wrote John Clubbe. The Sinton was also the spot where the visiting Chicago "Black Sox" players allegedly agreed to throw the 1919 World Series to the Cincinnati Reds. It was demolished in 1967. At right, Fifth Street was Cincinnati's Great White Way. Sarge was shooting from the Carew Tower, making a timed exposure in the small hours of the morning. You can see the trolley lines glistening in the rain.

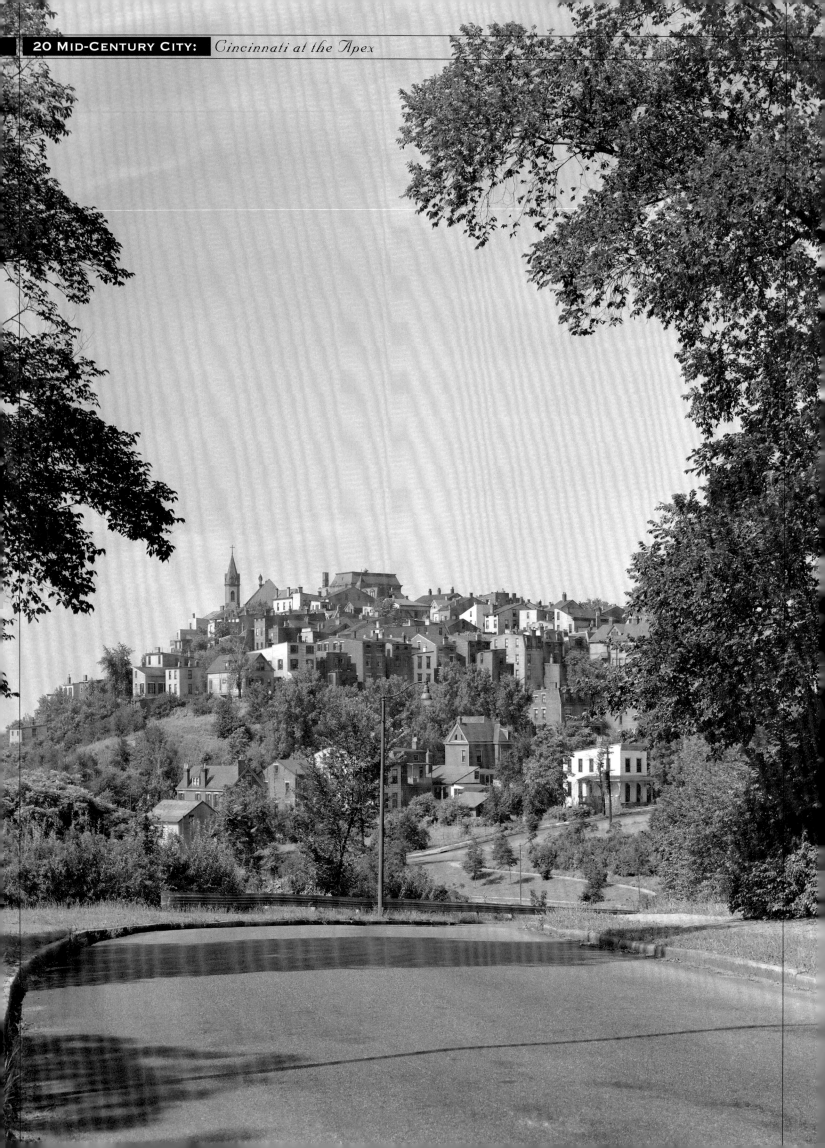

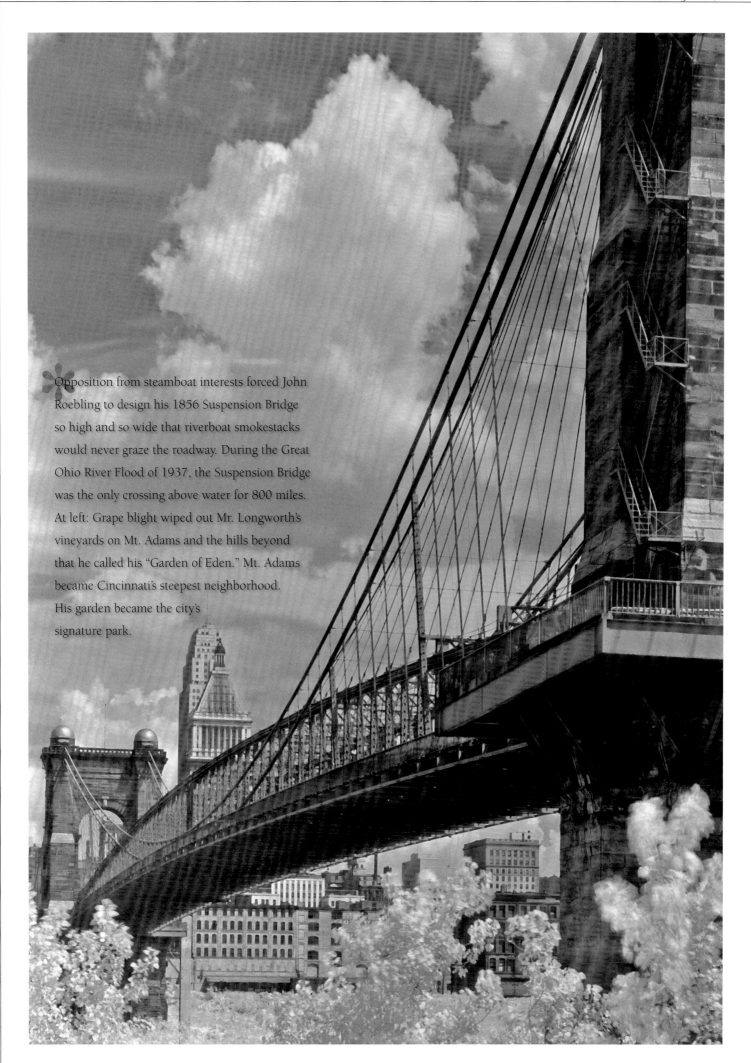

Opposition from steamboat interests forced John Roebling to design his 1856 Suspension Bridge so high and so wide that riverboat smokestacks would never graze the roadway. During the Great Ohio River Flood of 1937, the Suspension Bridge was the only crossing above water for 800 miles. At left: Grape blight wiped out Mr. Longworth's vineyards on Mt. Adams and the hills beyond that he called his "Garden of Eden." Mt. Adams became Cincinnati's steepest neighborhood. His garden became the city's signature park.

W o r k

Its stunning variety of things made—playing cards and pianos, coffins, mattresses, and shoes—kept it growing through Sarge's prime. It was always a P&G town, but it was also one of the largest inland coal ports in America, there was a company that made 600 silver coffeepots an hour, and in 1965 the average worker made $120.75 a week. Now consider the work itself, as Sarge saw it.

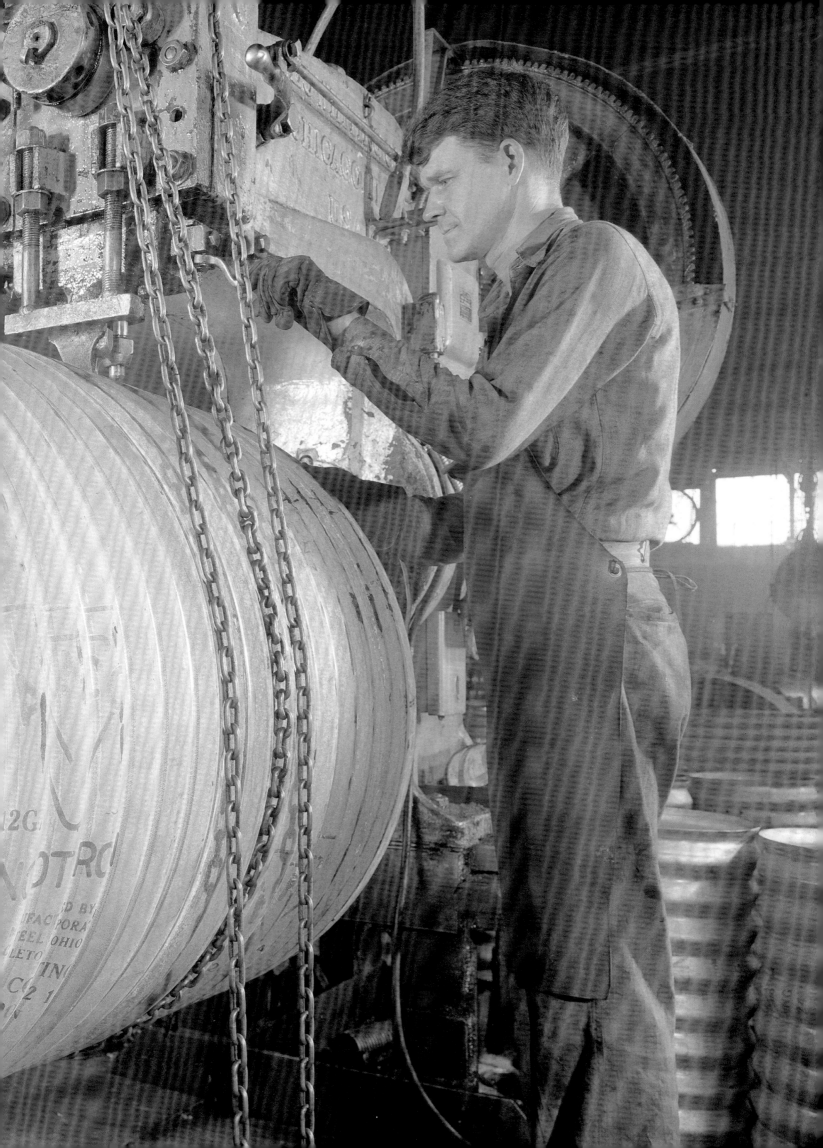

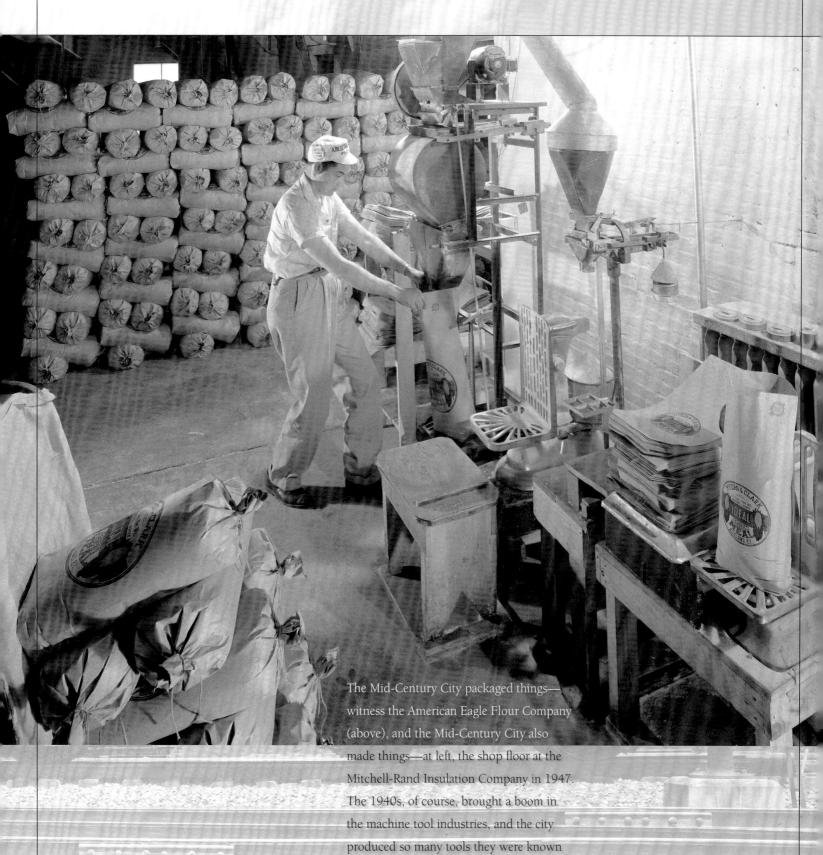

The Mid-Century City packaged things—
witness the American Eagle Flour Company
(above), and the Mid-Century City also
made things—at left, the shop floor at the
Mitchell-Rand Insulation Company in 1947.
The 1940s, of course, brought a boom in
the machine tool industries, and the city
produced so many tools they were known
in Russia as "Cincinnatis."

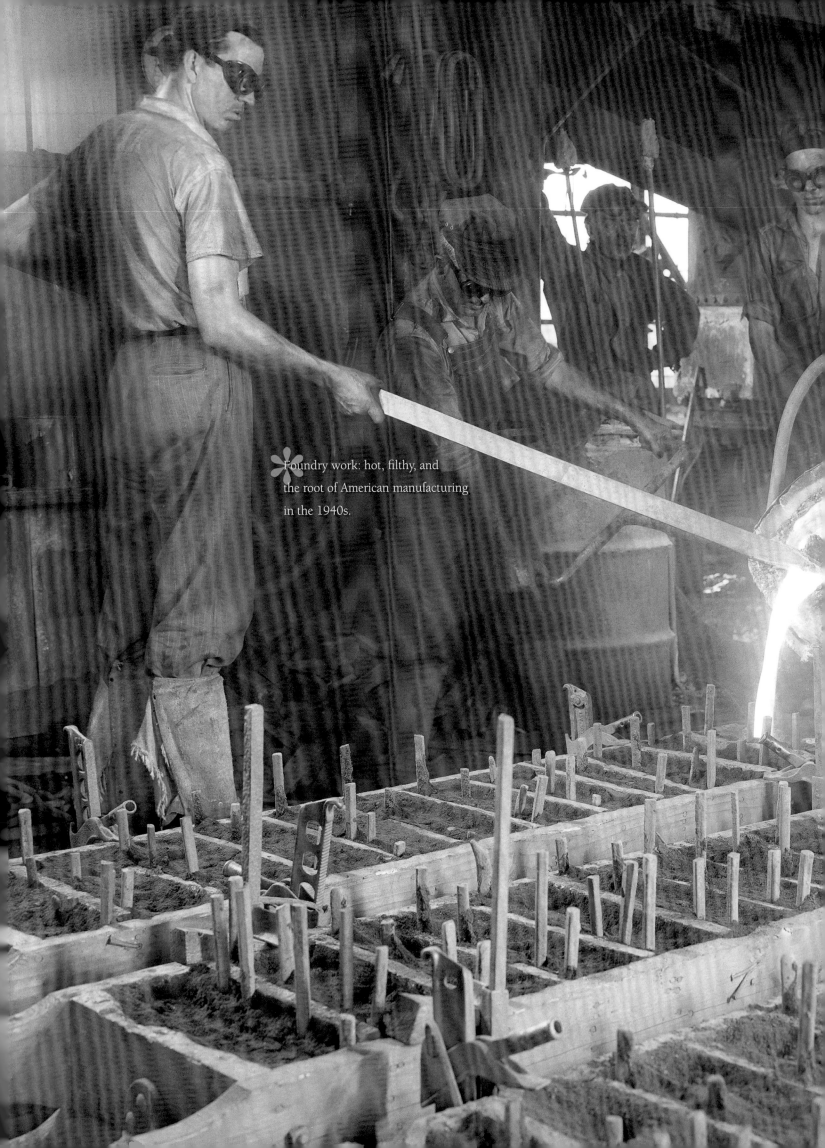

Foundry work: hot, filthy, and the root of American manufacturing in the 1940s.

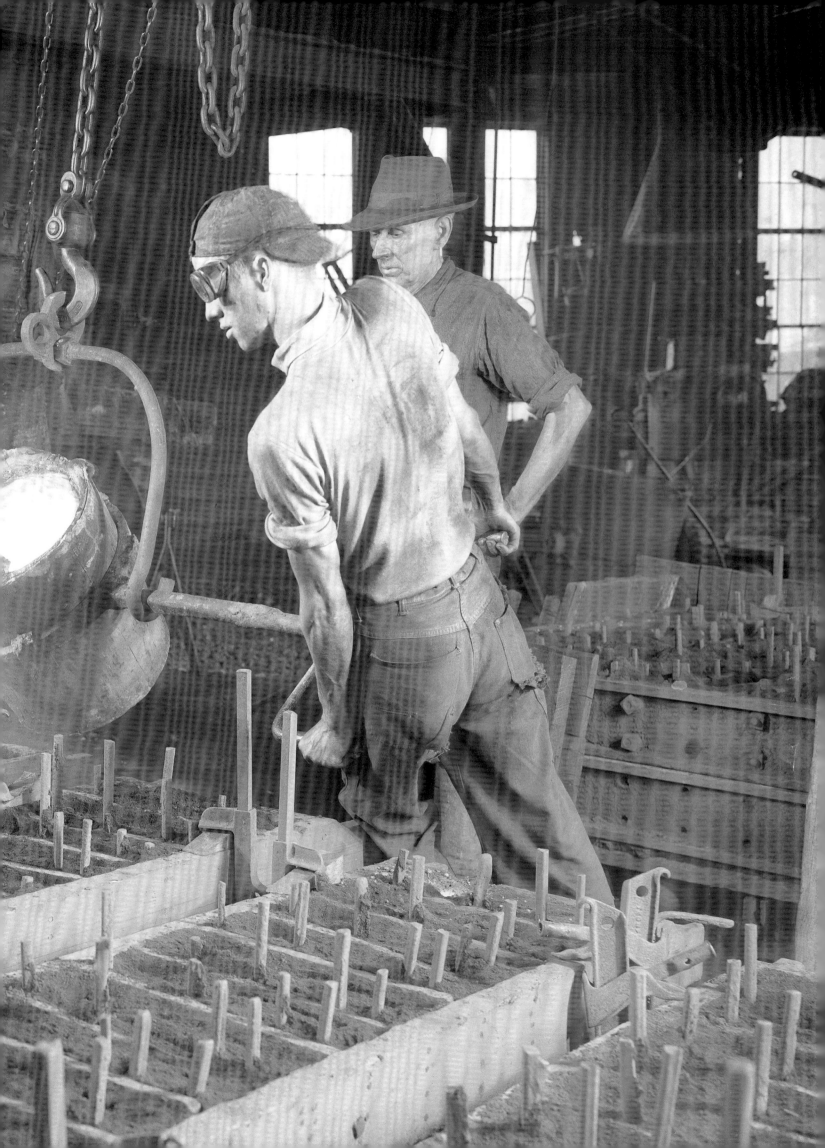

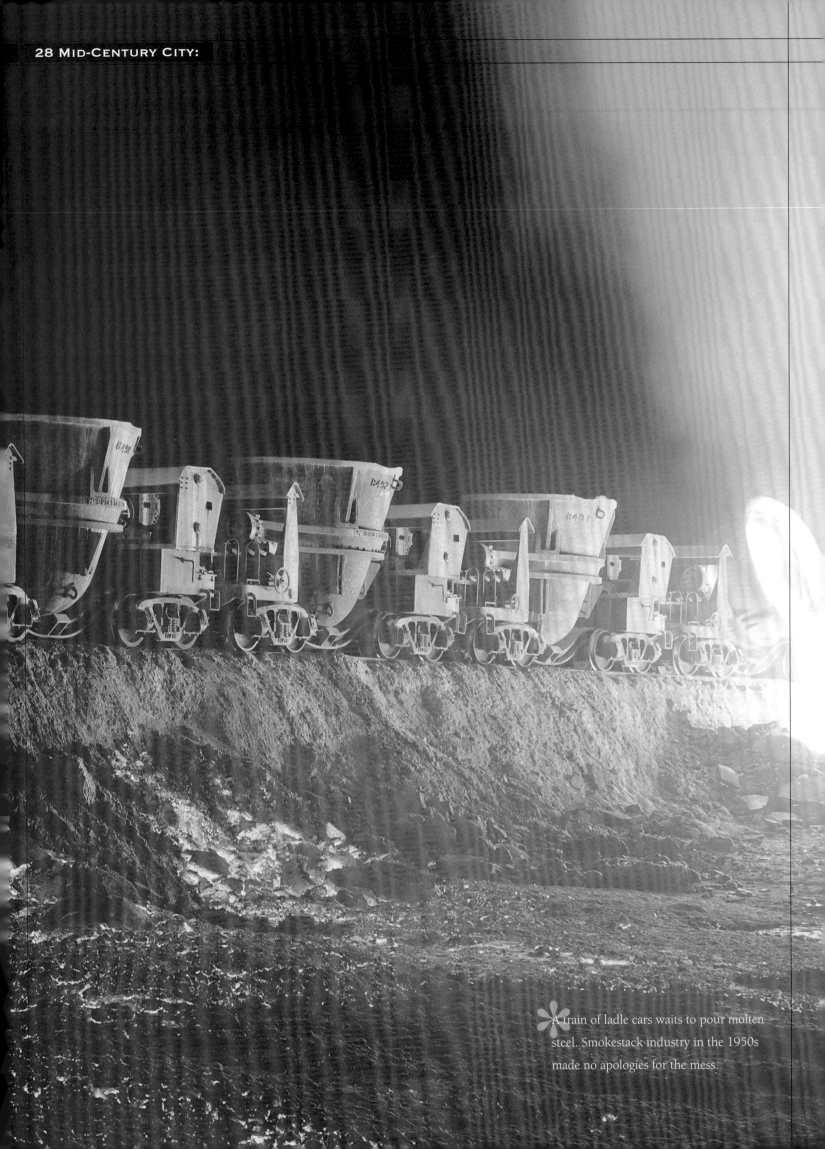

A train of ladle cars waits to pour molten steel. Smokestack industry in the 1950s made no apologies for the mess.

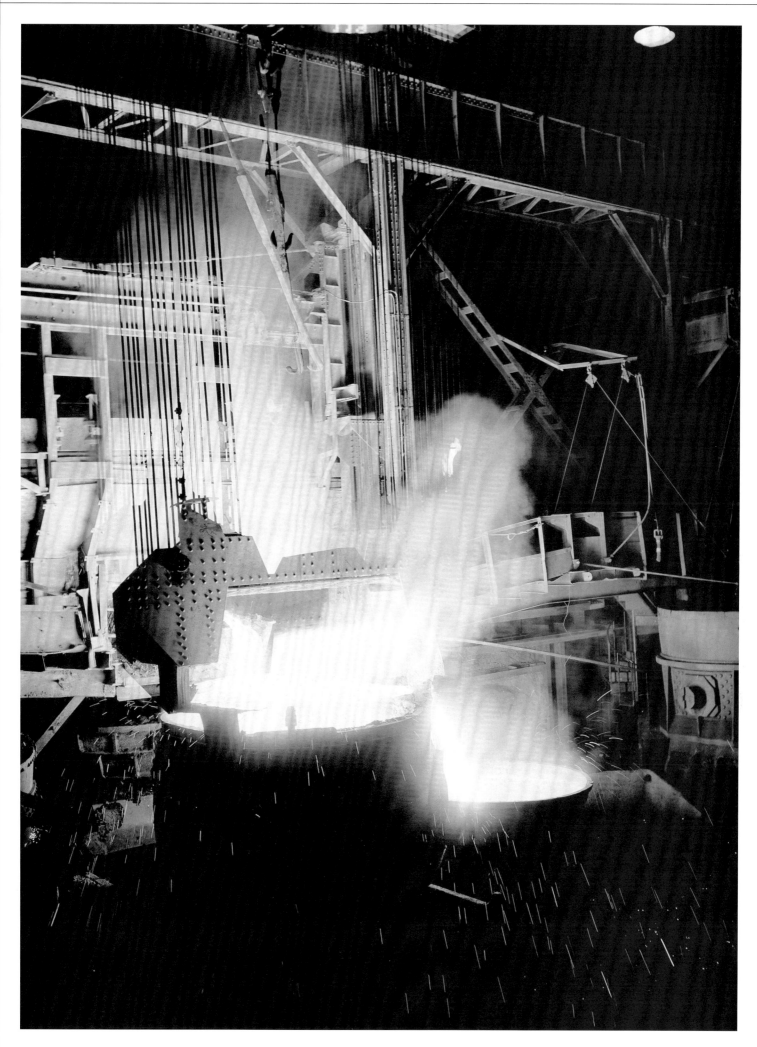

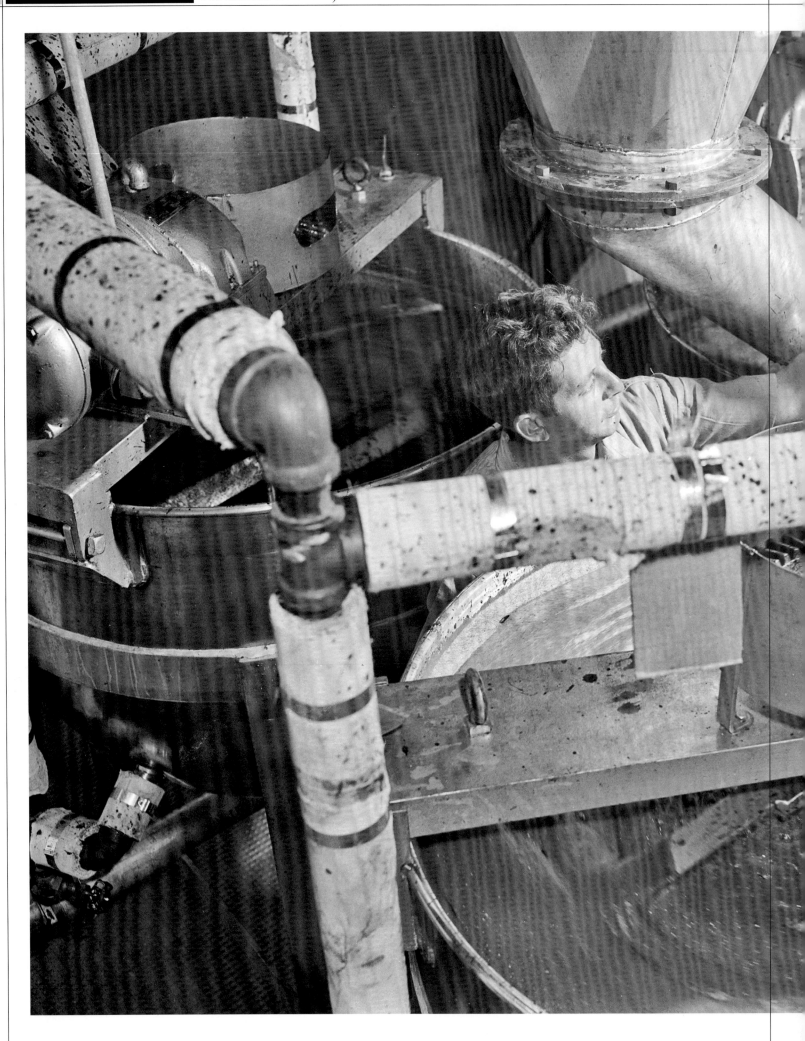

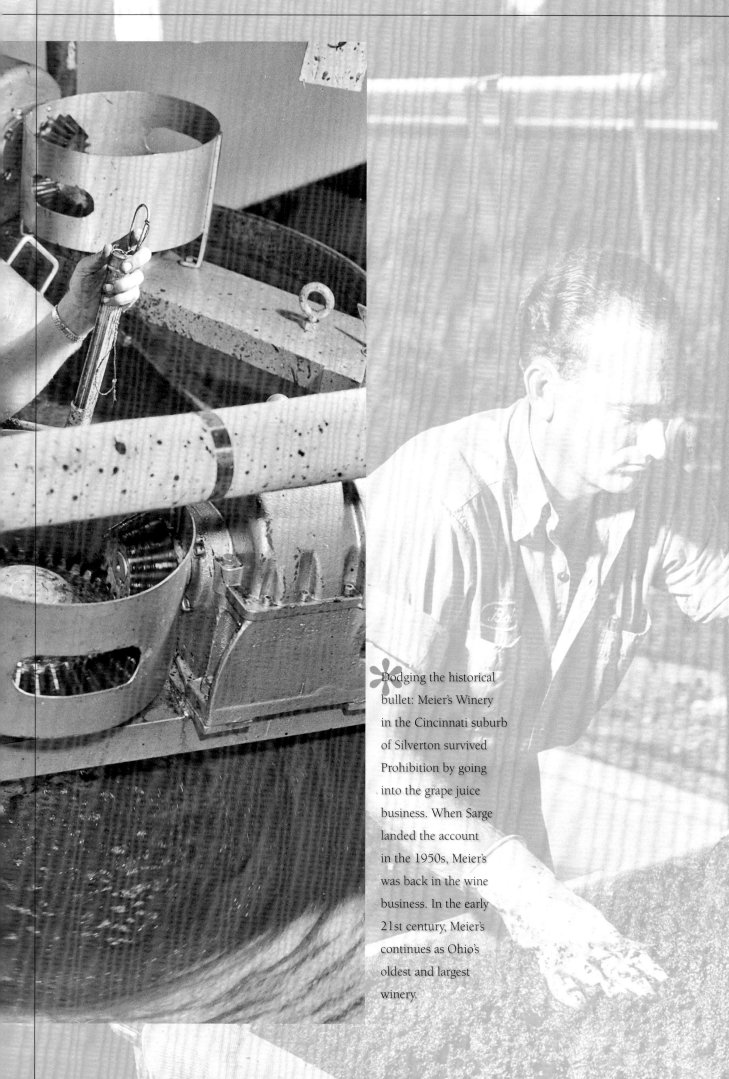

Dodging the historical bullet: Meier's Winery in the Cincinnati suburb of Silverton survived Prohibition by going into the grape juice business. When Sarge landed the account in the 1950s, Meier's was back in the wine business. In the early 21st century, Meier's continues as Ohio's oldest and largest winery.

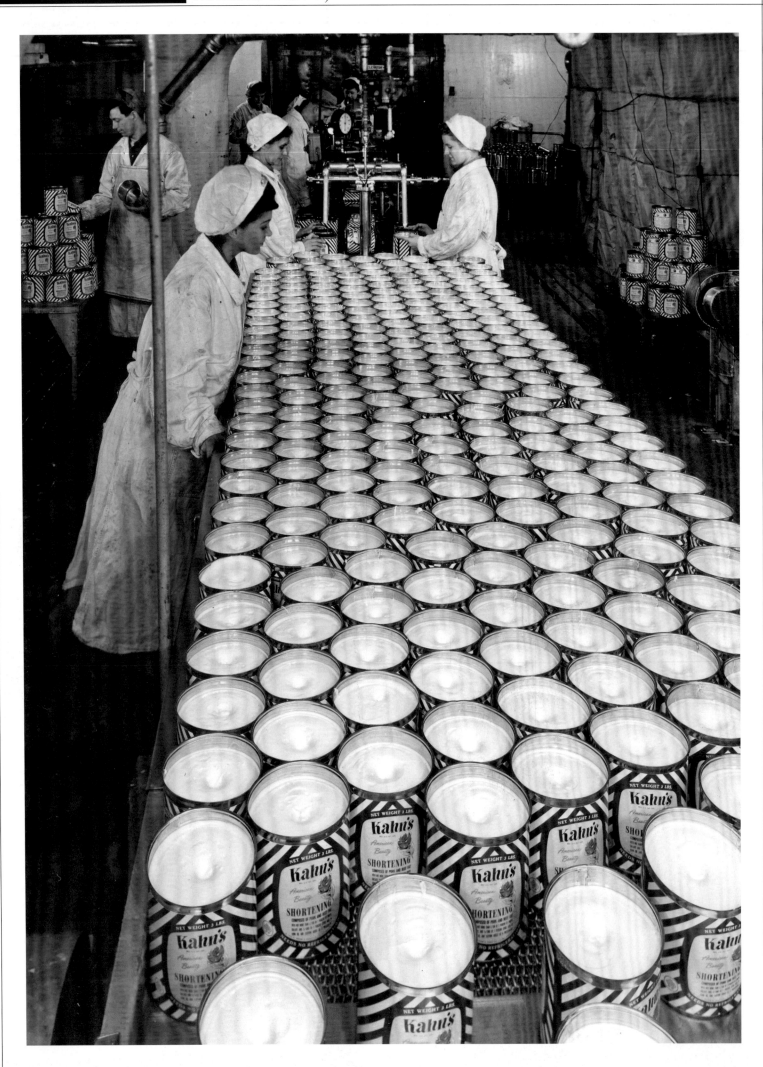

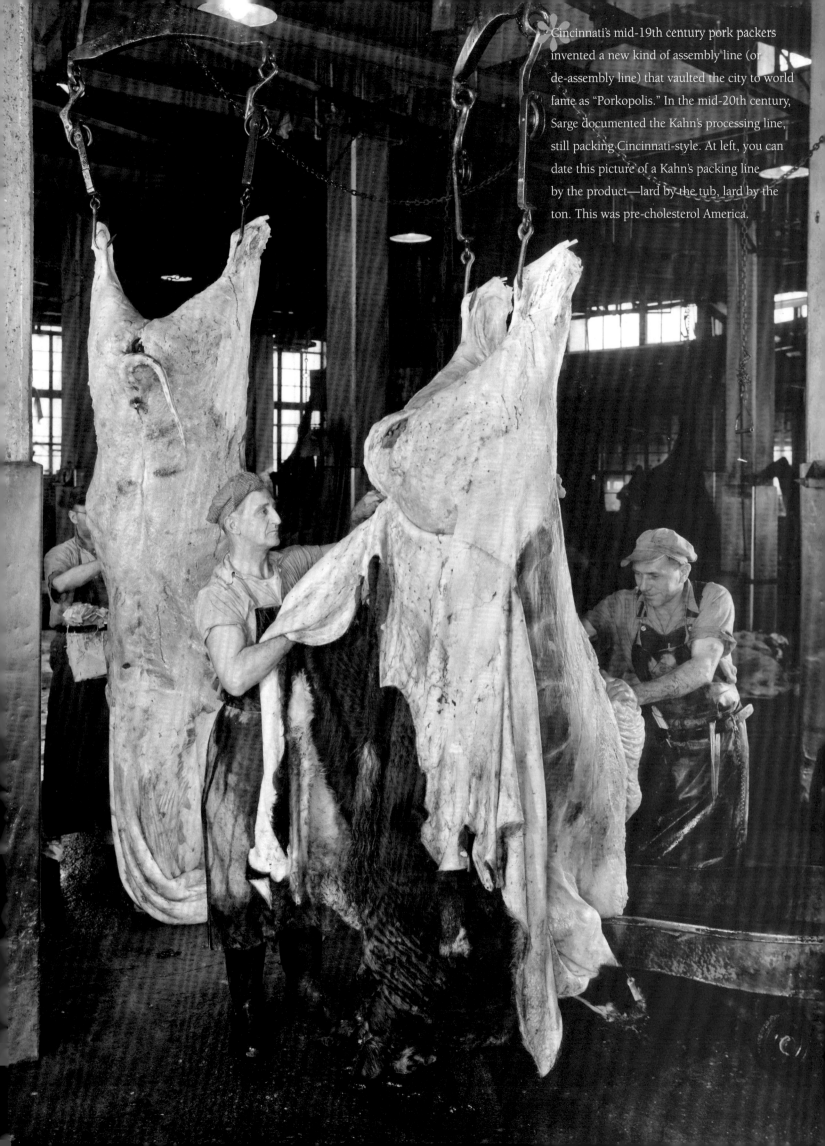

Cincinnati's mid-19th century pork packers invented a new kind of assembly line (or de-assembly line) that vaulted the city to world fame as "Porkopolis." In the mid-20th century, Sarge documented the Kahn's processing line, still packing Cincinnati-style. At left, you can date this picture of a Kahn's packing line by the product—lard by the tub, lard by the ton. This was pre-cholesterol America.

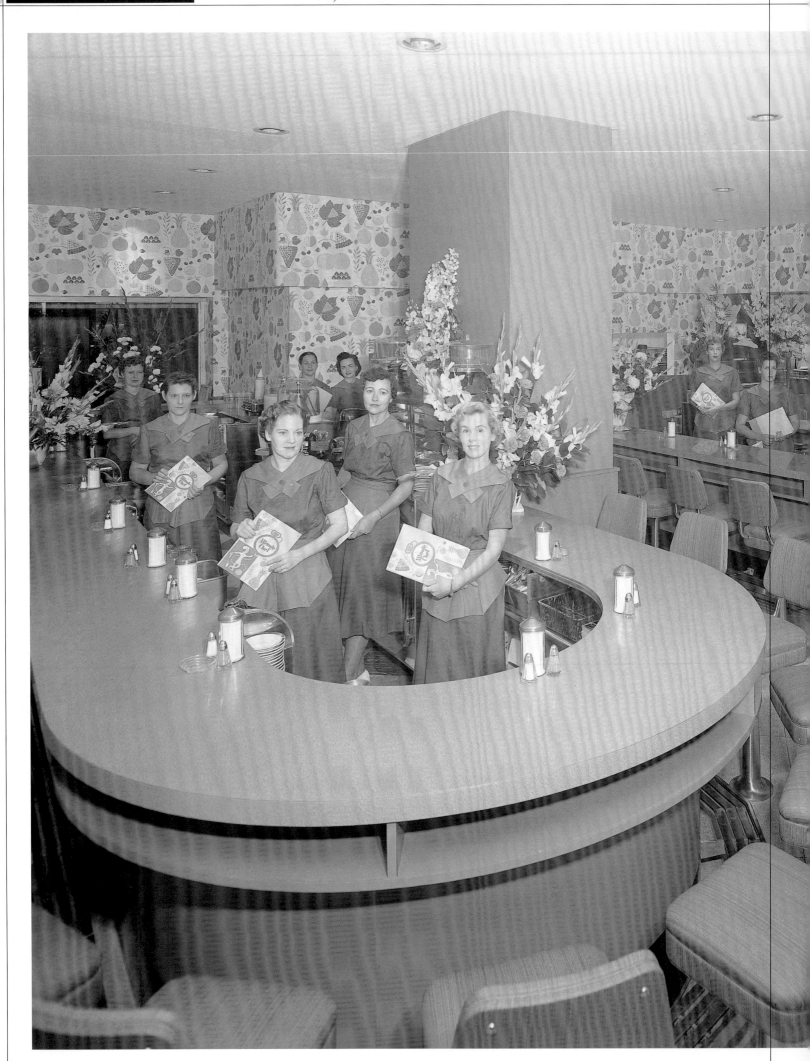

Waitresses on parade at the Minute Chef Grill inside the Gibson Hotel on Fifth Street. The Gibson was demolished in the 1980s to make way for the new permanent Fountain Square, which was demolished in 2006 to make way for the next version.

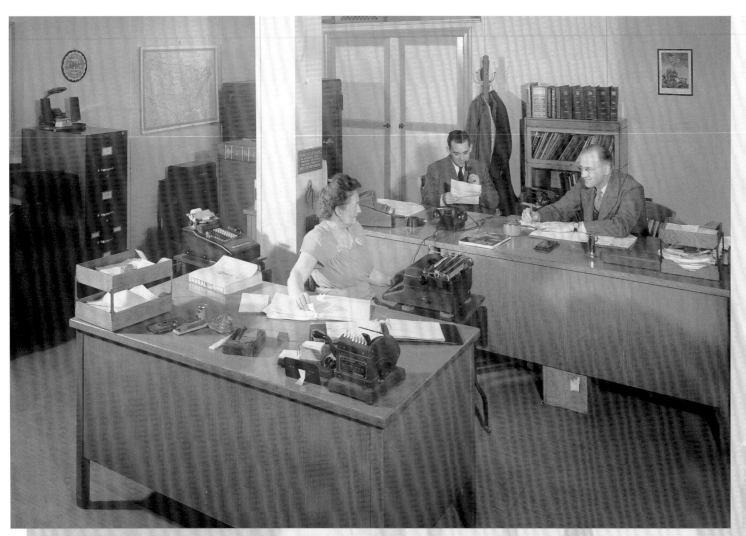

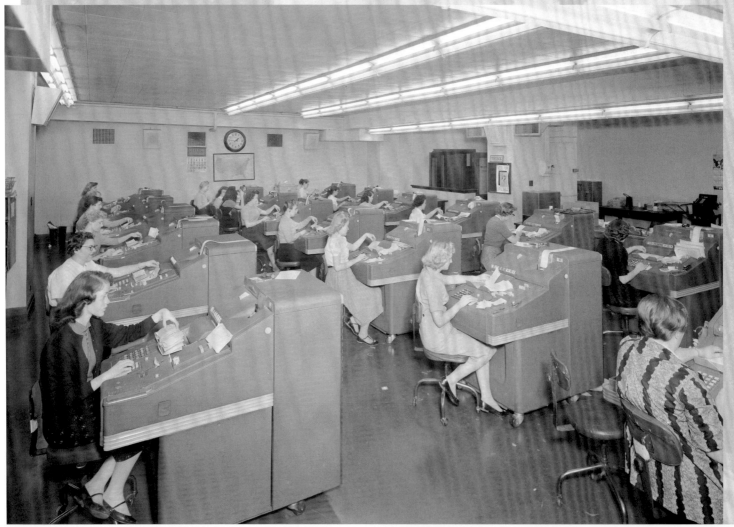

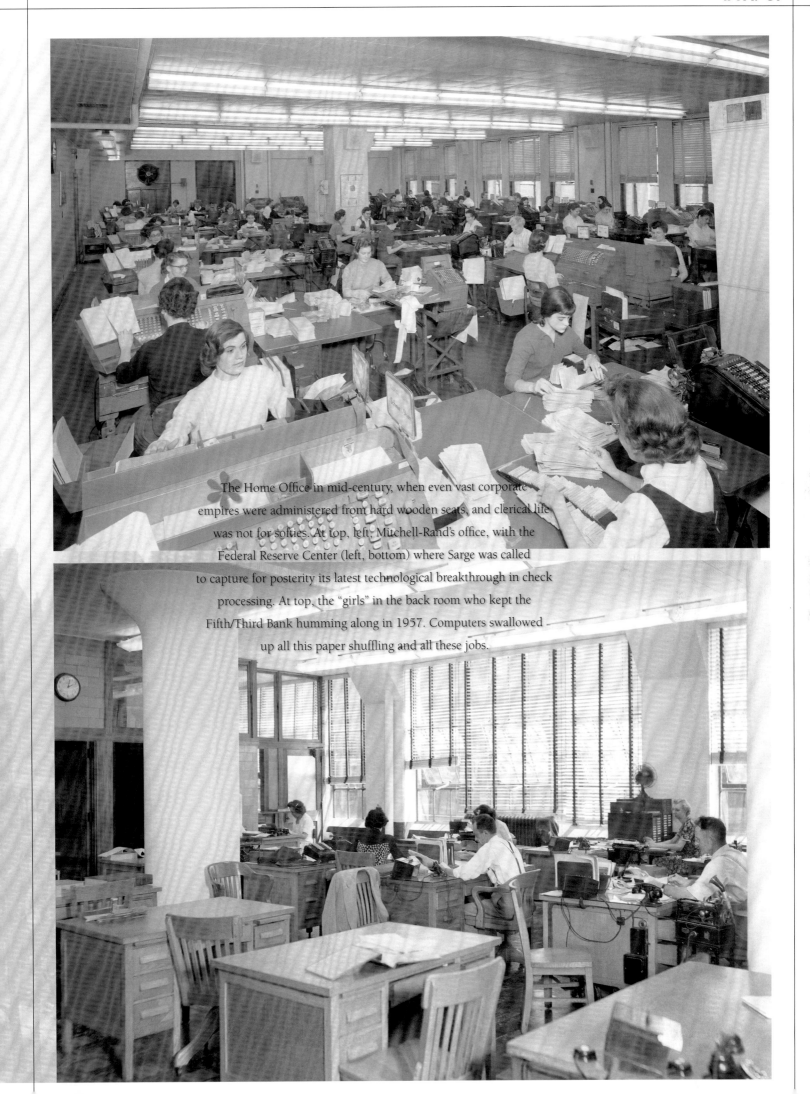

The Home Office in mid-century, when even vast corporate empires were administered from hard wooden seats, and clerical life was not for softies. At top, left, Mitchell-Rand's office, with the Federal Reserve Center (left, bottom) where Sarge was called to capture for posterity its latest technological breakthrough in check processing. At top, the "girls" in the back room who kept the Fifth/Third Bank humming along in 1957. Computers swallowed up all this paper shuffling and all these jobs.

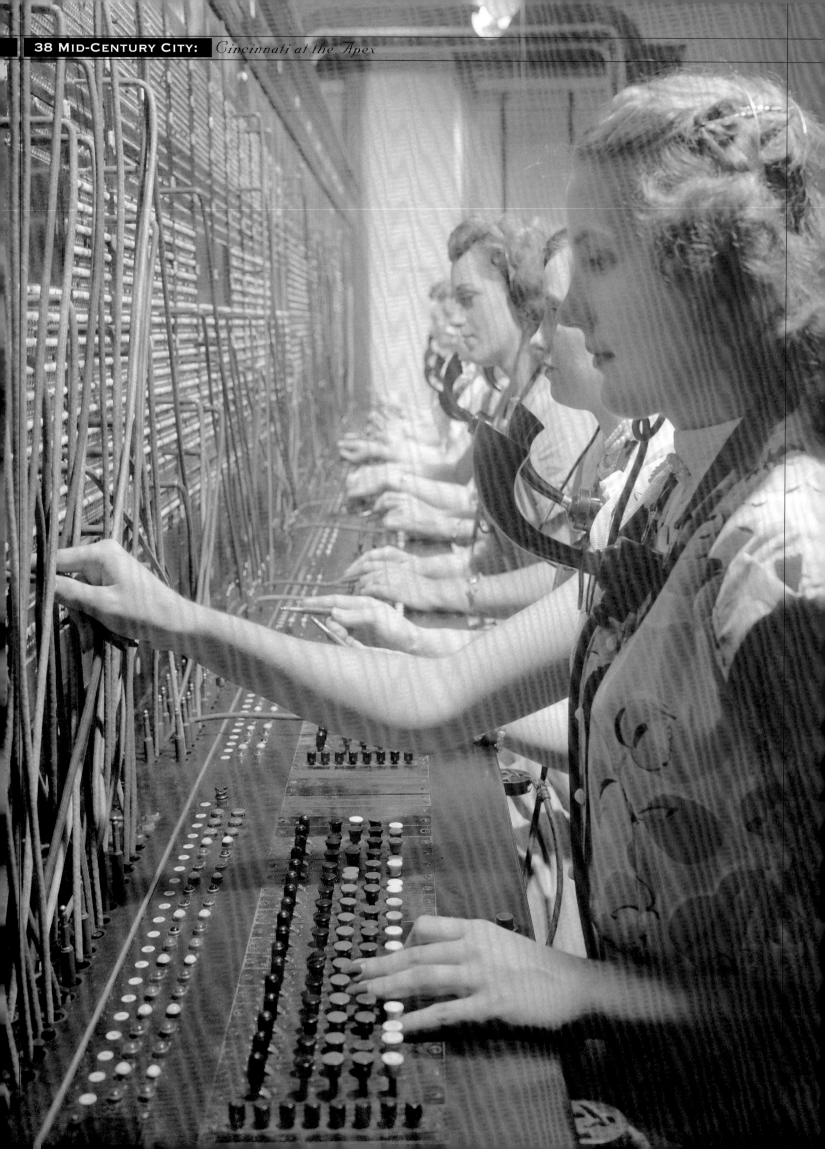

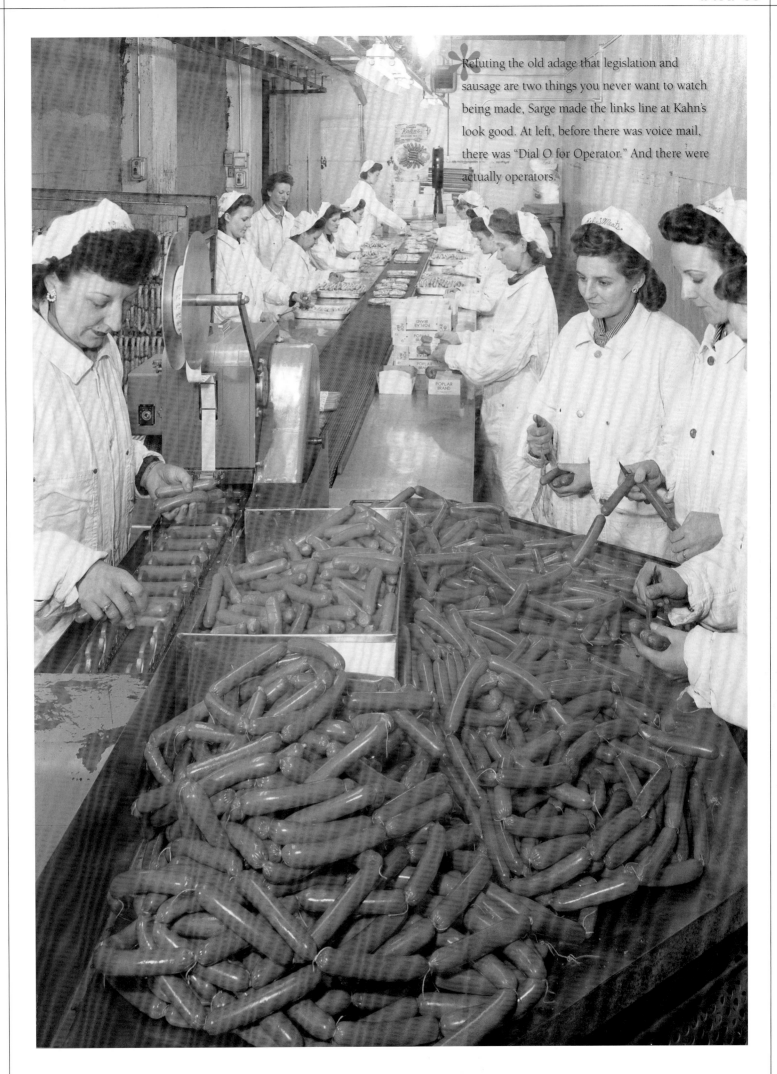

Refuting the old adage that legislation and sausage are two things you never want to watch being made, Sarge made the links line at Kahn's look good. At left, before there was voice mail, there was "Dial O for Operator." And there were actually operators.

SCHENLEY DISTILLERIES INC
No 2 GREENDALE IND

C A 6 9 0 1 2
D 100 P
RYE WHISKEY
SERIAL N D 69 12
FILLED SEP 5 1945

INSPECTED

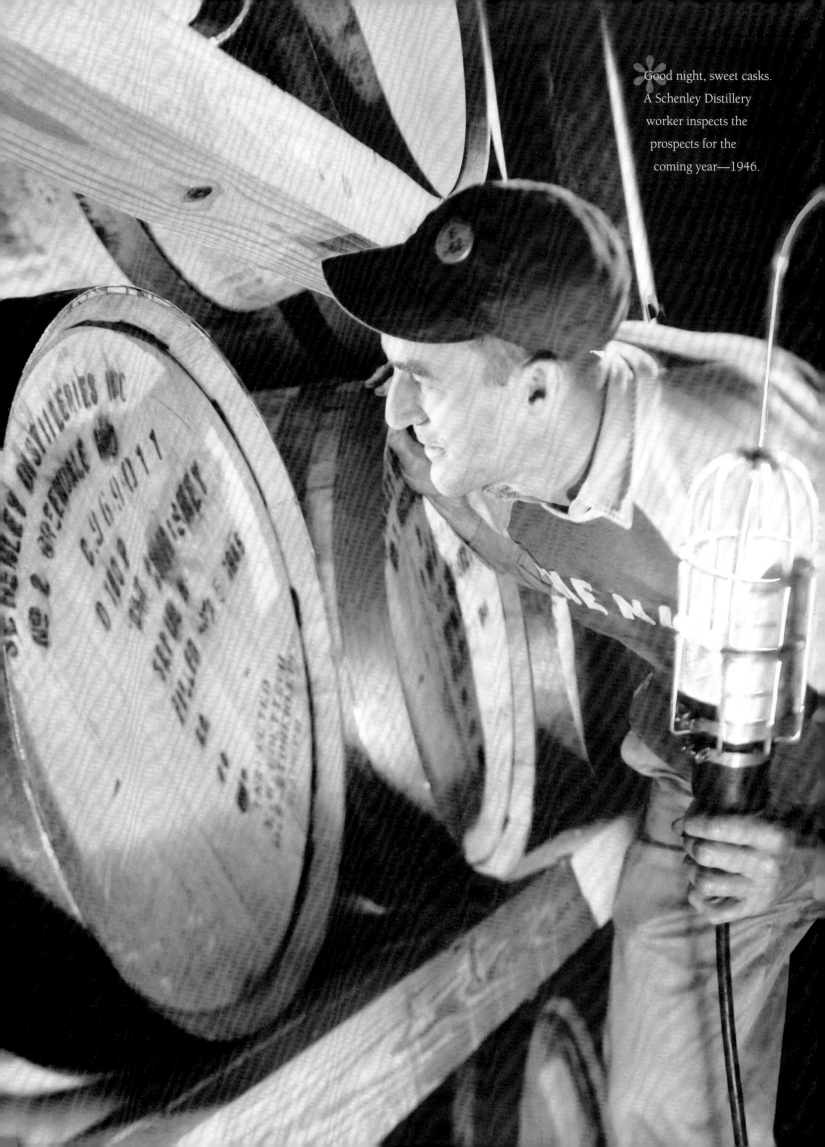

Good night, sweet casks. A Schenley Distillery worker inspects the prospects for the coming year—1946.

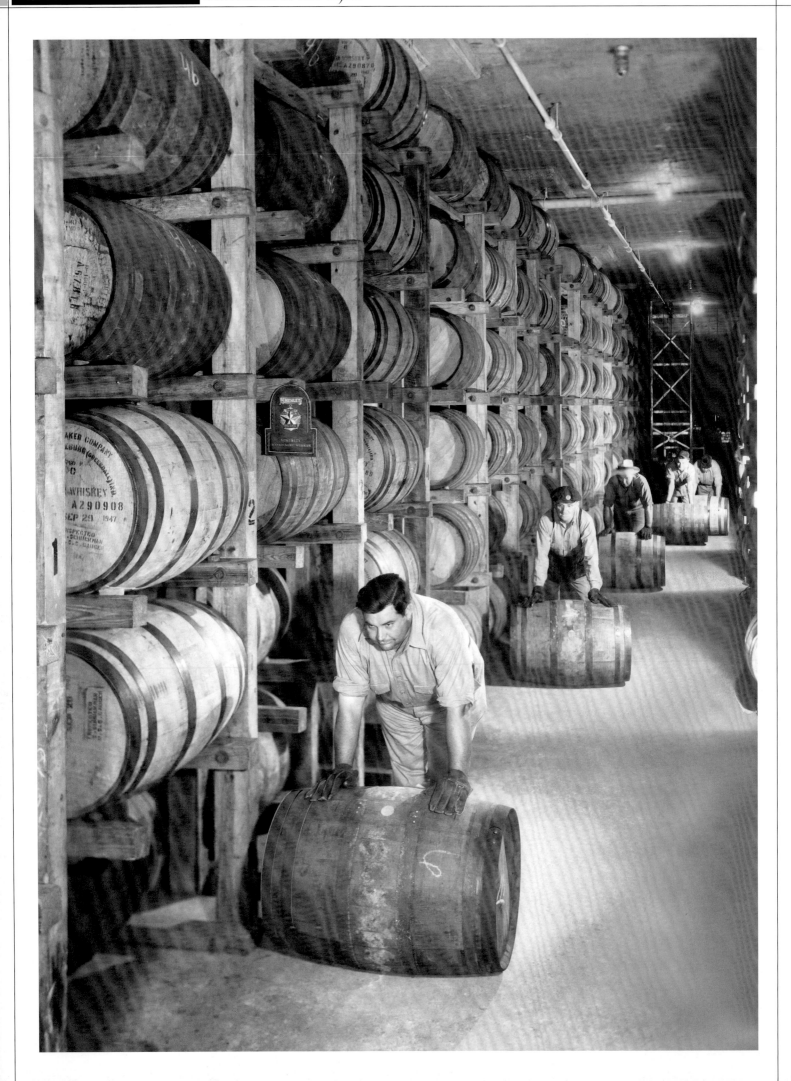

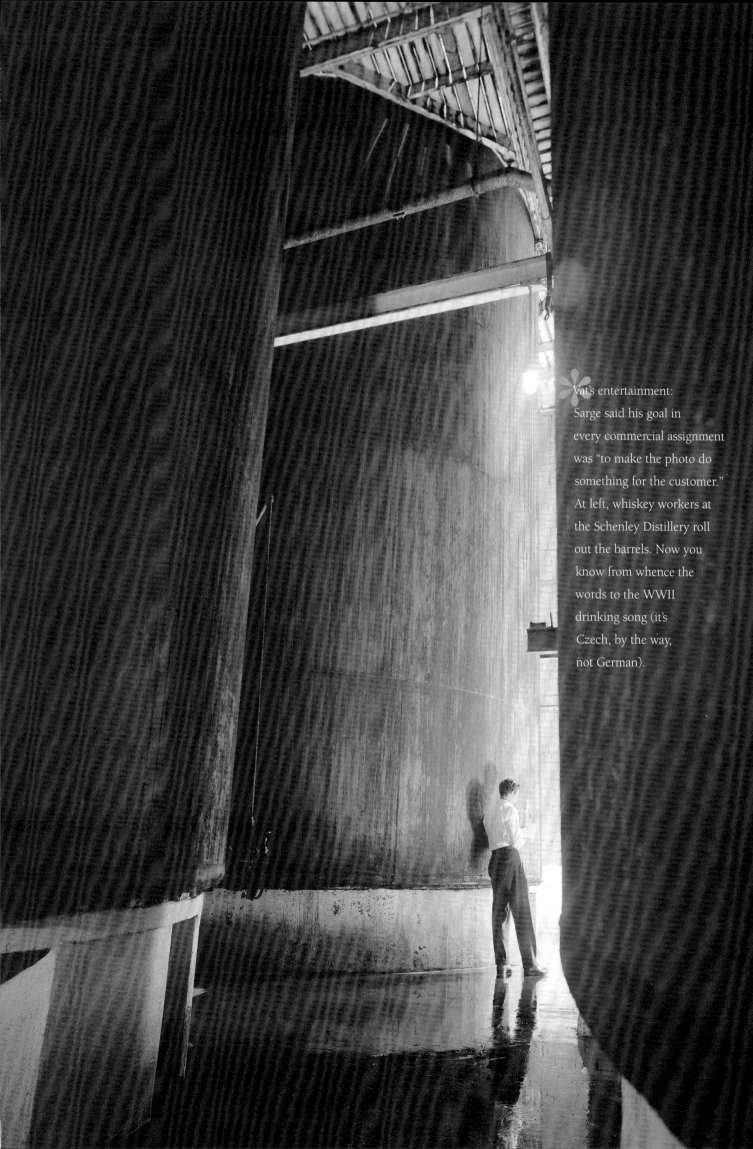

Vat's entertainment: Sarge said his goal in every commercial assignment was "to make the photo do something for the customer." At left, whiskey workers at the Schenley Distillery roll out the barrels. Now you know from whence the words to the WWII drinking song (it's Czech, by the way, not German).

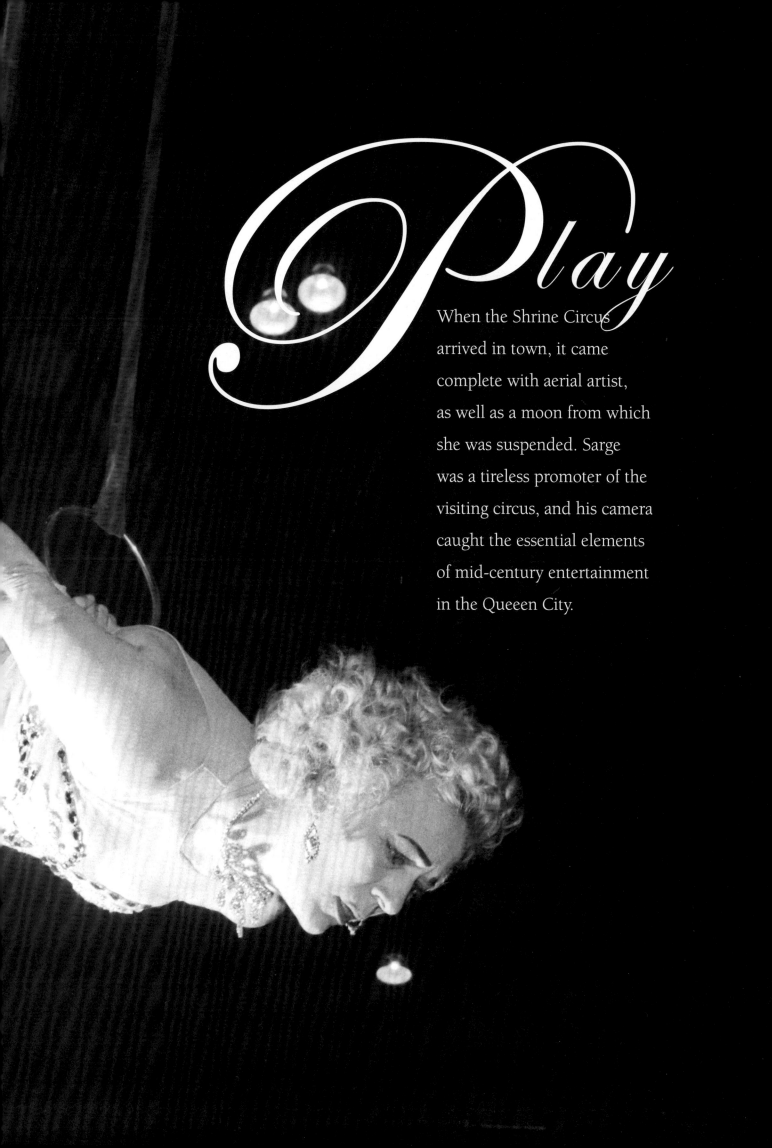

Play

When the Shrine Circus arrived in town, it came complete with aerial artist, as well as a moon from which she was suspended. Sarge was a tireless promoter of the visiting circus, and his camera caught the essential elements of mid-century entertainment in the Queeen City.

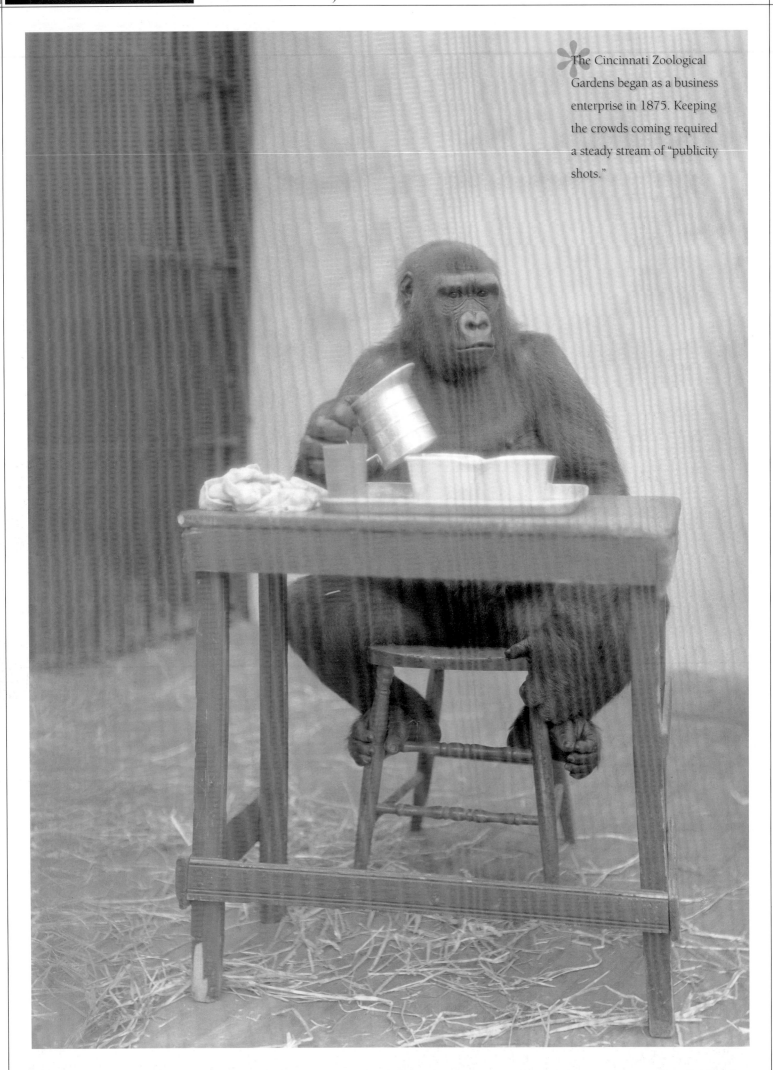

The Cincinnati Zoological Gardens began as a business enterprise in 1875. Keeping the crowds coming required a steady stream of "publicity shots."

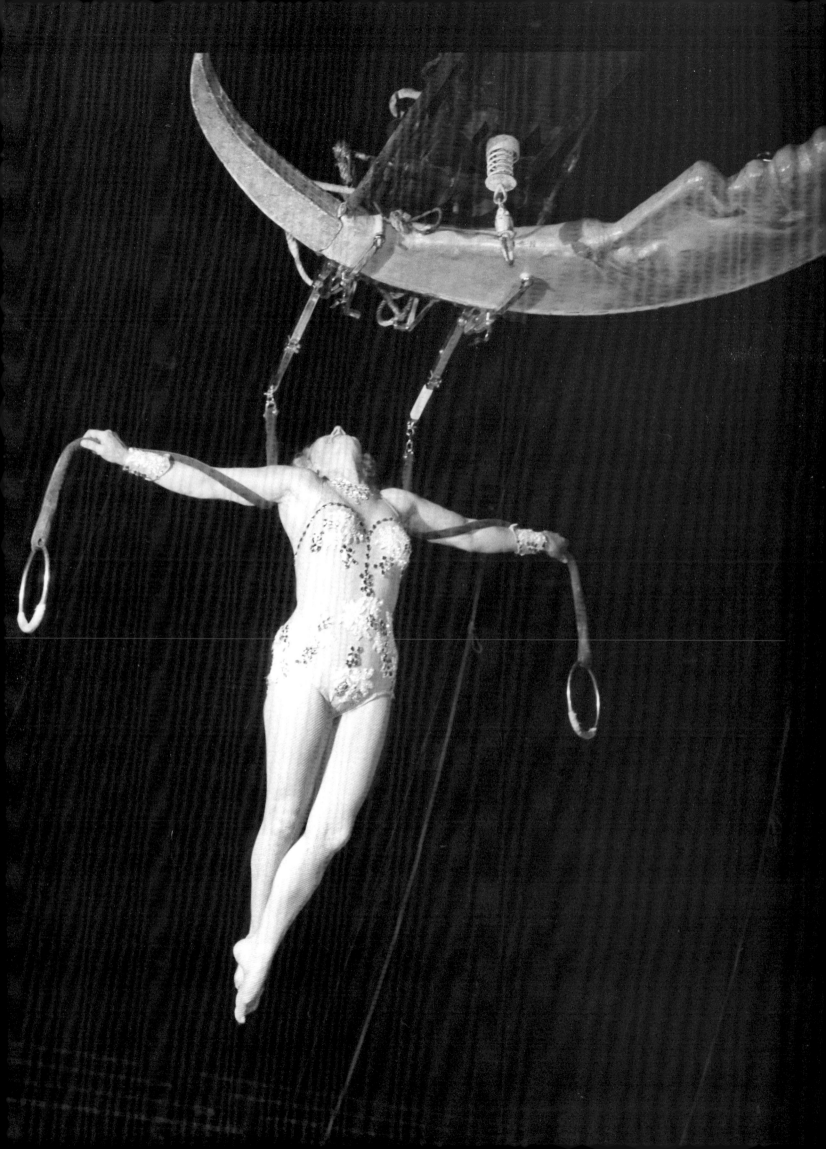

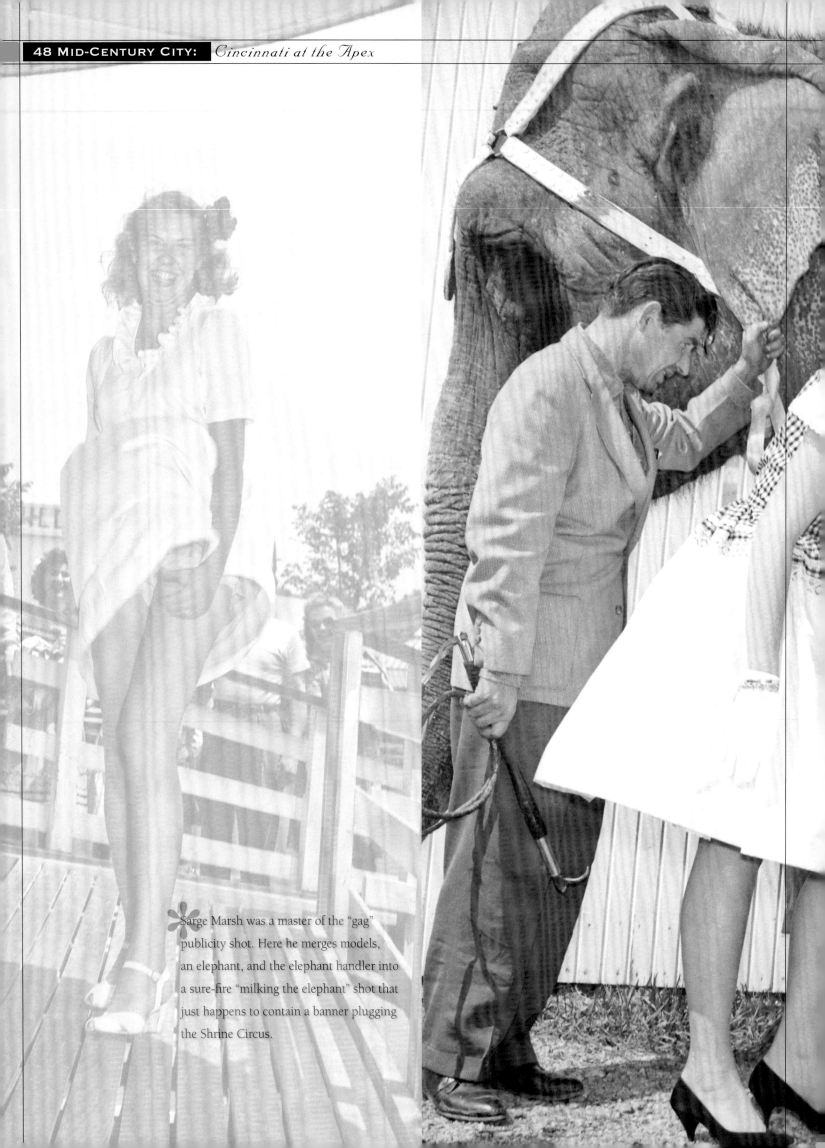

Sarge Marsh was a master of the "gag" publicity shot. Here he merges models, an elephant, and the elephant handler into a sure-fire "milking the elephant" shot that just happens to contain a banner plugging the Shrine Circus.

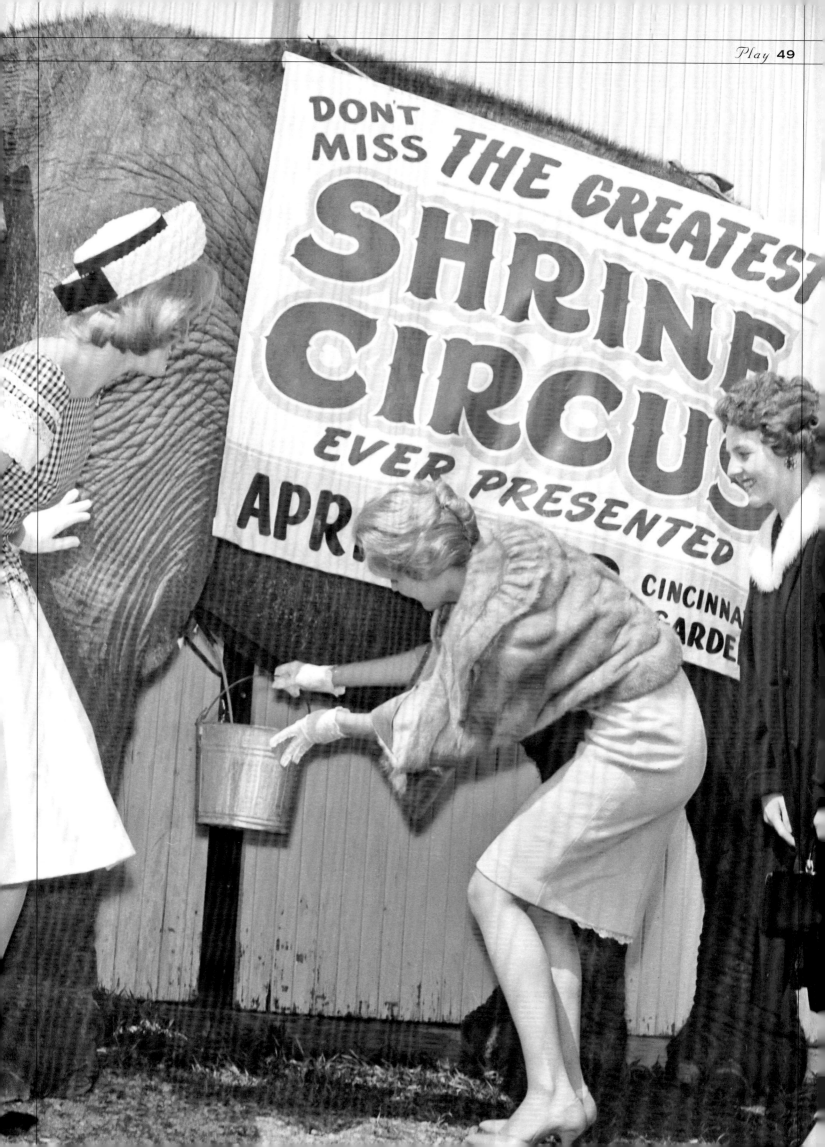

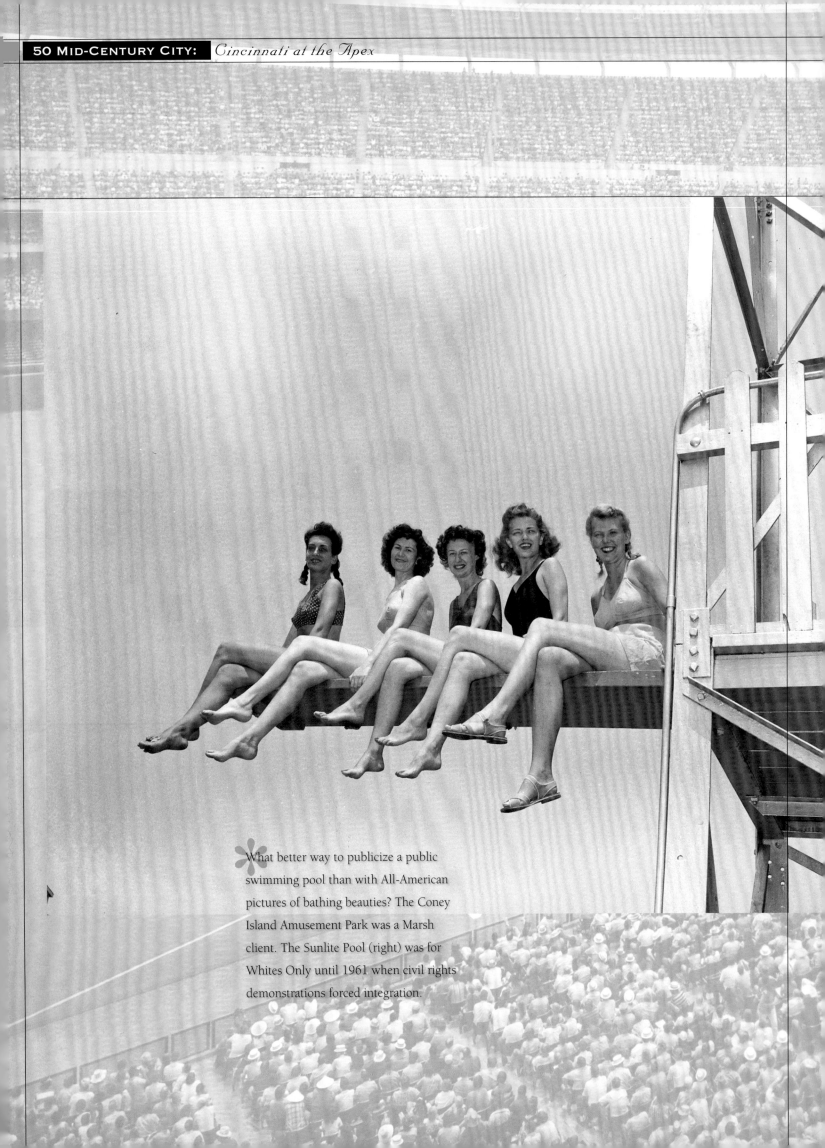

What better way to publicize a public swimming pool than with All-American pictures of bathing beauties? The Coney Island Amusement Park was a Marsh client. The Sunlite Pool (right) was for Whites Only until 1961 when civil rights demonstrations forced integration.

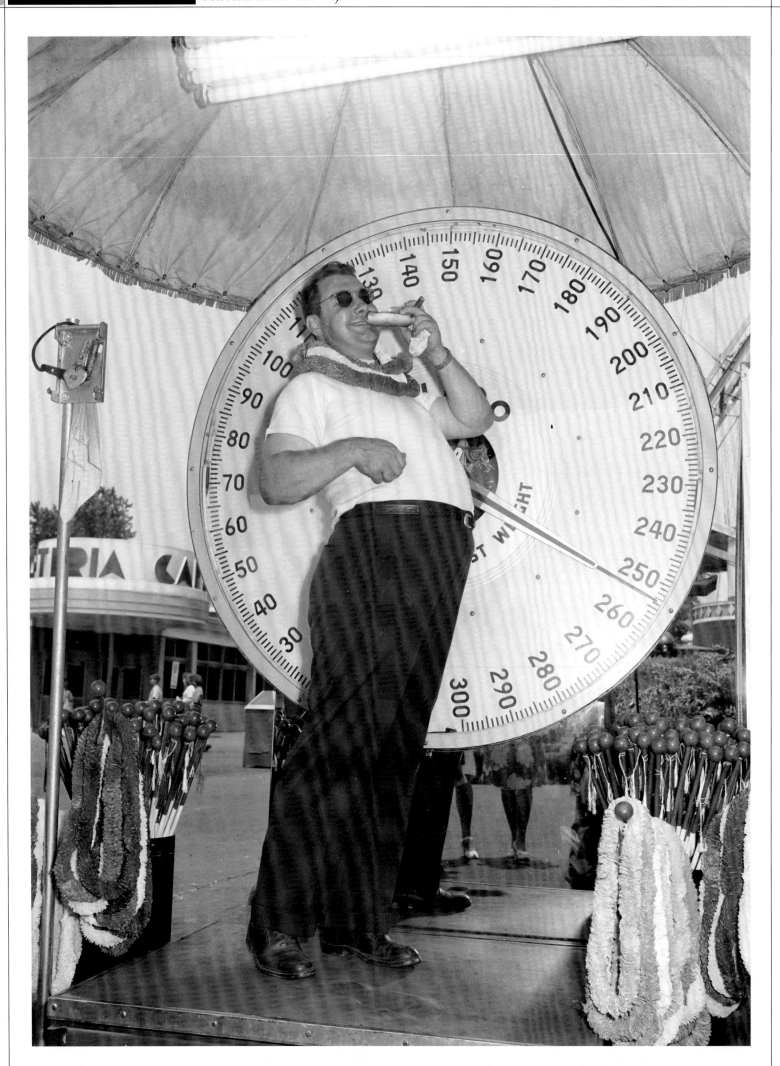

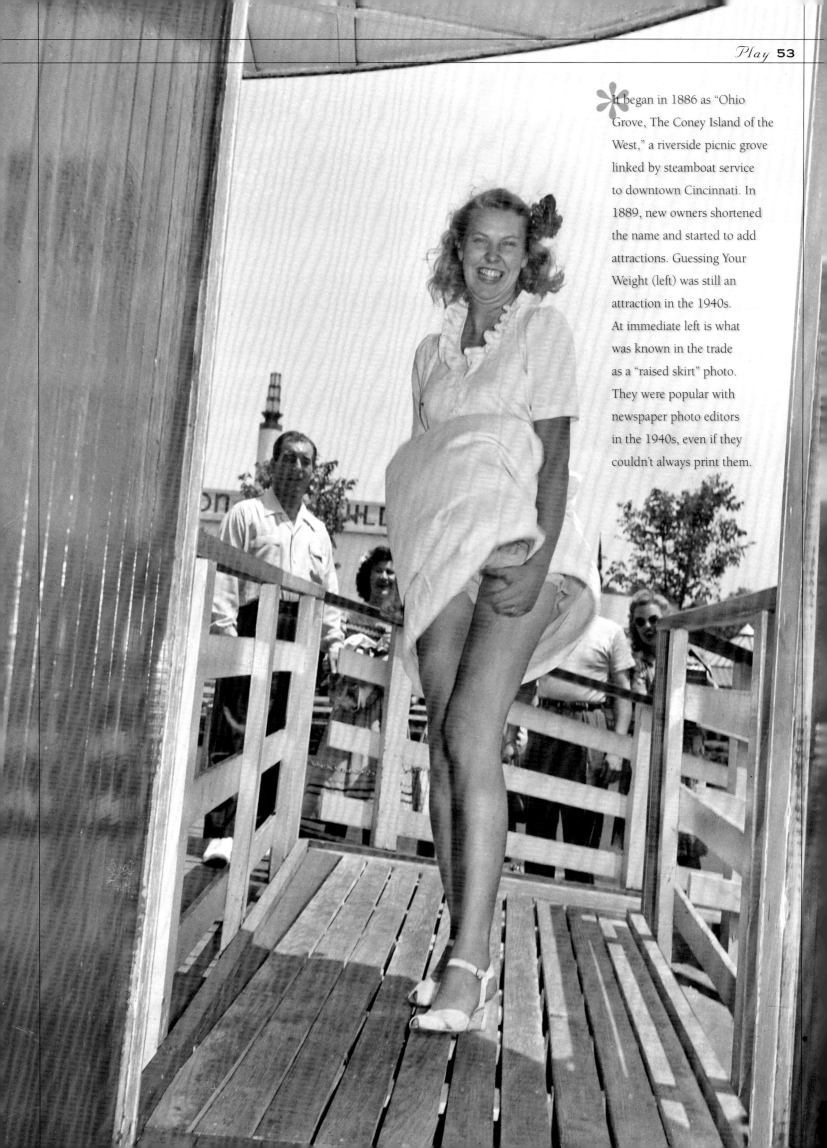

It began in 1886 as "Ohio Grove, The Coney Island of the West," a riverside picnic grove linked by steamboat service to downtown Cincinnati. In 1889, new owners shortened the name and started to add attractions. Guessing Your Weight (left) was still an attraction in the 1940s. At immediate left is what was known in the trade as a "raised skirt" photo. They were popular with newspaper photo editors in the 1940s, even if they couldn't always print them.

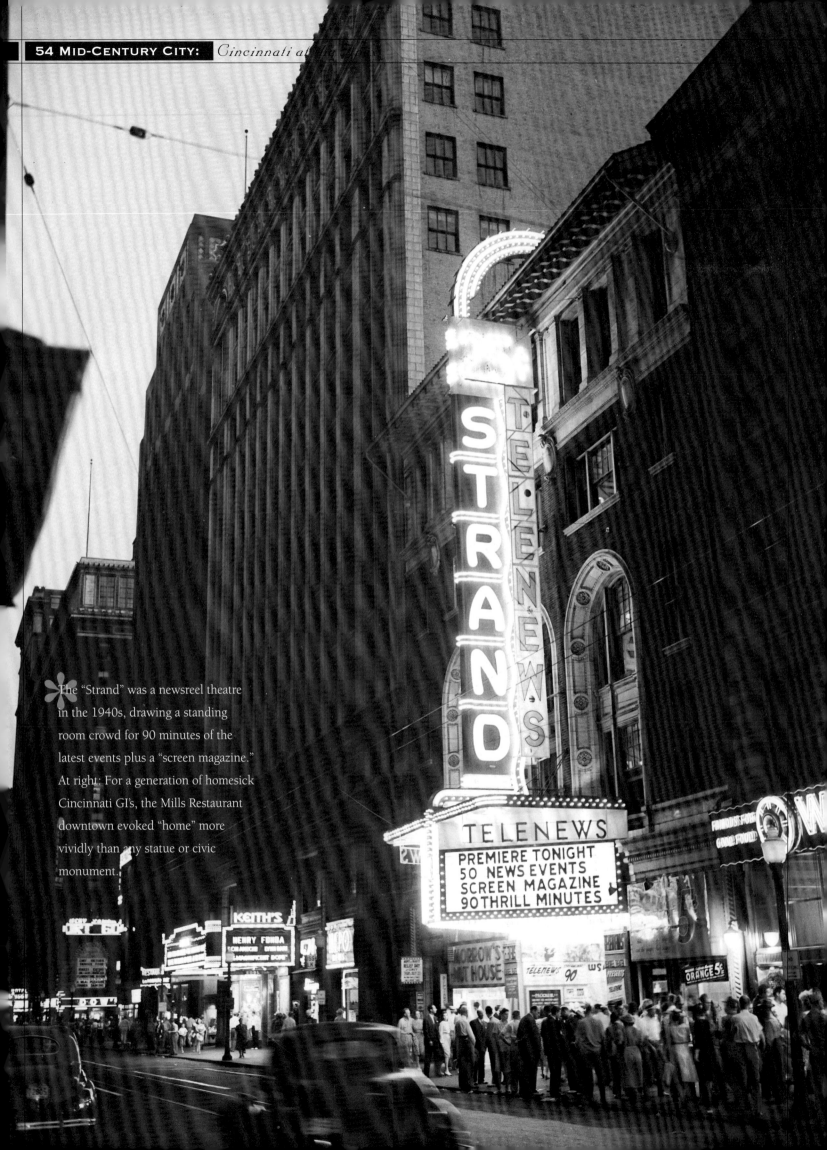

✳The "Strand" was a newsreel theatre in the 1940s, drawing a standing room crowd for 90 minutes of the latest events plus a "screen magazine." At right: For a generation of homesick Cincinnati GI's, the Mills Restaurant downtown evoked "home" more vividly than any statue or civic monument.

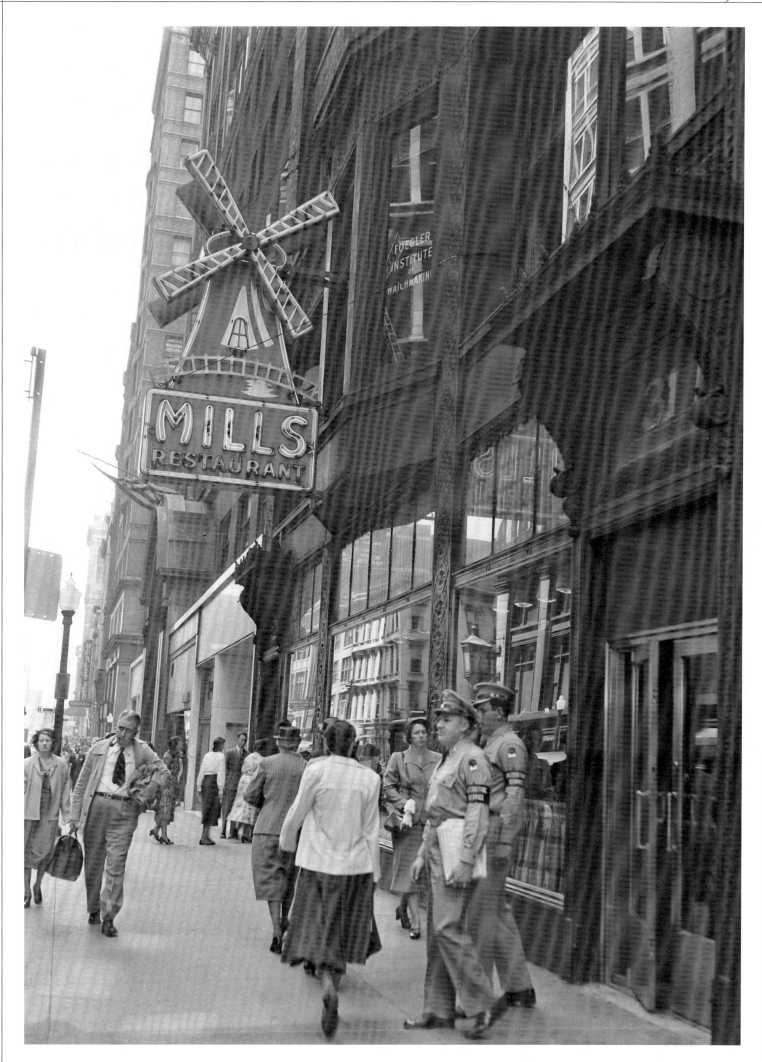

In the Mid-Century City, the "pictures" still came to your neighborhood theatre. This one (above) was in Hyde Park. The Albee was as big as the Big Time got in Cincinnati. It cost $4 million and could seat 3,300 customers, some of whom were ladies who did not remove their hats. Top, right: The projection booth, possibly at the Albee in the late 1940s. Note the chimneys to carry away the heat generated by the powerful projection lamps. In 1947, the downtown movie palaces (bottom, right), including the Grand, shown here, staged colorful shows on the sidewalk outside as well as on the screen inside. Sarge did their local publicity shots.

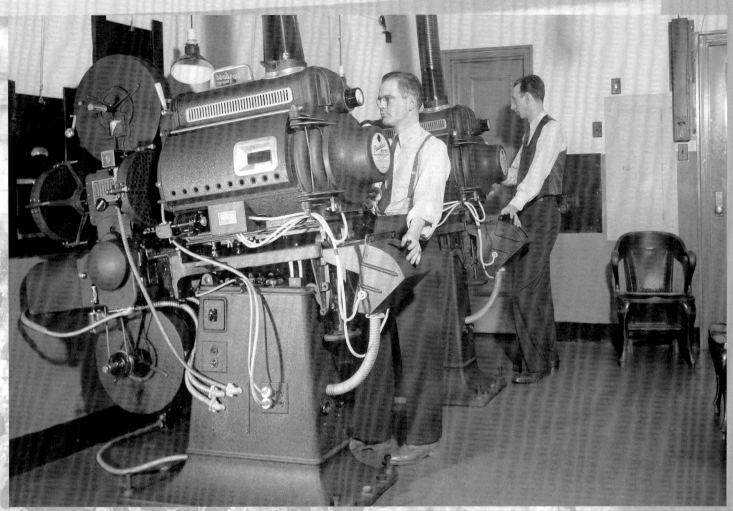

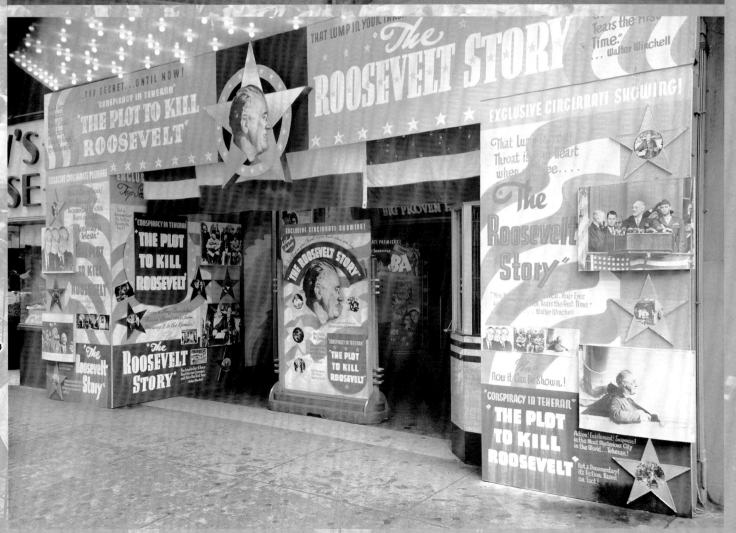

With the new Interstate 71 at its doorstep, Kings Island stepped out into the deep country in 1971, on 1,600 acres of Ohio farmland. The amusement park's name was an amalgam of Coney Island (which it replaced) and the nearby village of Kings Mill. By the early 21st century, "exurbia" was lapping around the park.

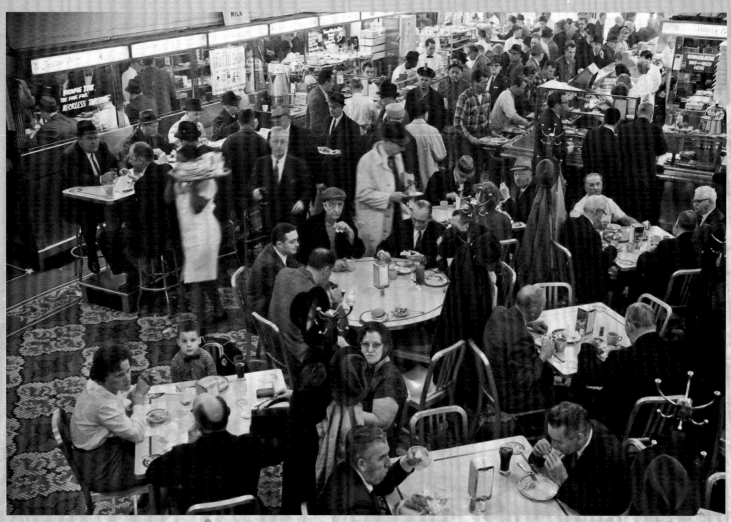

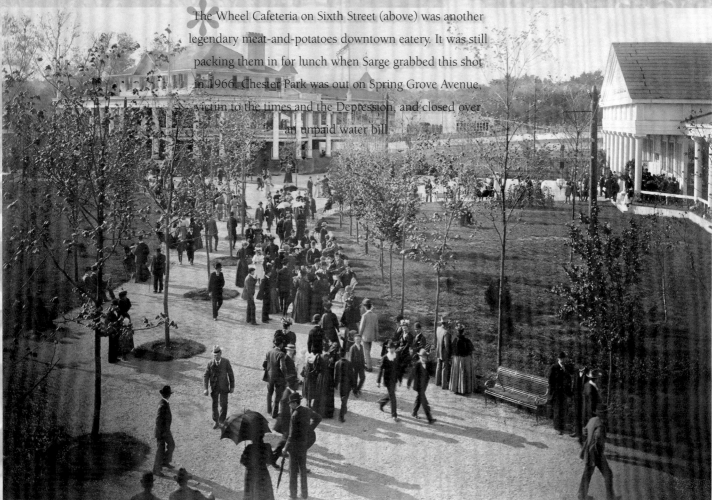

The Wheel Cafeteria on Sixth Street (above) was another legendary meat-and-potatoes downtown eatery. It was still packing them in for lunch when Sarge grabbed this shot in 1966. Chester Park was out on Spring Grove Avenue, victim to the times and the Depression, and closed over an unpaid water bill.

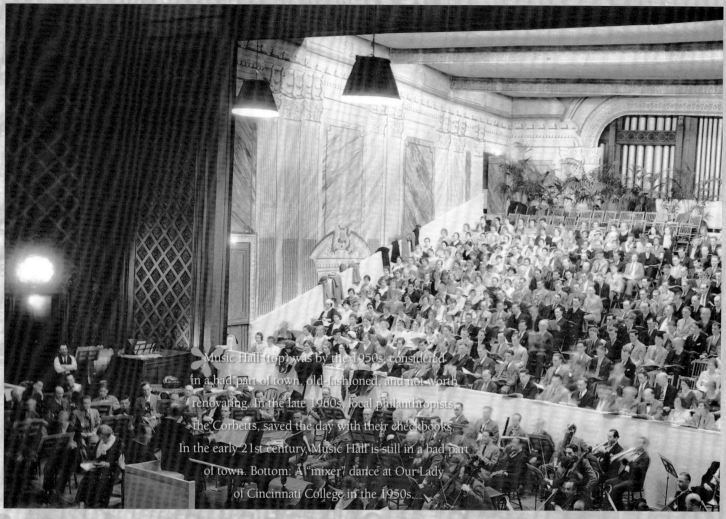

Music Hall (top) was by the 1950s, considered
in a bad part of town, old-fashioned, and not worth
renovating. In the late 1960s, local philanthropists,
the Corbetts, saved the day with their checkbooks.
In the early 21st century, Music Hall is still in a bad part
of town. Bottom: A "mixer" dance at Our Lady
of Cincinnati College in the 1950s.

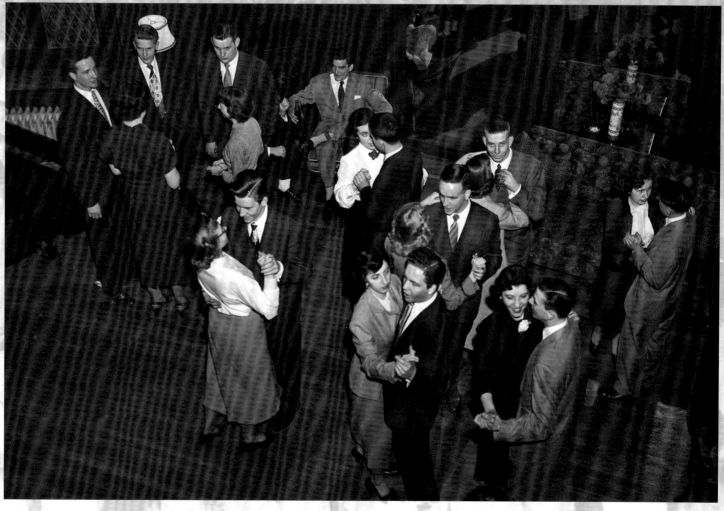

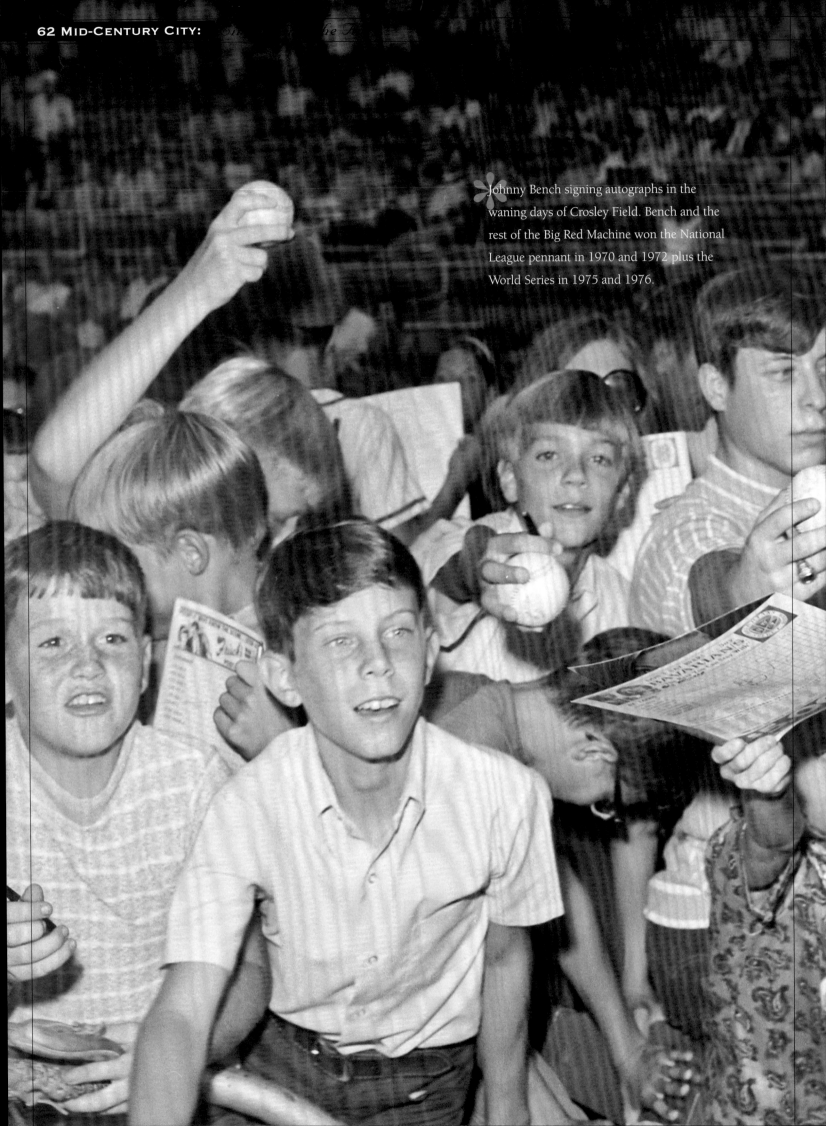

Johnny Bench signing autographs in the waning days of Crosley Field. Bench and the rest of the Big Red Machine won the National League pennant in 1970 and 1972 plus the World Series in 1975 and 1976.

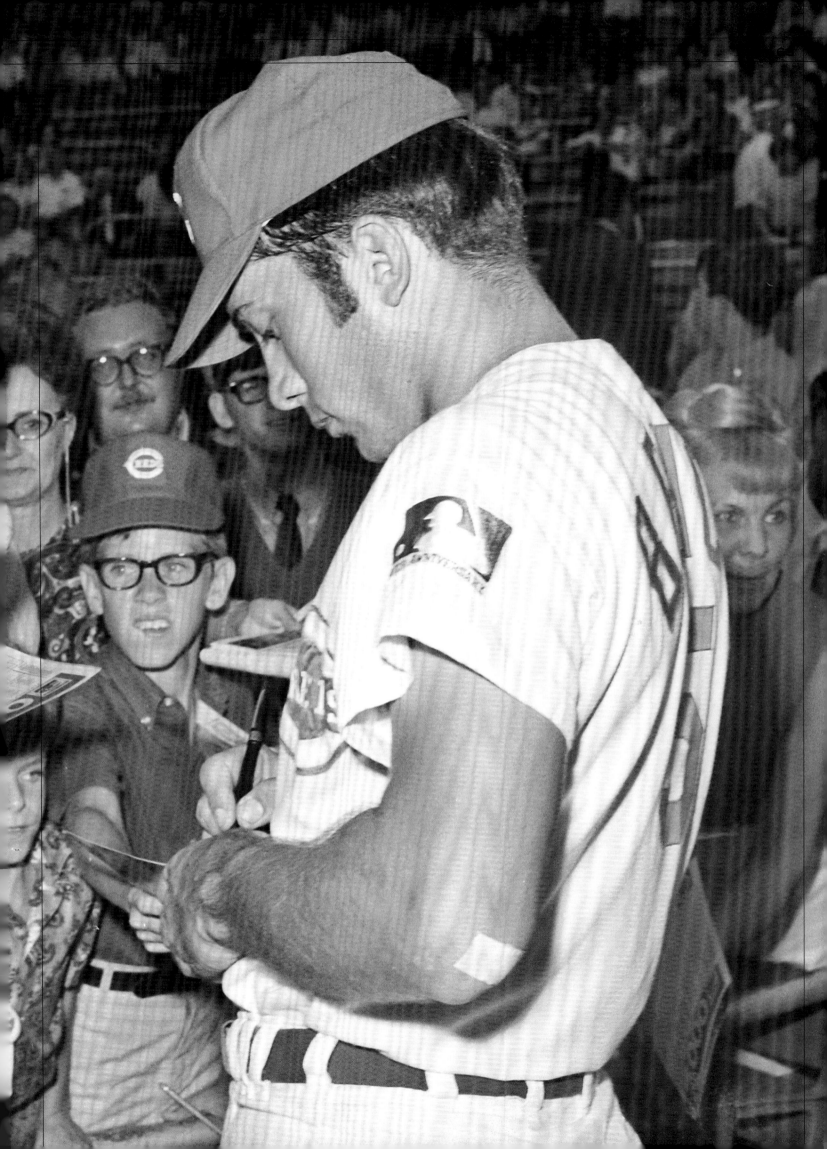

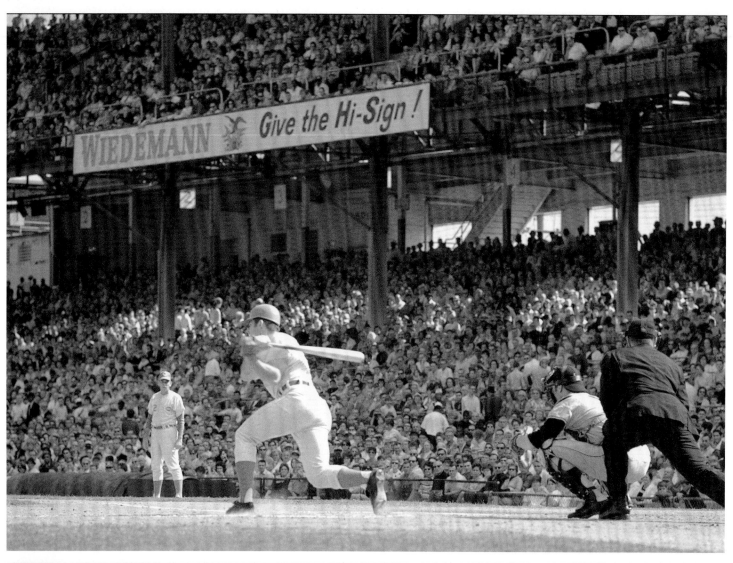

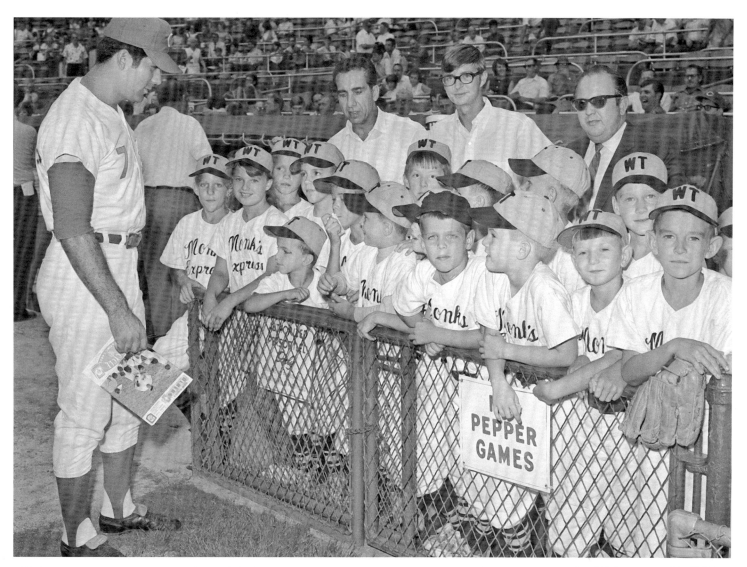

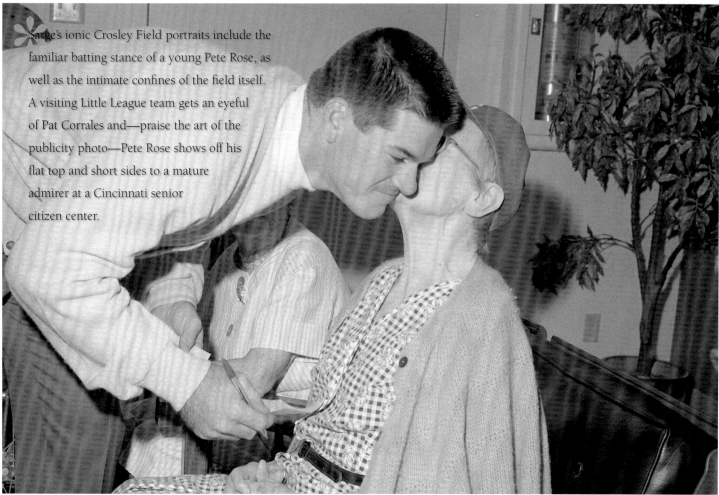

Sarge's iconic Crosley Field portraits include the familiar batting stance of a young Pete Rose, as well as the intimate confines of the field itself. A visiting Little League team gets an eyeful of Pat Corrales and—praise the art of the publicity photo—Pete Rose shows off his flat top and short sides to a mature admirer at a Cincinnati senior citizen center.

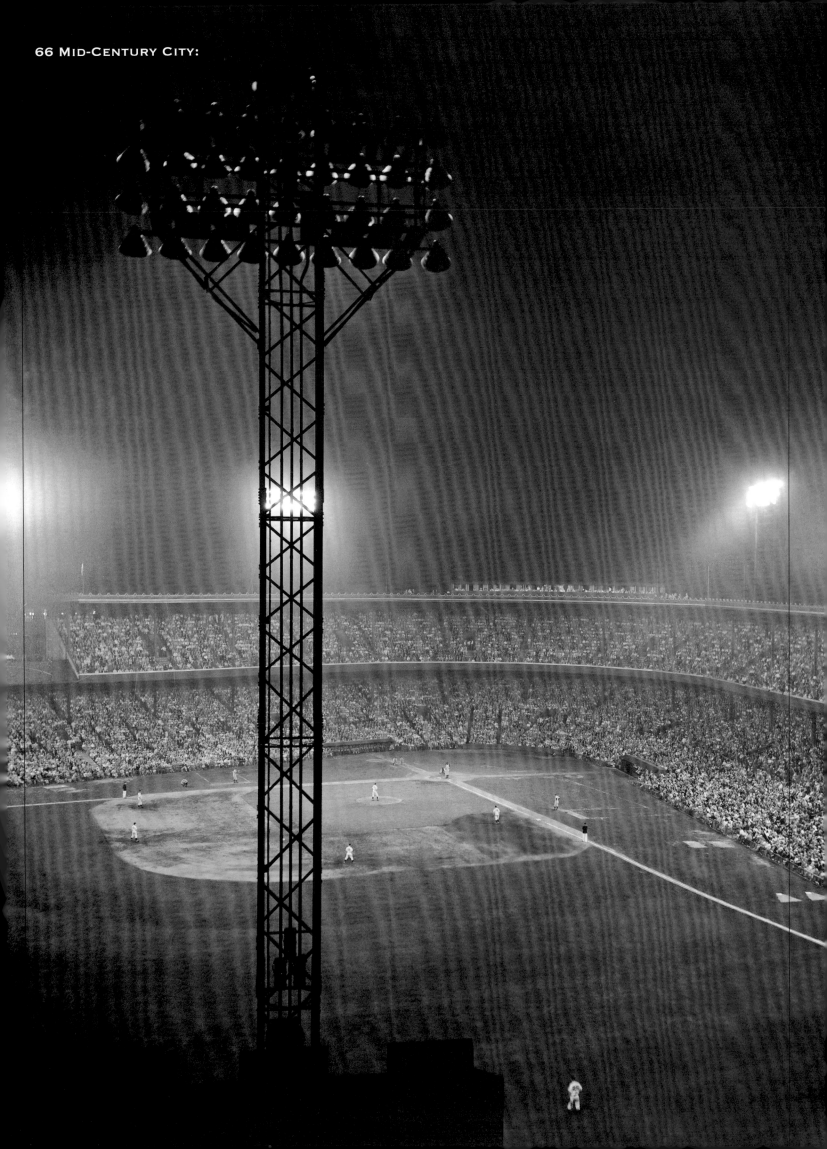

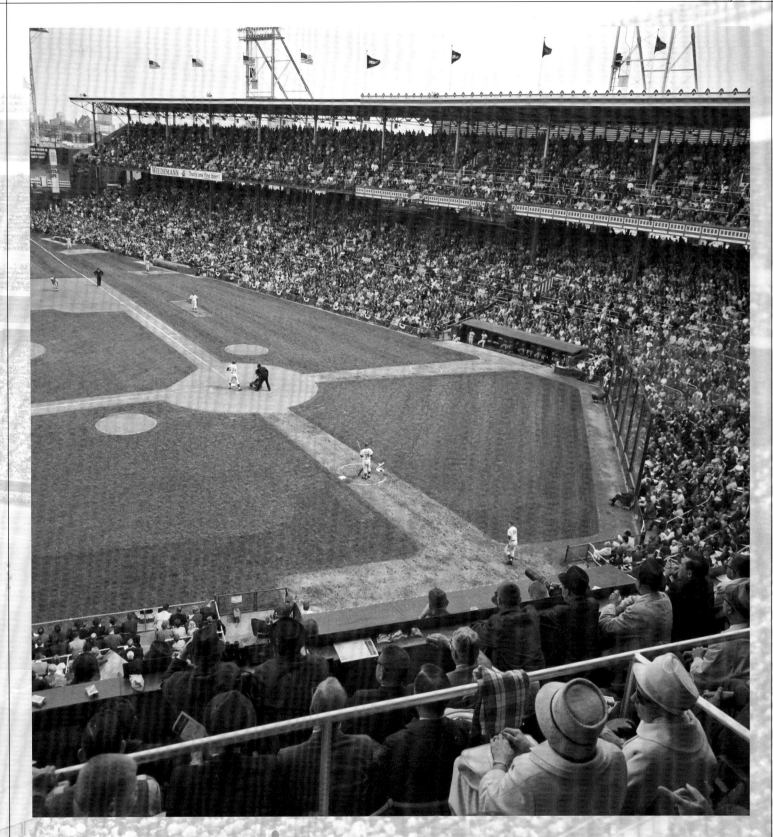

Crosley Field in 1968, Tony Perez at-bat,
Sarge Marsh at work. The first night game
in major league history was played under the
lights at Crosley Field in 1935. At left, Sarge
captures one of Crosley's last night games.

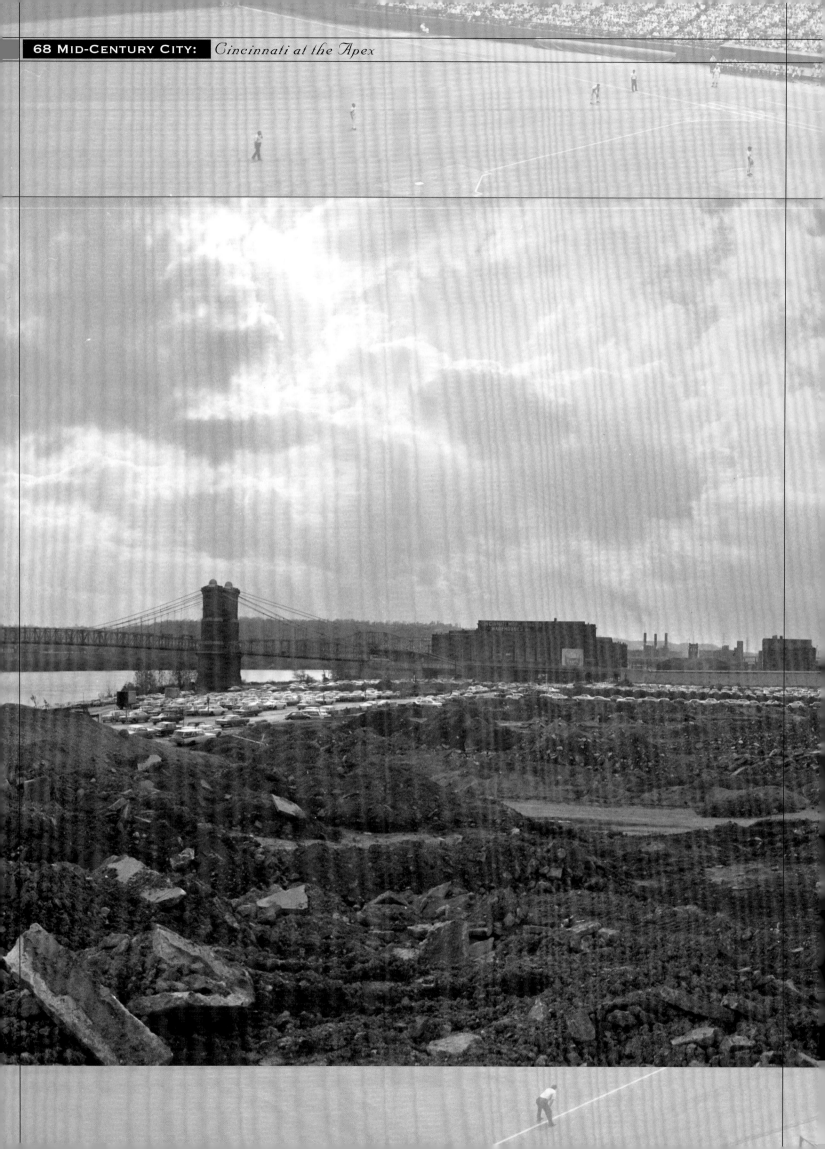

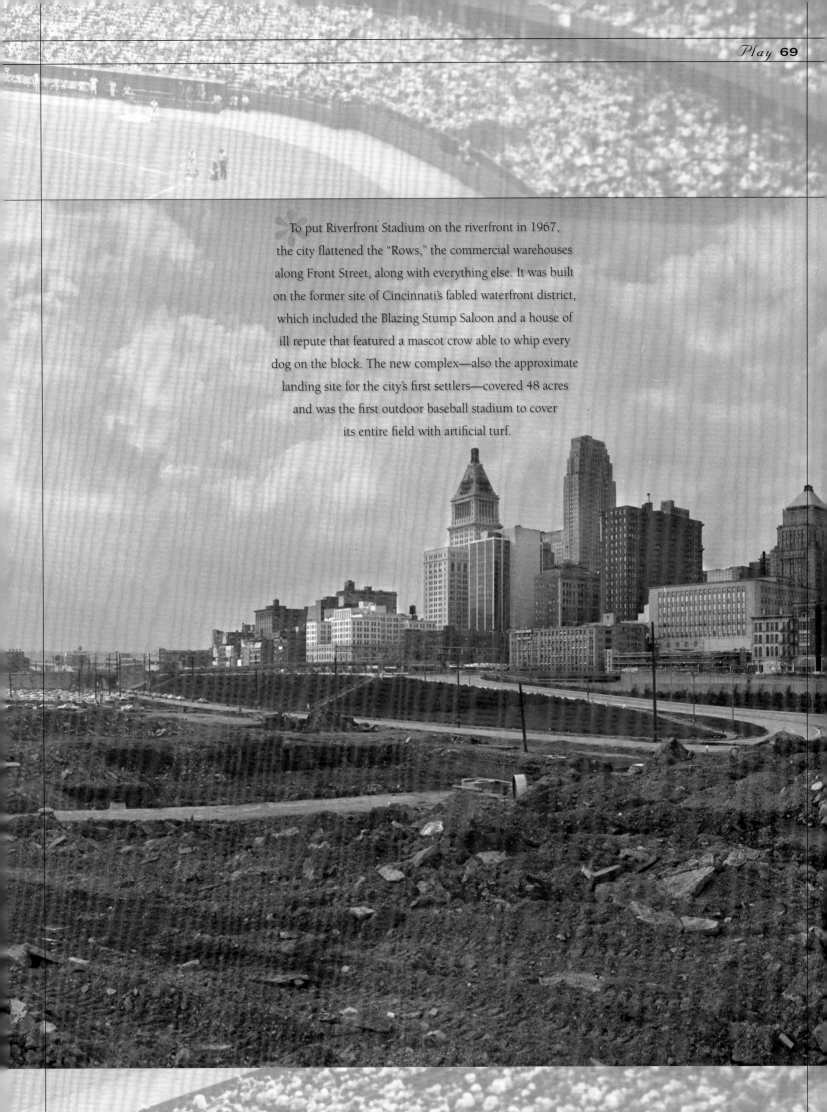

To put Riverfront Stadium on the riverfront in 1967,
the city flattened the "Rows," the commercial warehouses
along Front Street, along with everything else. It was built
on the former site of Cincinnati's fabled waterfront district,
which included the Blazing Stump Saloon and a house of
ill repute that featured a mascot crow able to whip every
dog on the block. The new complex—also the approximate
landing site for the city's first settlers—covered 48 acres
and was the first outdoor baseball stadium to cover
its entire field with artificial turf.

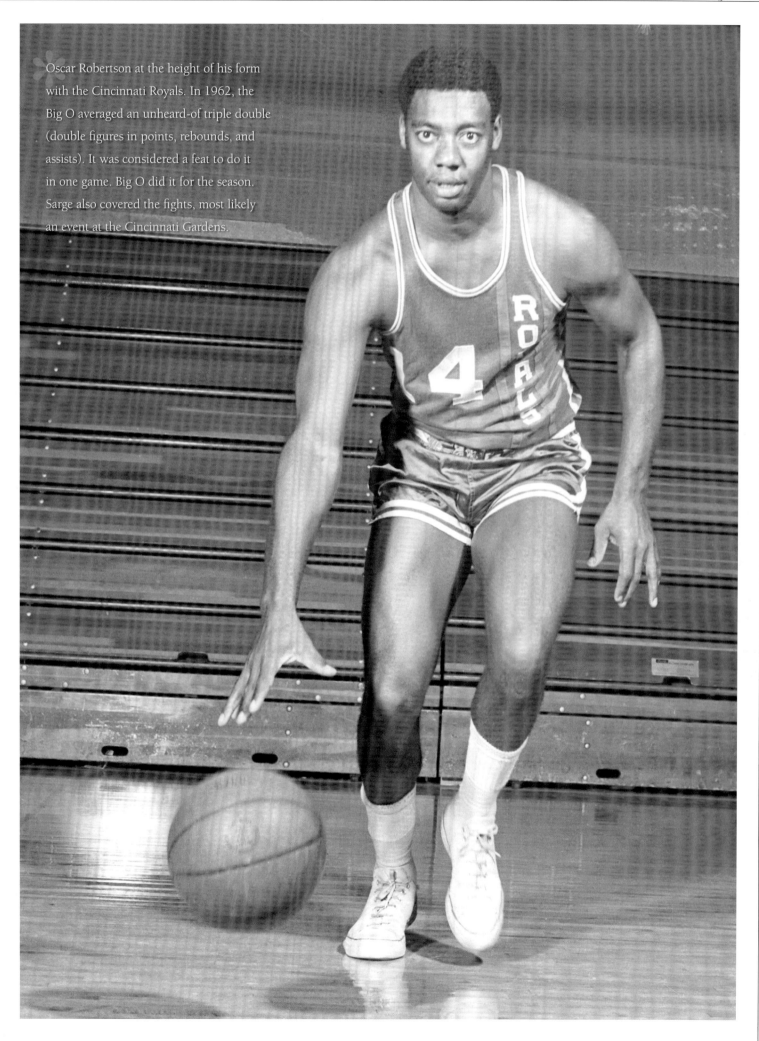

Oscar Robertson at the height of his form with the Cincinnati Royals. In 1962, the Big O averaged an unheard-of triple double (double figures in points, rebounds, and assists). It was considered a feat to do it in one game. Big O did it for the season. Sarge also covered the fights, most likely an event at the Cincinnati Gardens.

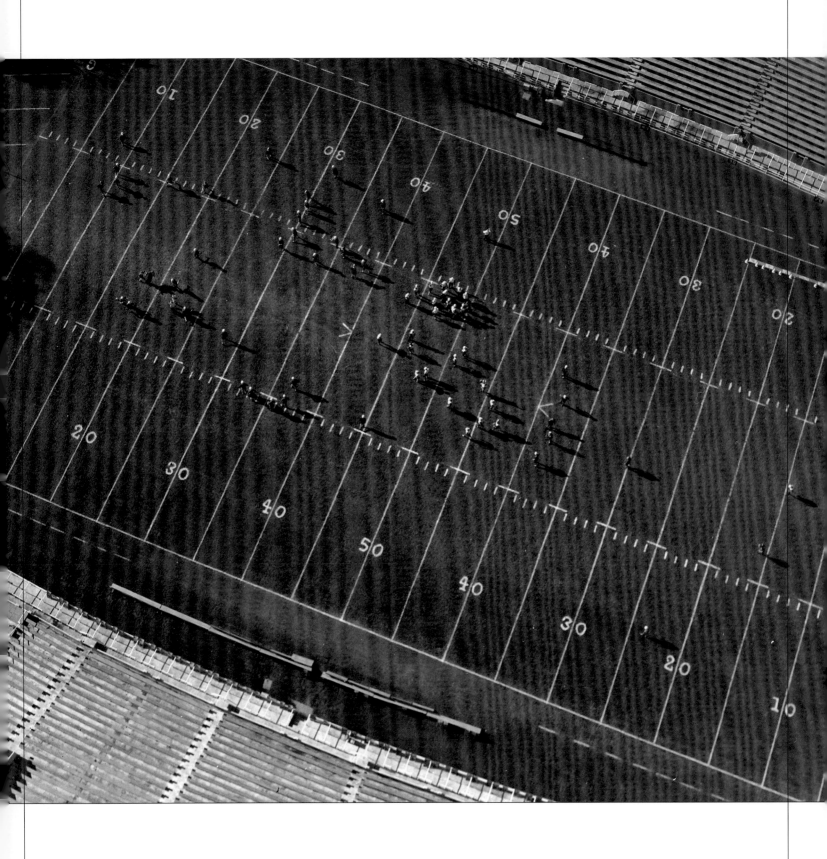

Xavier University still had a football team and Sarge
still had the account when he flew over one of their practices
in the 1950s. There was actually a time when Xavier was
a football school, and basketball was largely unheard of.
Imagine *that*. In 1951, Xavier integrated its gridiron with a
Steubenville linebacker named Dennis Davis, who beat UC
three of his four years at X and later recalled the fans tearing
down the UC goal posts and carrying them back to Xavier.
The other photograph is believed to be of Sarge's alma mater,
Withrow High, back when, yes, men *were* men but they
probably needed an orthodontist on the sidelines.

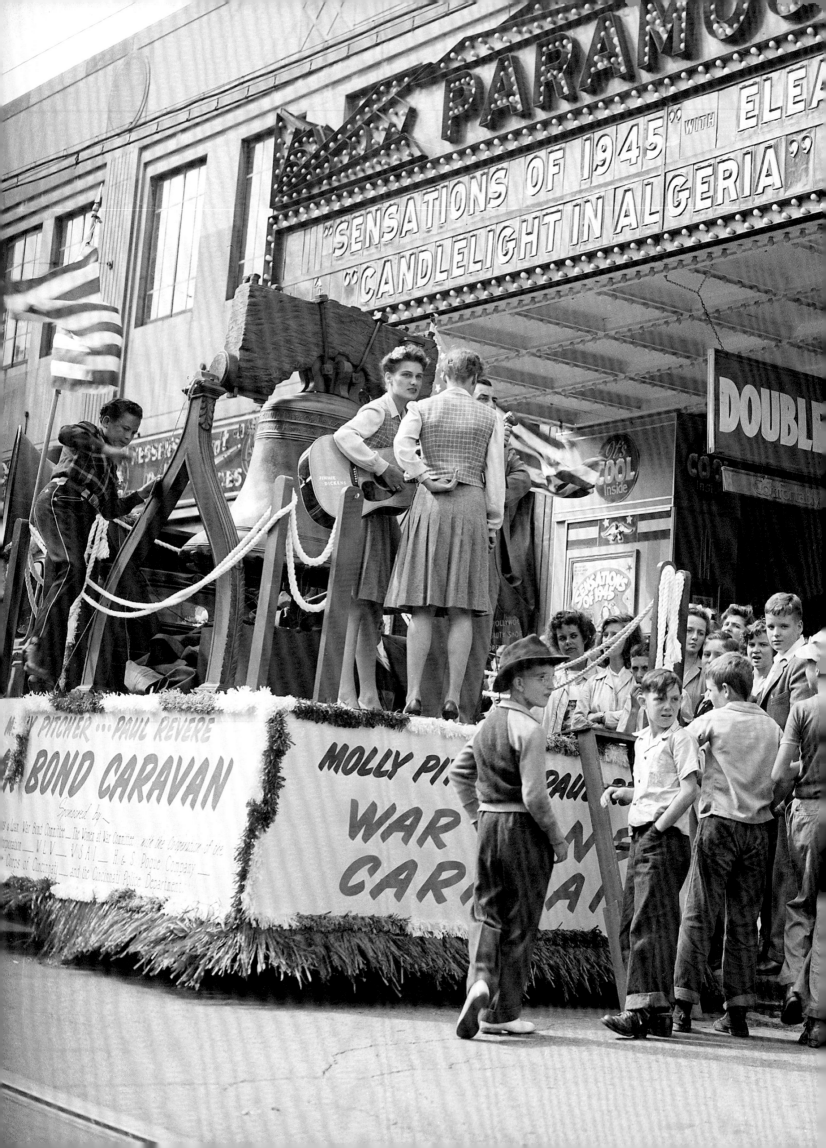

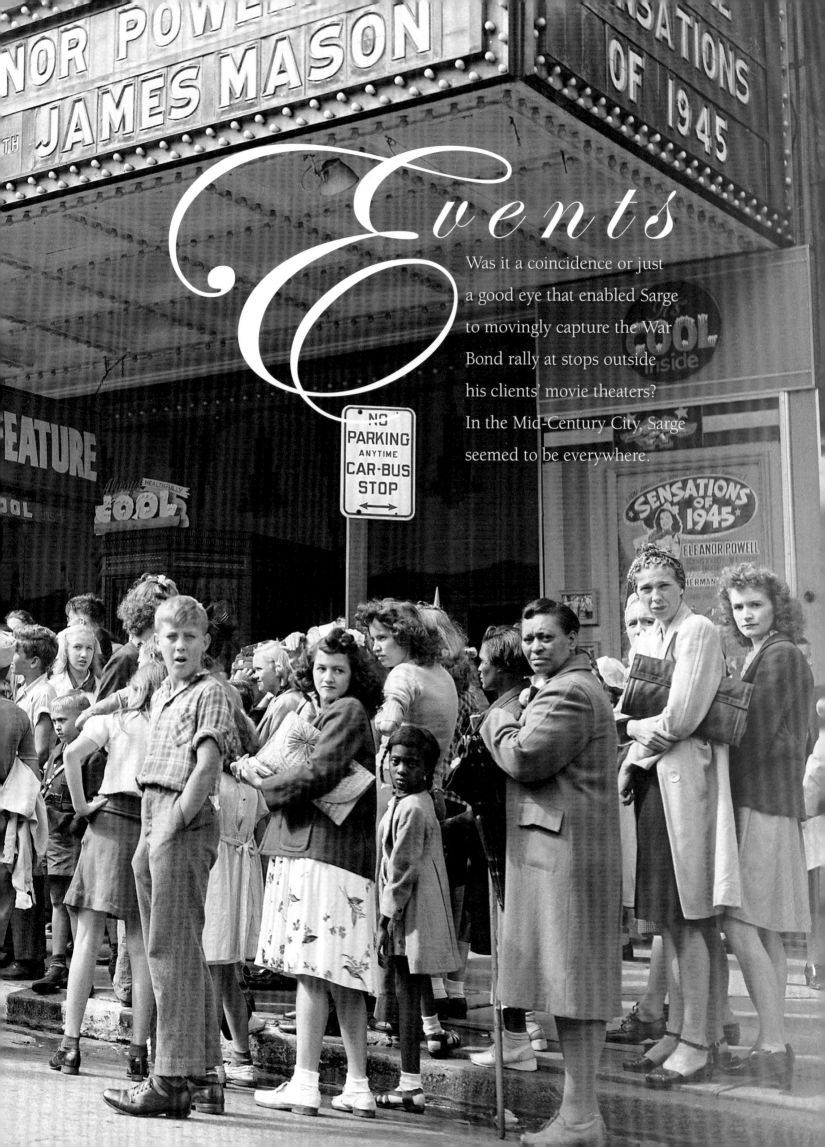

Events

Was it a coincidence or just a good eye that enabled Sarge to movingly capture the War Bond rally at stops outside his clients' movie theaters? In the Mid-Century City, Sarge seemed to be everywhere.

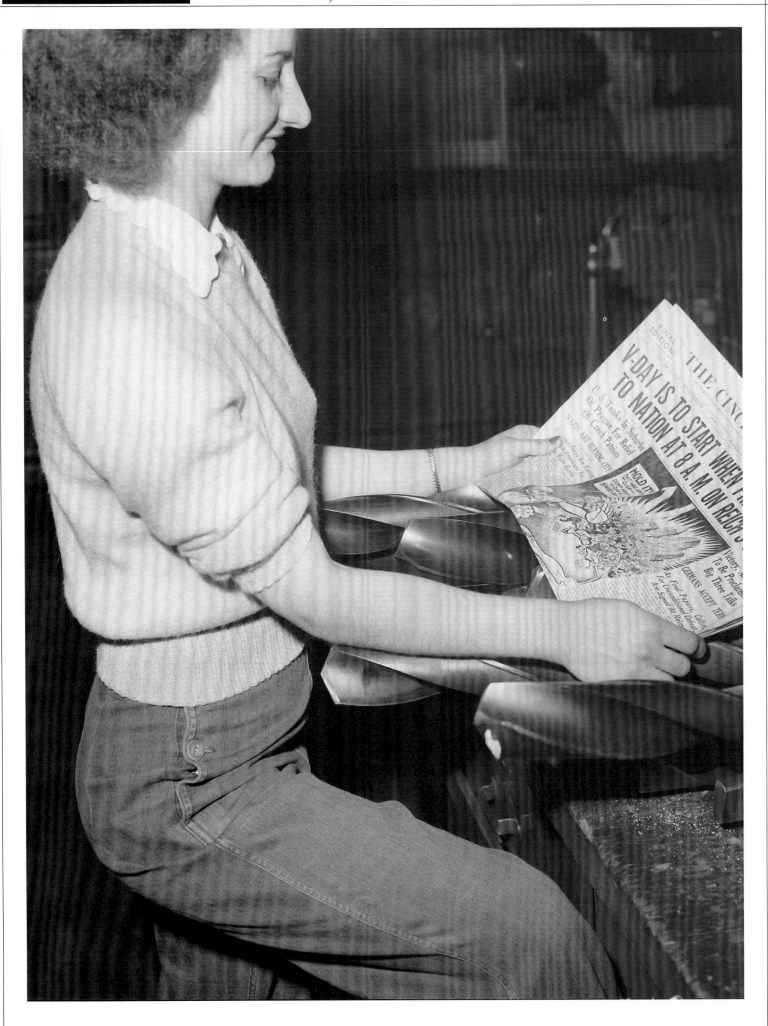

Telling a news story: VE-Day 1945,
Sarge uses the newspaper itself as a prop,
first with a woman war worker and then
with plant security guards.

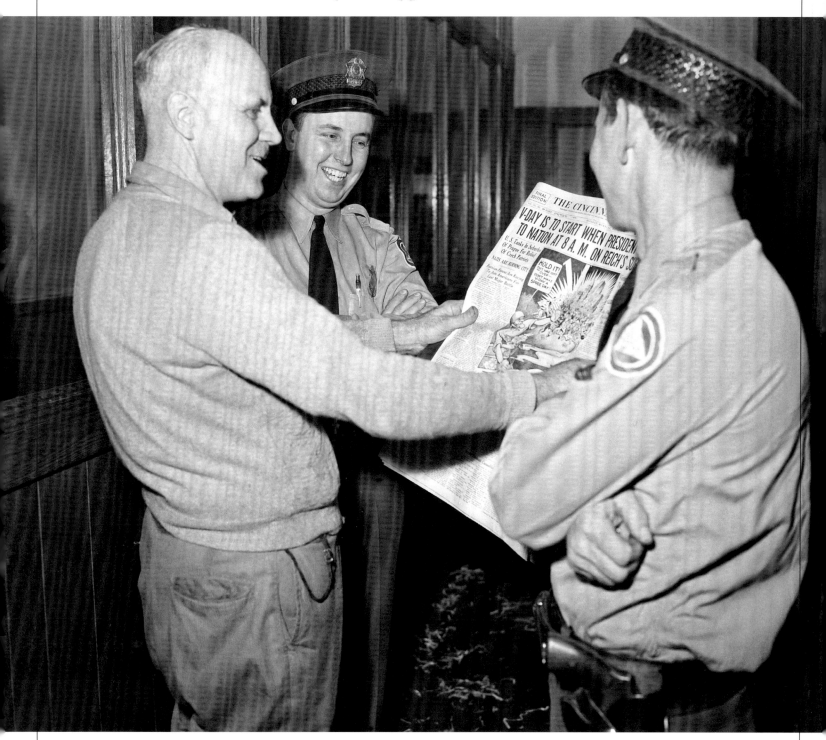

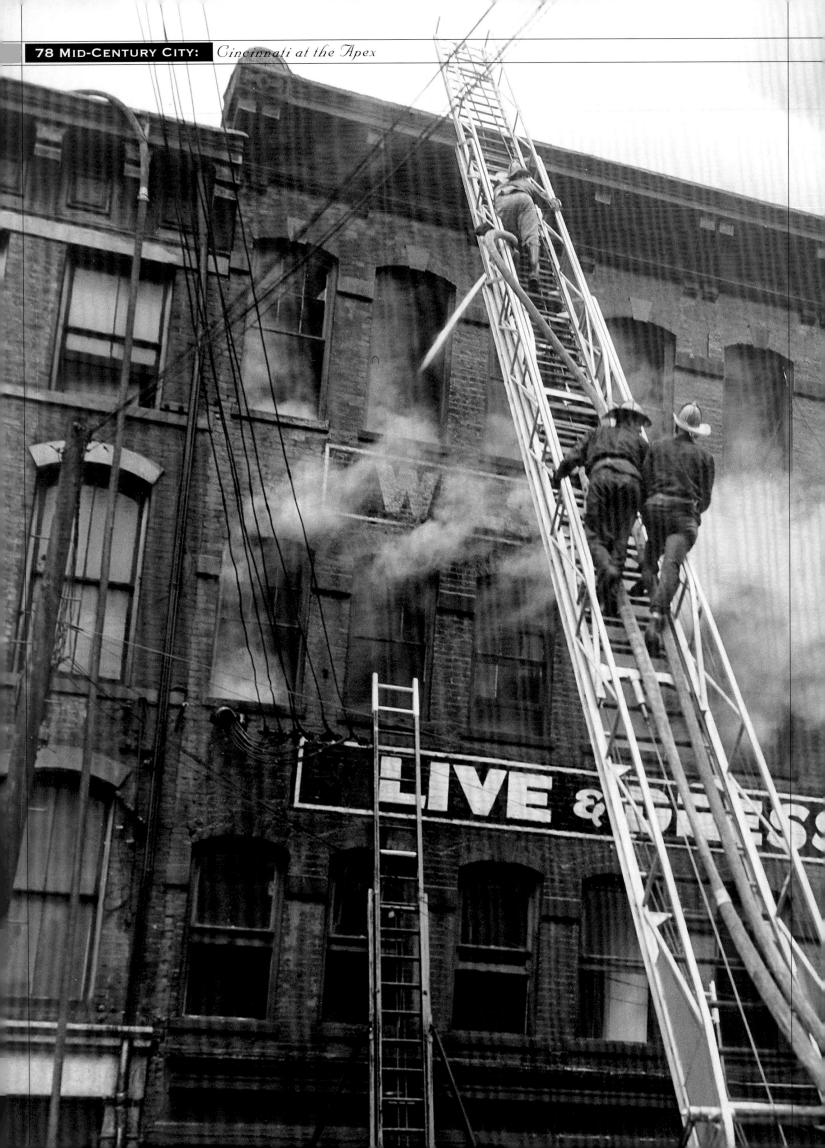

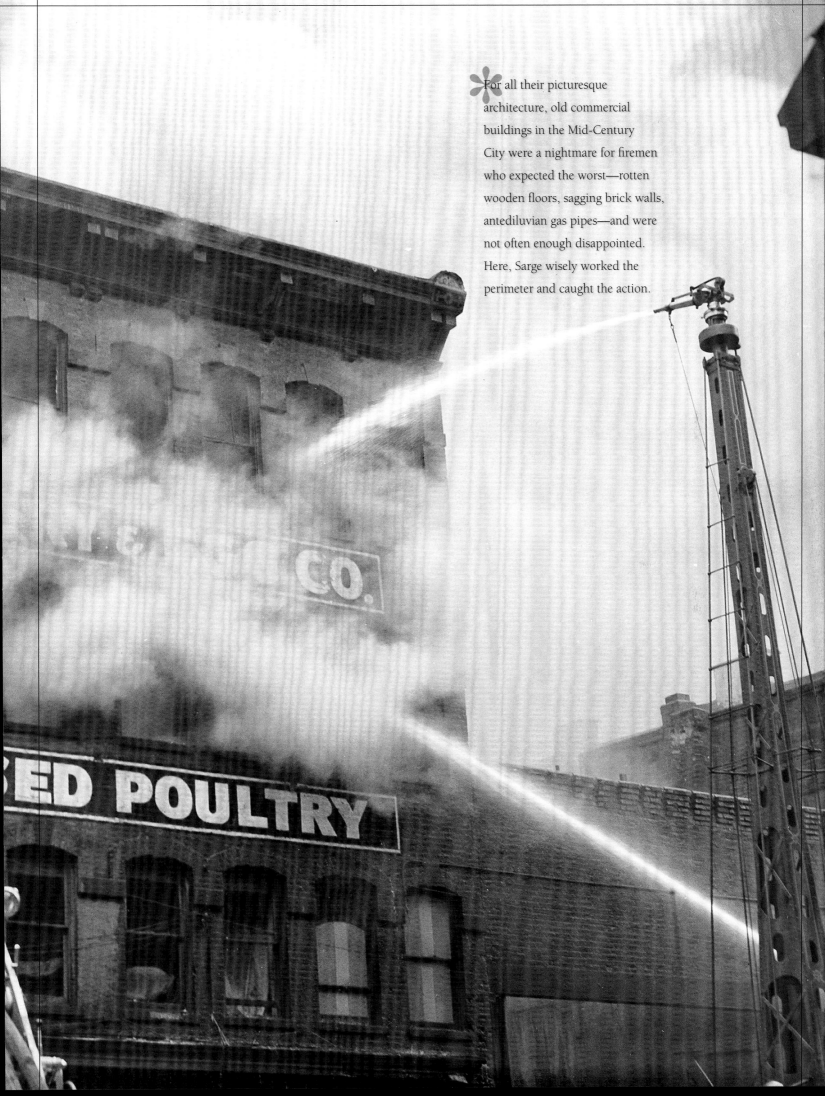

For all their picturesque architecture, old commercial buildings in the Mid-Century City were a nightmare for firemen who expected the worst—rotten wooden floors, sagging brick walls, antediluvian gas pipes—and were not often enough disappointed. Here, Sarge wisely worked the perimeter and caught the action.

CO.

ED POULTRY

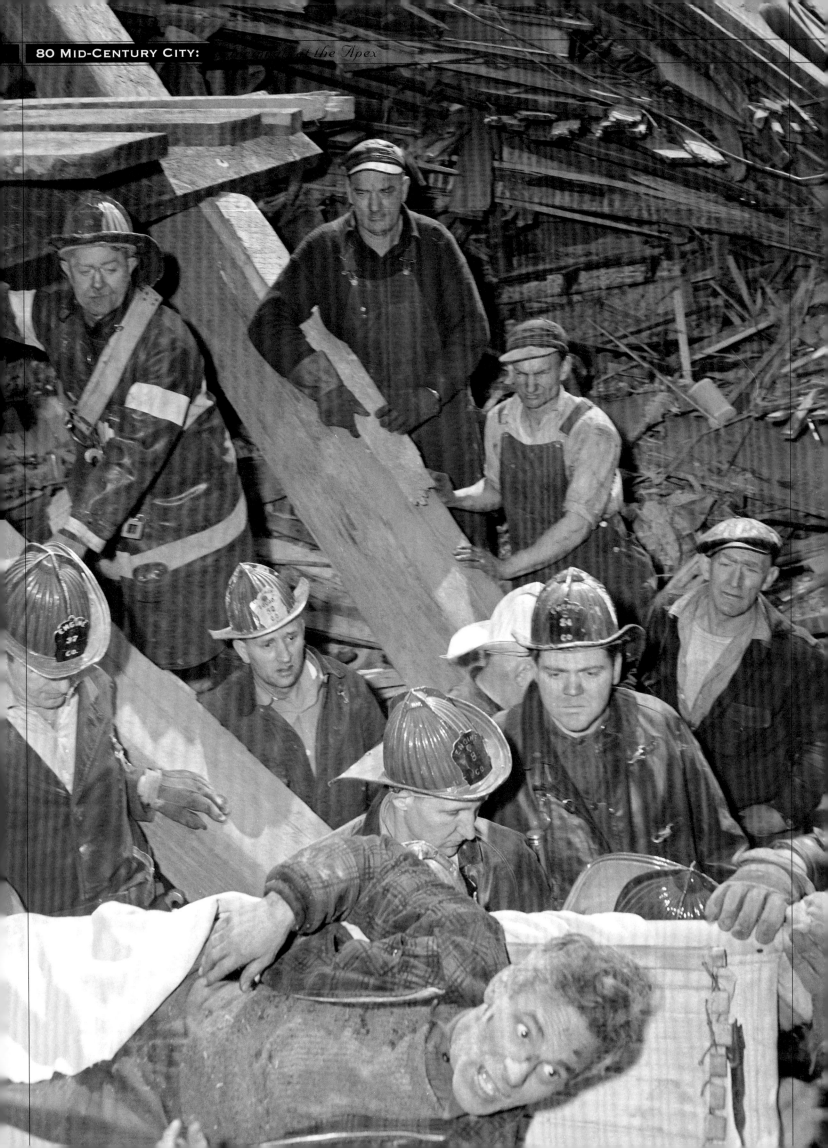

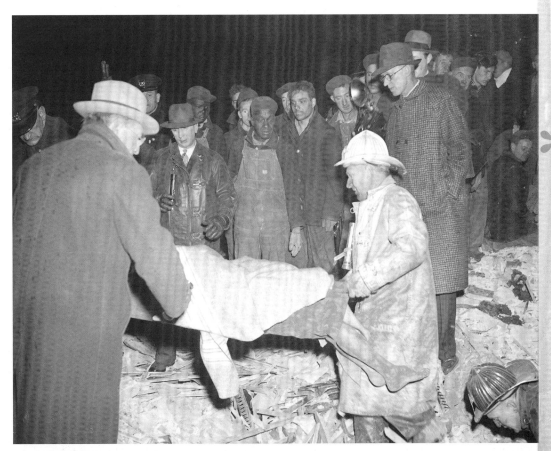

Sarge was proud of his skill at "spot news." You grabbed your hat and your camera and followed the sirens to the latest disaster. We no longer know the details of this explosion and building collapse but the eternals of spot news coverage are all here—the smoke, the disoriented survivors, the dusty dead, and the morbidly curious.

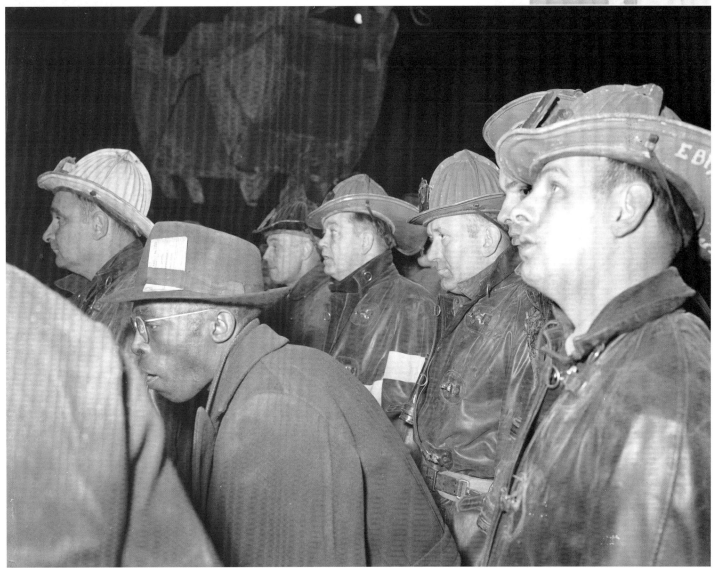

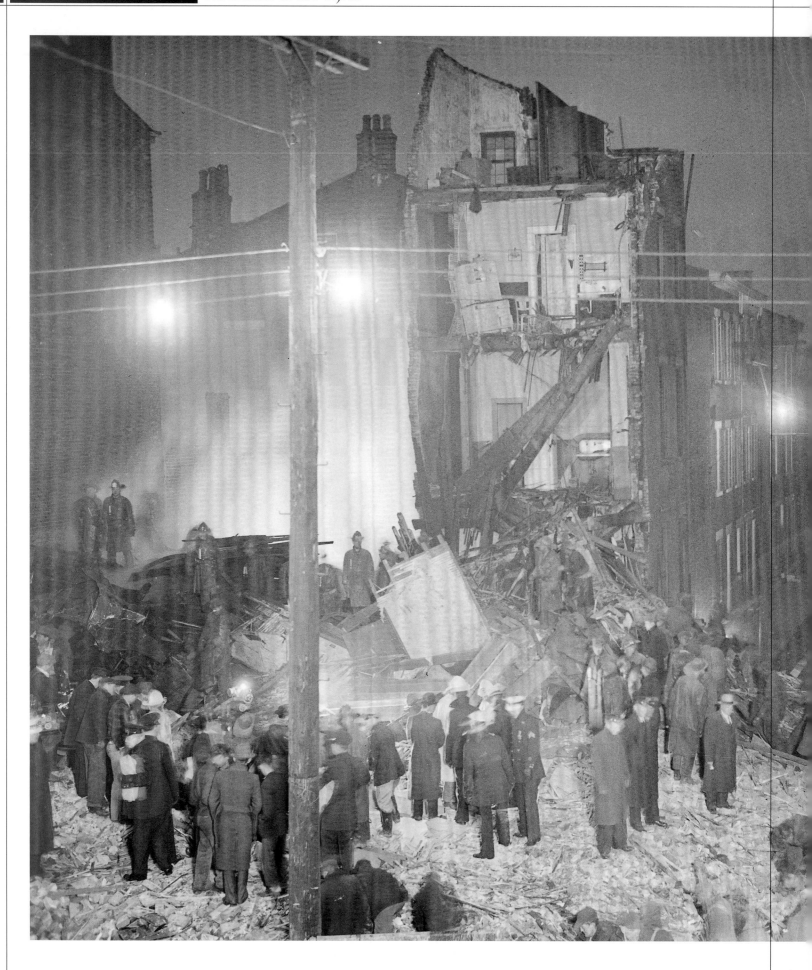

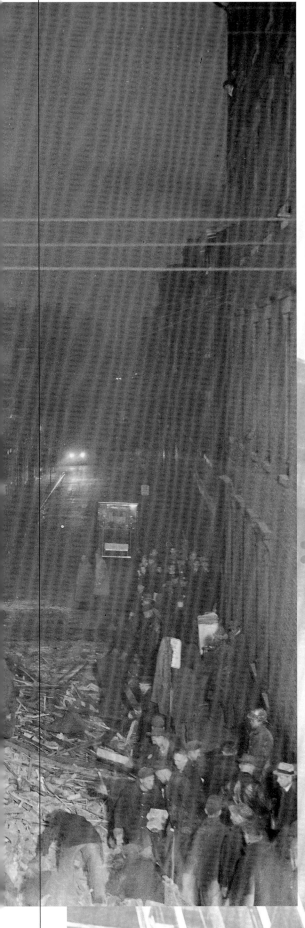

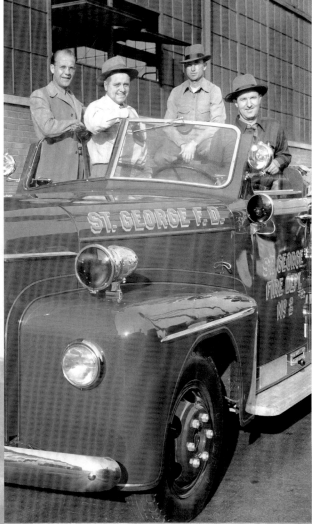

Sarge was also able to capture the gothic mood of a Queen City tragedy—as well as a moody, foreboding urban landscape that suggested a capricious fate may await any of us, even in the midst of the most daily routine. Above is the St. George Fire Department taking delivery of their new Ahrens-Fox engine. Ahrens-Fox was the last in a long line of Cincinnati fire engine manufacturers.

Once a routine occasion in a river city, a new steamboat coming to town had become a news event by the early 1960s.

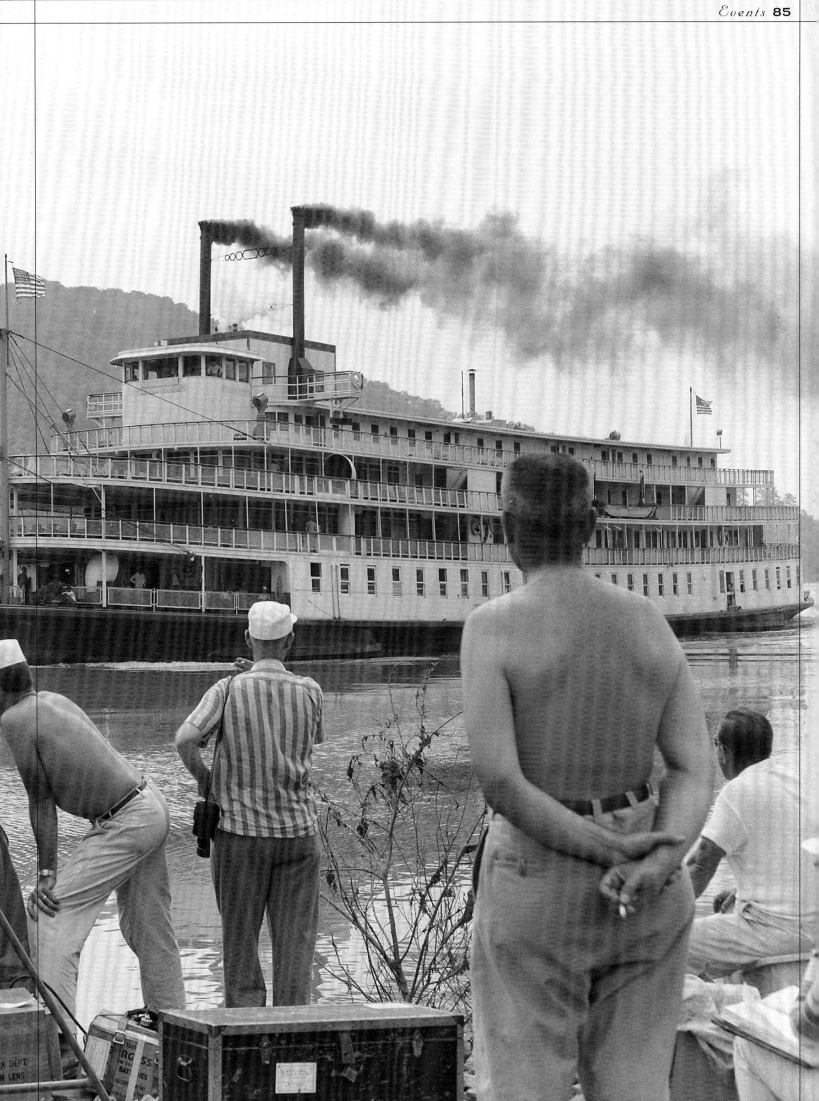

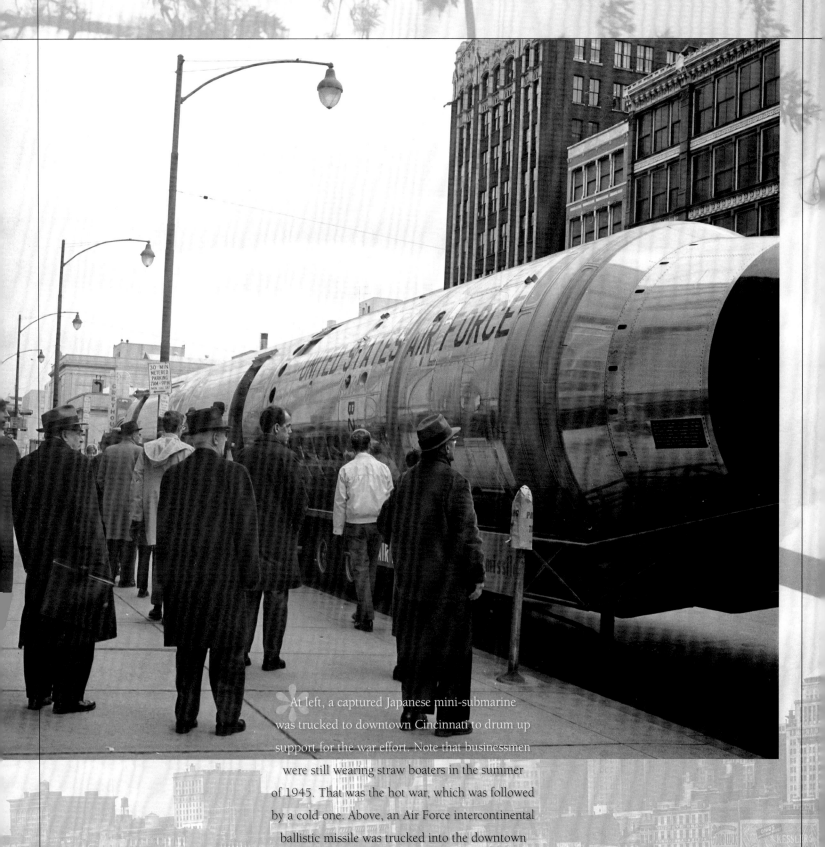

✴ At left, a captured Japanese mini-submarine
was trucked to downtown Cincinnati to drum up
support for the war effort. Note that businessmen
were still wearing straw boaters in the summer
of 1945. That was the hot war, which was followed
by a cold one. Above, an Air Force intercontinental
ballistic missile was trucked into the downtown
to drum up support for the cold war effort. Note
that in the winter of 1966 older businessmen still
wore fedora hats in the winter.

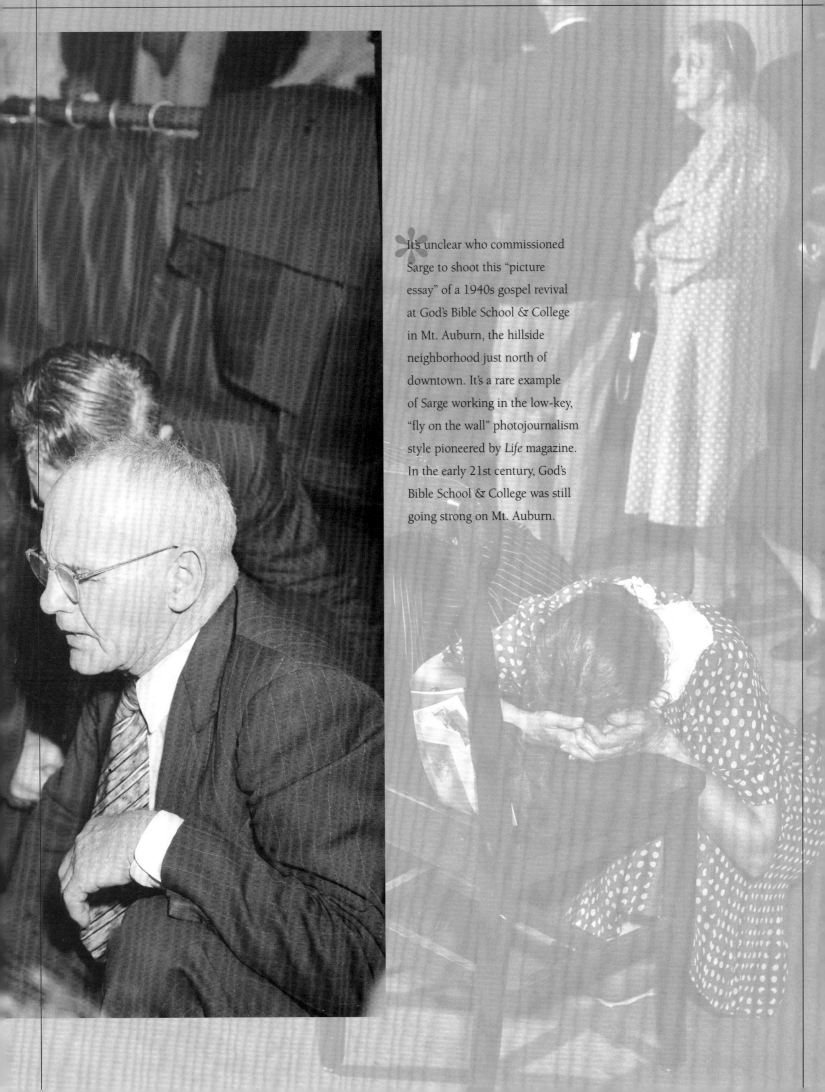

It's unclear who commissioned Sarge to shoot this "picture essay" of a 1940s gospel revival at God's Bible School & College in Mt. Auburn, the hillside neighborhood just north of downtown. It's a rare example of Sarge working in the low-key, "fly on the wall" photojournalism style pioneered by *Life* magazine. In the early 21st century, God's Bible School & College was still going strong on Mt. Auburn.

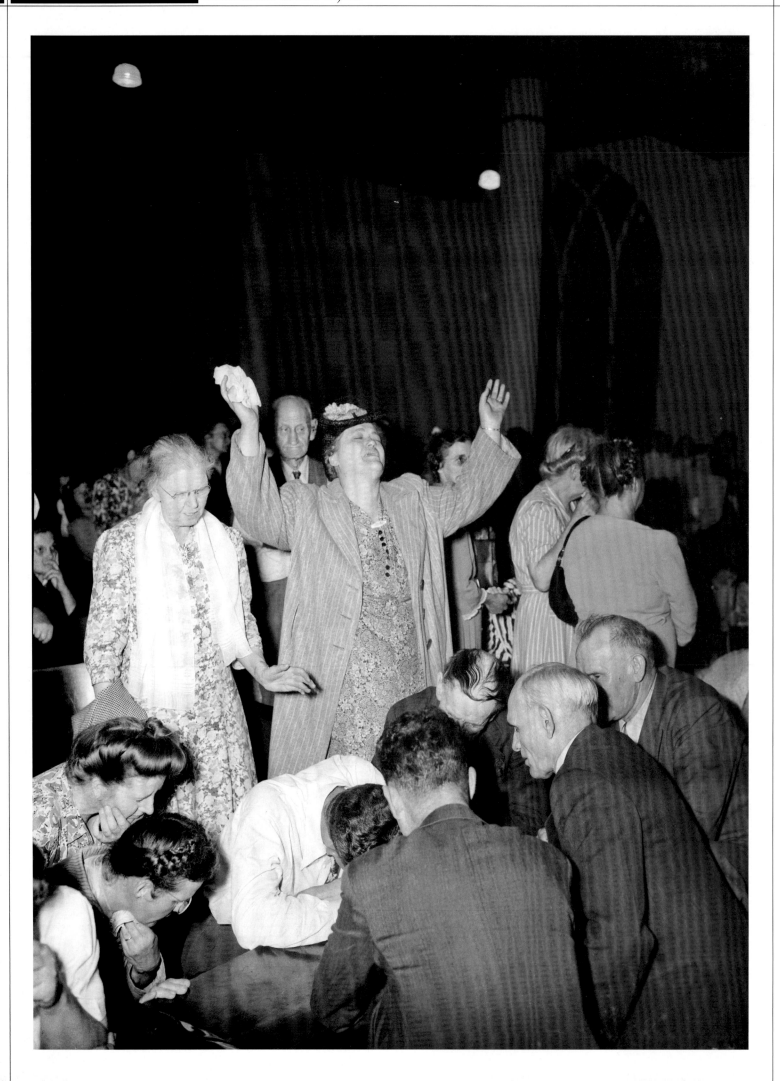

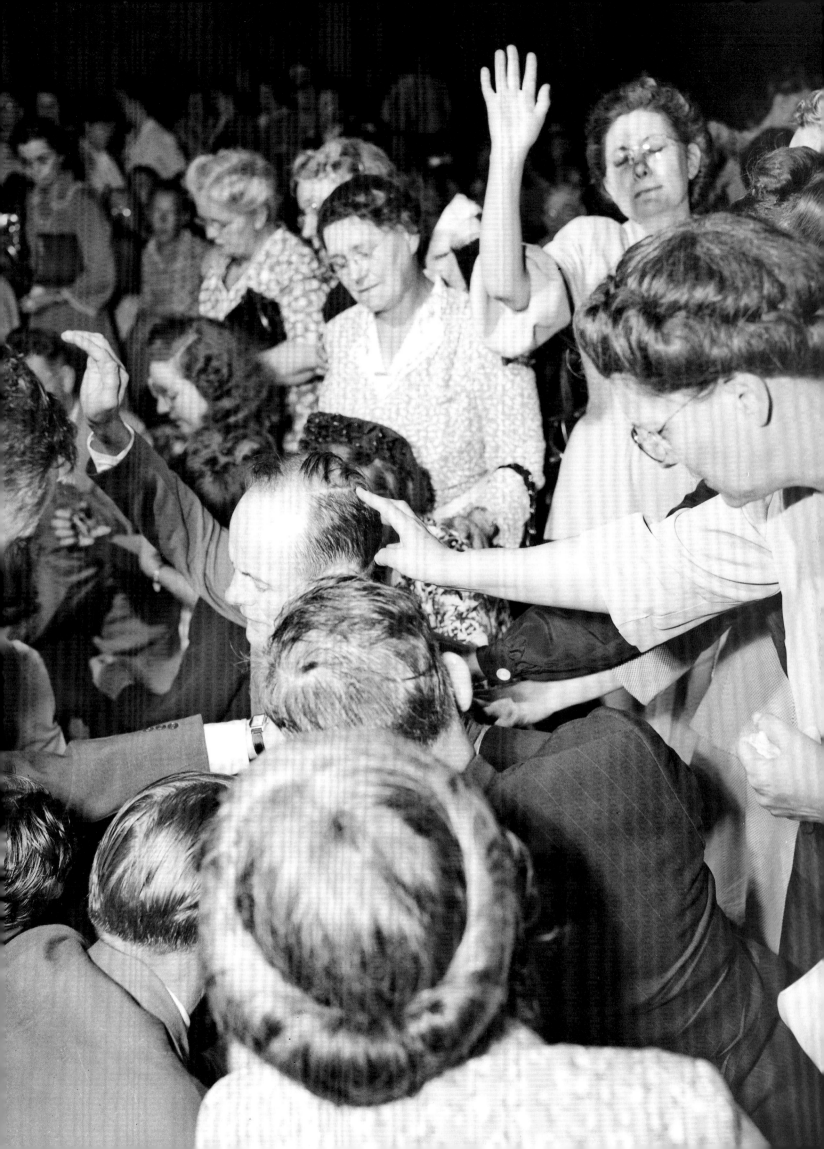

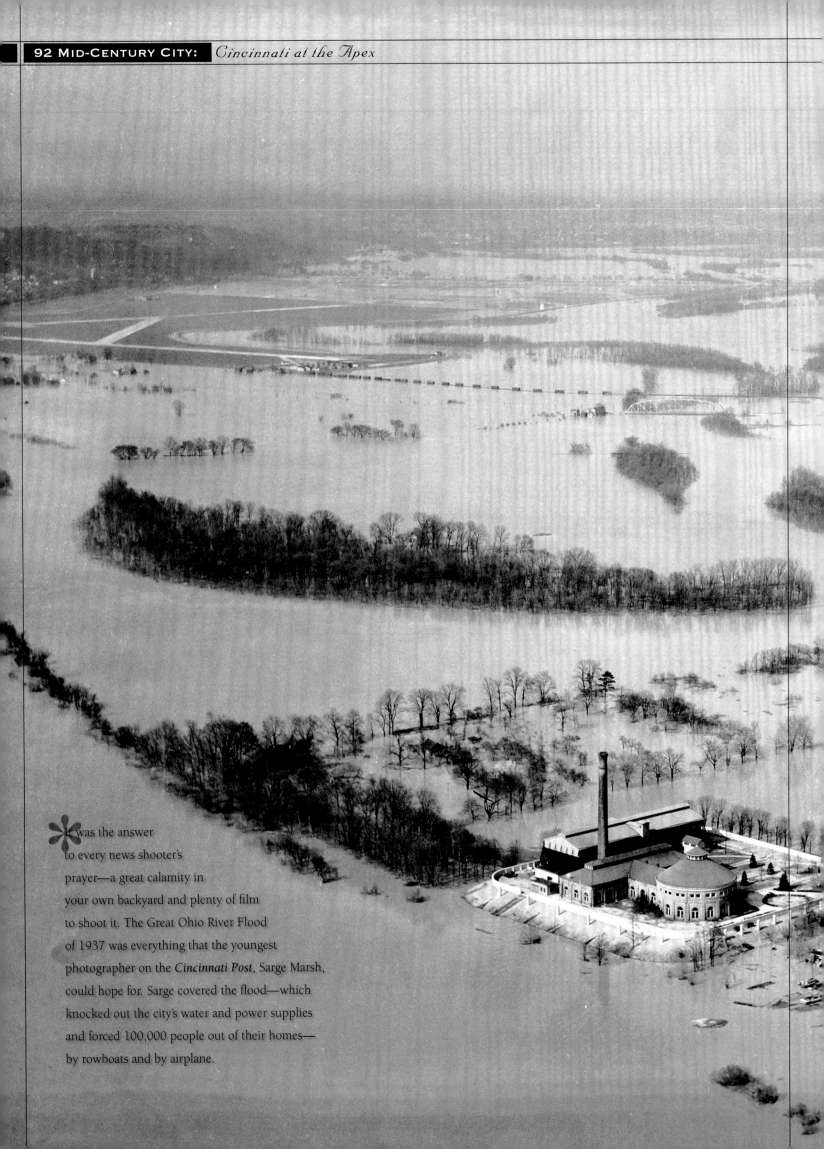

It was the answer to every news shooter's prayer—a great calamity in your own backyard and plenty of film to shoot it. The Great Ohio River Flood of 1937 was everything that the youngest photographer on the *Cincinnati Post*, Sarge Marsh, could hope for. Sarge covered the flood—which knocked out the city's water and power supplies and forced 100,000 people out of their homes— by rowboats and by airplane.

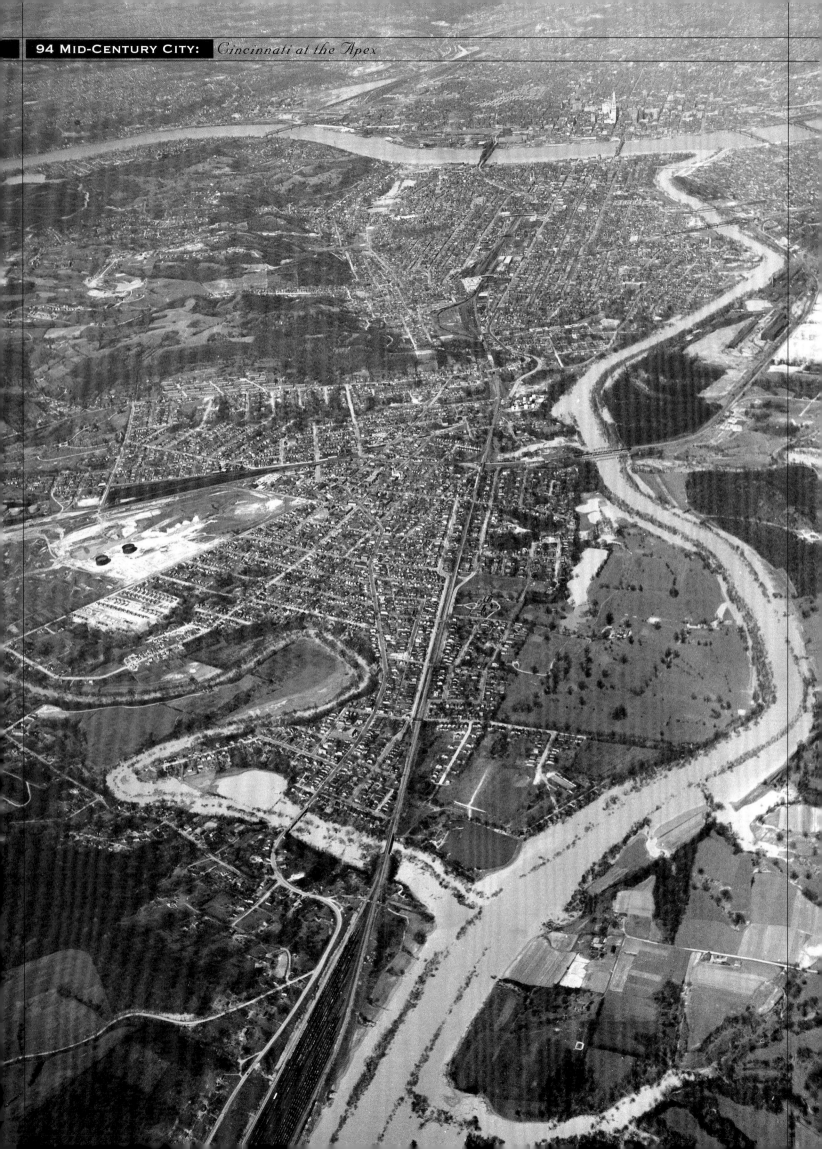

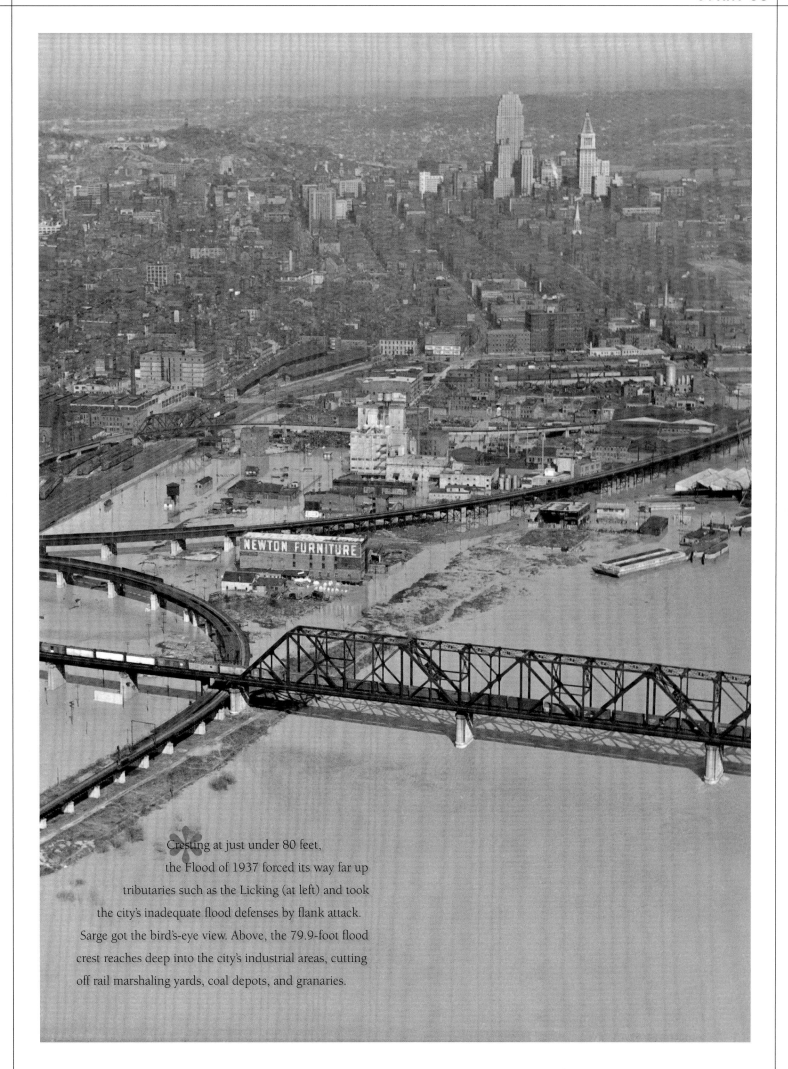

Cresting at just under 80 feet,
the Flood of 1937 forced its way far up
tributaries such as the Licking (at left) and took
the city's inadequate flood defenses by flank attack.
Sarge got the bird's-eye view. Above, the 79.9-foot flood
crest reaches deep into the city's industrial areas, cutting
off rail marshaling yards, coal depots, and granaries.

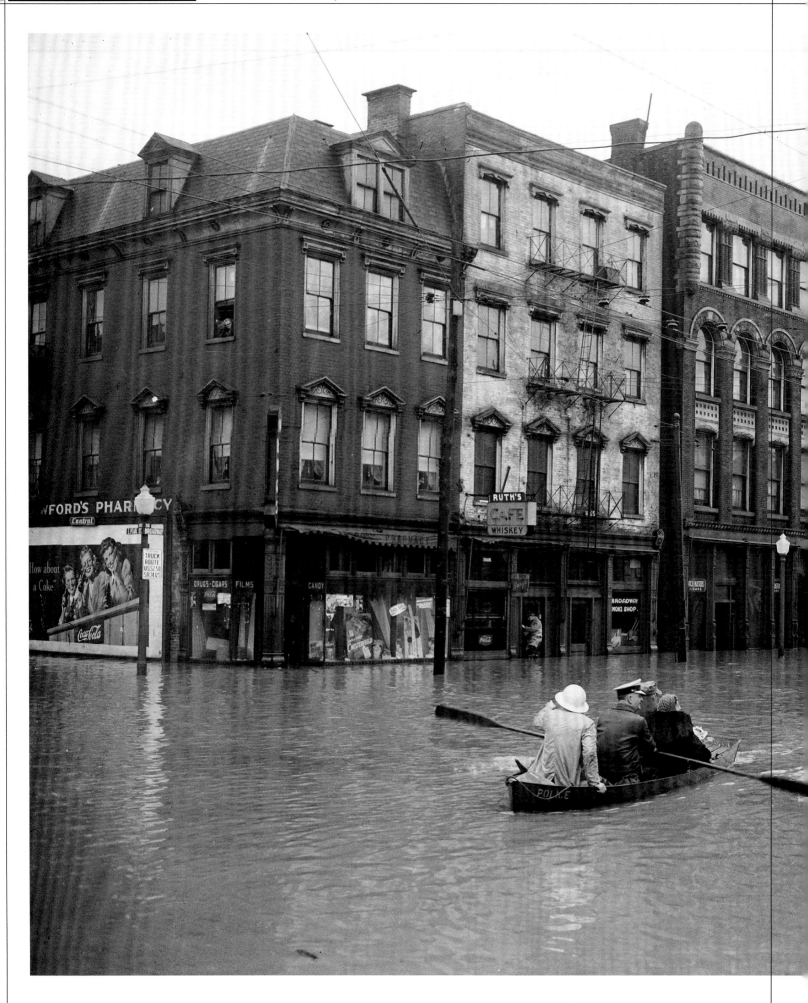

For 19 days during the Flood
of 1937, rowboats were the only
traffic on the city's riverfront streets,
and the little riverside villages up
and down the Ohio knew they
were on their own. Newspapers were
delivered—spottily—in johnboats,
but the news was about the flood.
Amidst it all—the city coming to a
complete halt—a woman called the
police and asked for someone to help
her rescue a piano from her flooded
home. "Lady," said the dispatcher,
"Play *Beautiful Ohio* just once and
get out."

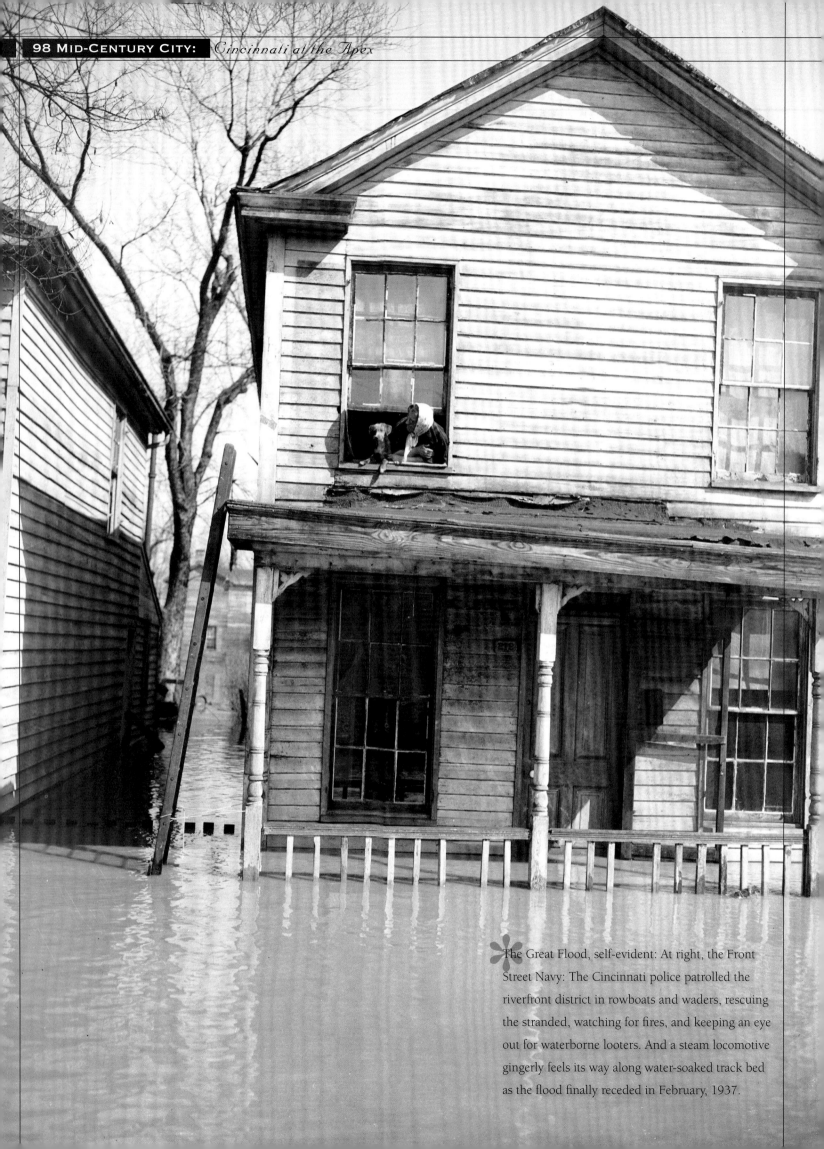

The Great Flood, self-evident: At right, the Front Street Navy: The Cincinnati police patrolled the riverfront district in rowboats and waders, rescuing the stranded, watching for fires, and keeping an eye out for waterborne looters. And a steam locomotive gingerly feels its way along water-soaked track bed as the flood finally receded in February, 1937.

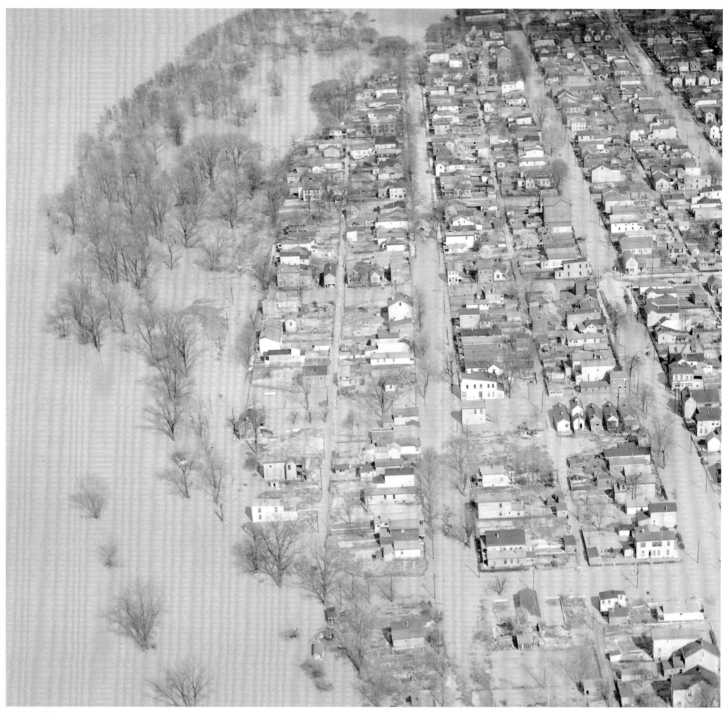

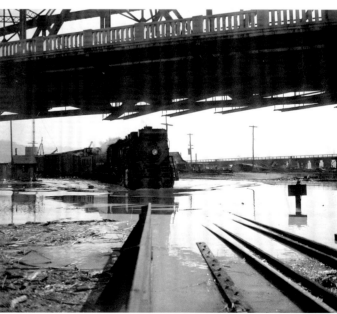

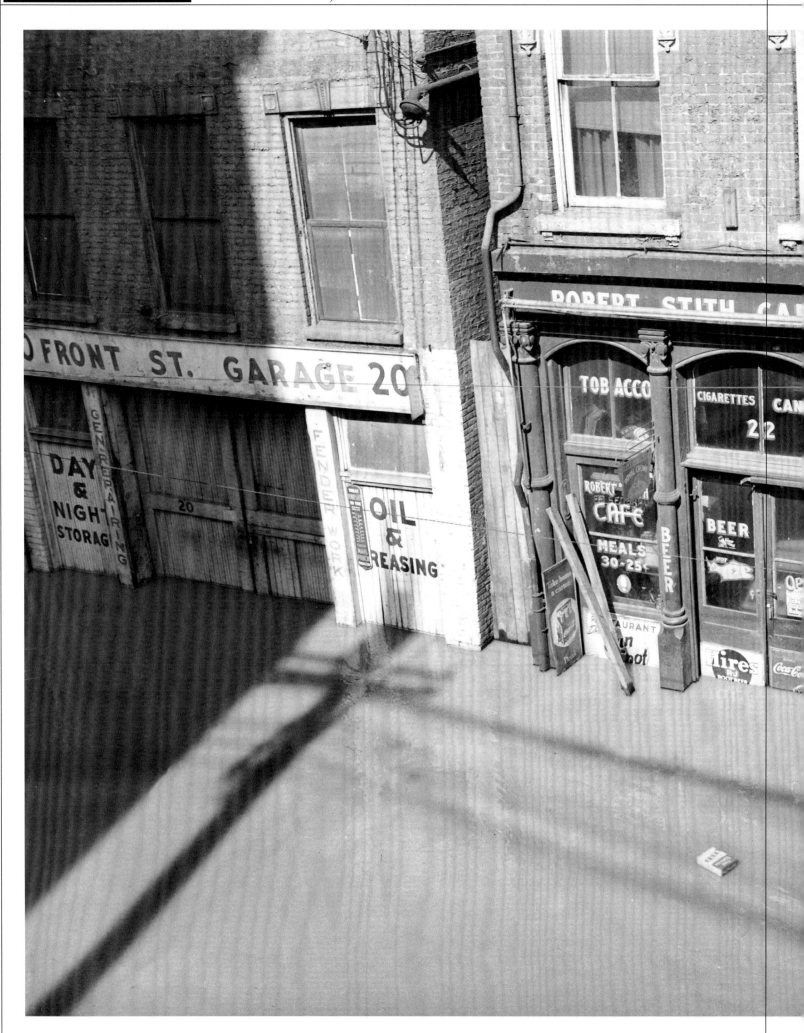

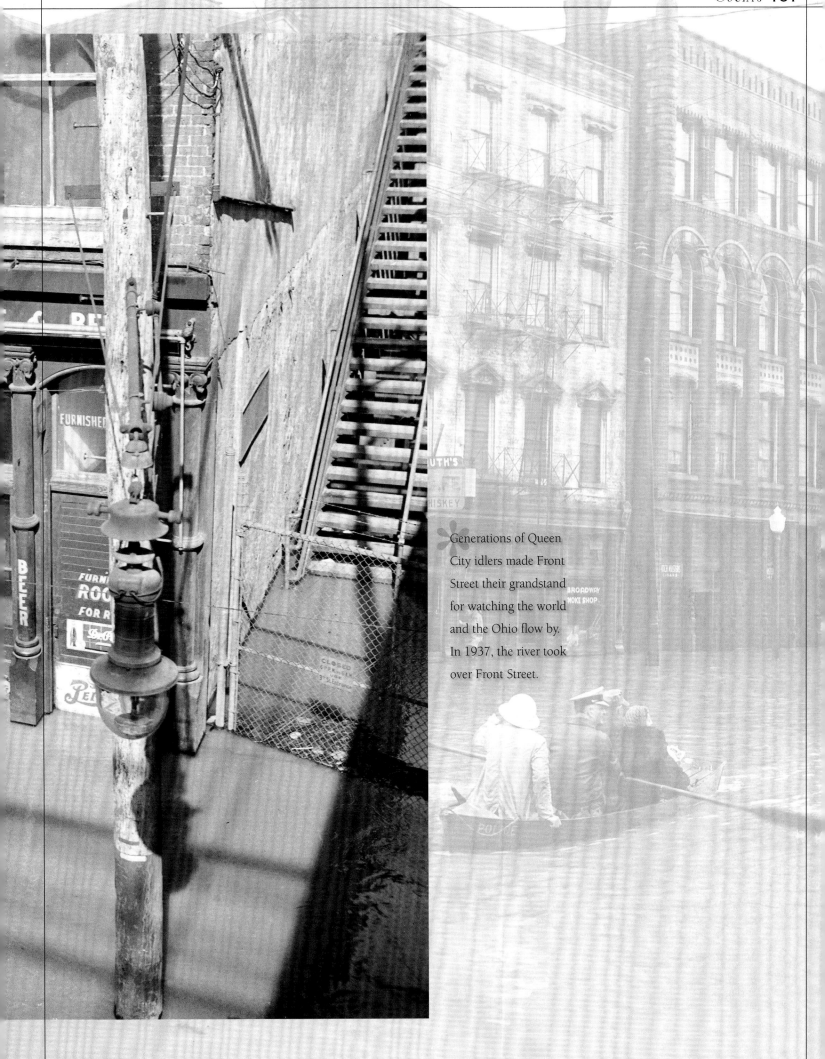

Generations of Queen City idlers made Front Street their grandstand for watching the world and the Ohio flow by. In 1937, the river took over Front Street.

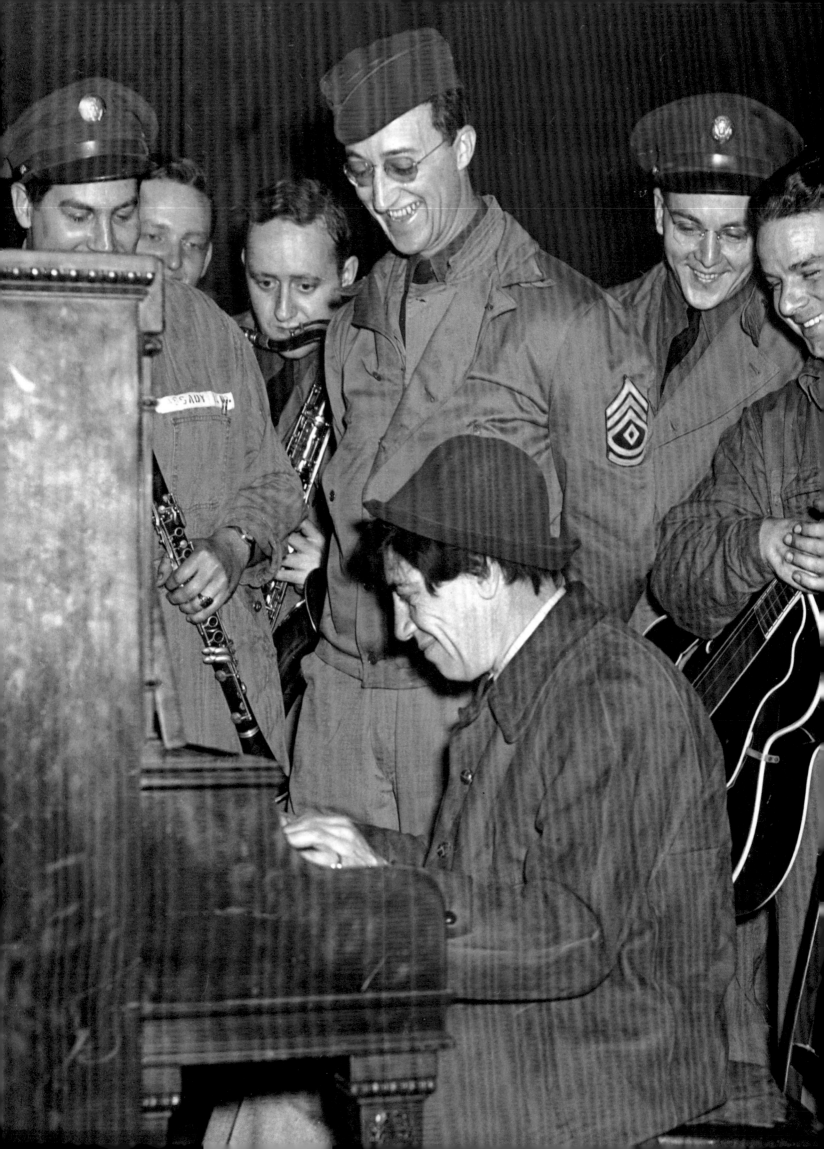

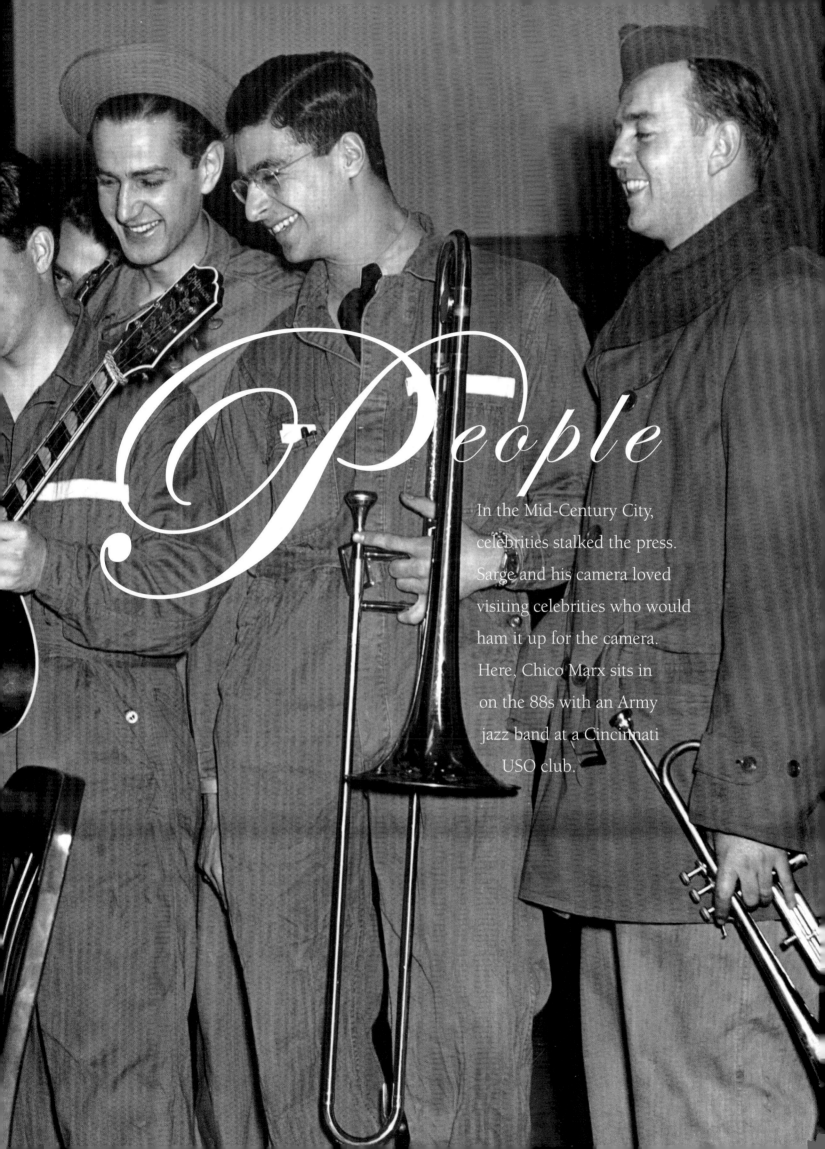

People

In the Mid-Century City, celebrities stalked the press. Sarge and his camera loved visiting celebrities who would ham it up for the camera. Here, Chico Marx sits in on the 88s with an Army jazz band at a Cincinnati USO club.

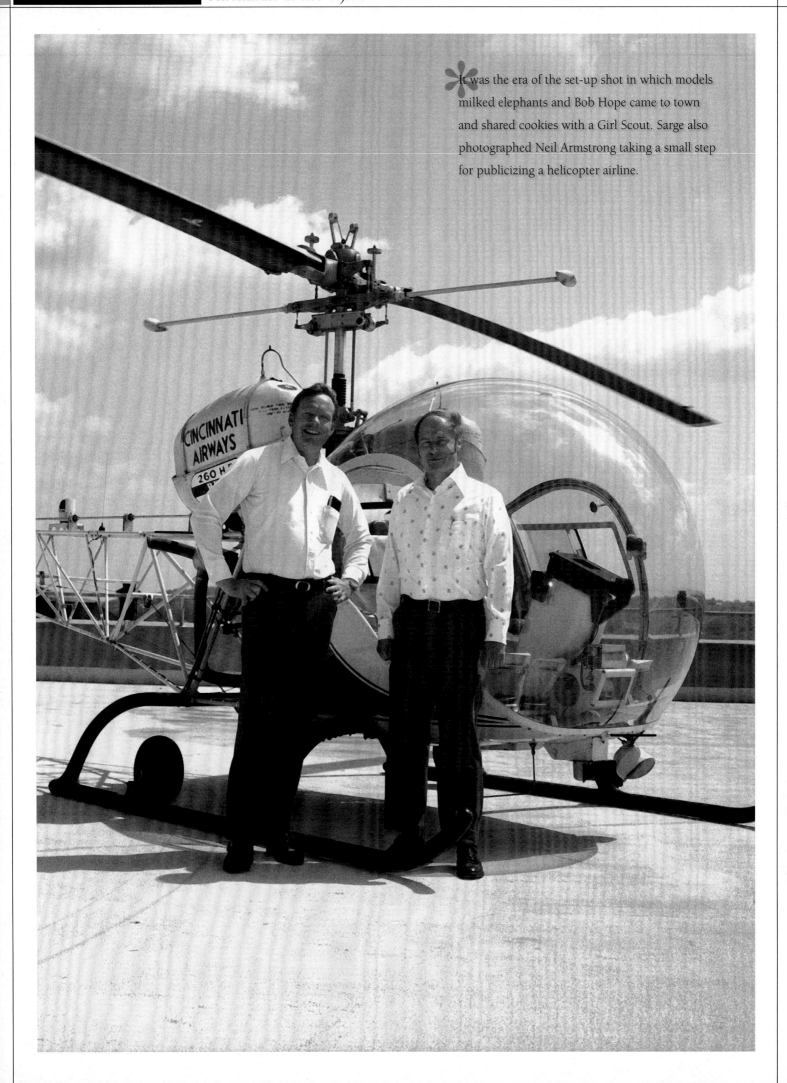

It was the era of the set-up shot in which models milked elephants and Bob Hope came to town and shared cookies with a Girl Scout. Sarge also photographed Neil Armstrong taking a small step for publicizing a helicopter airline.

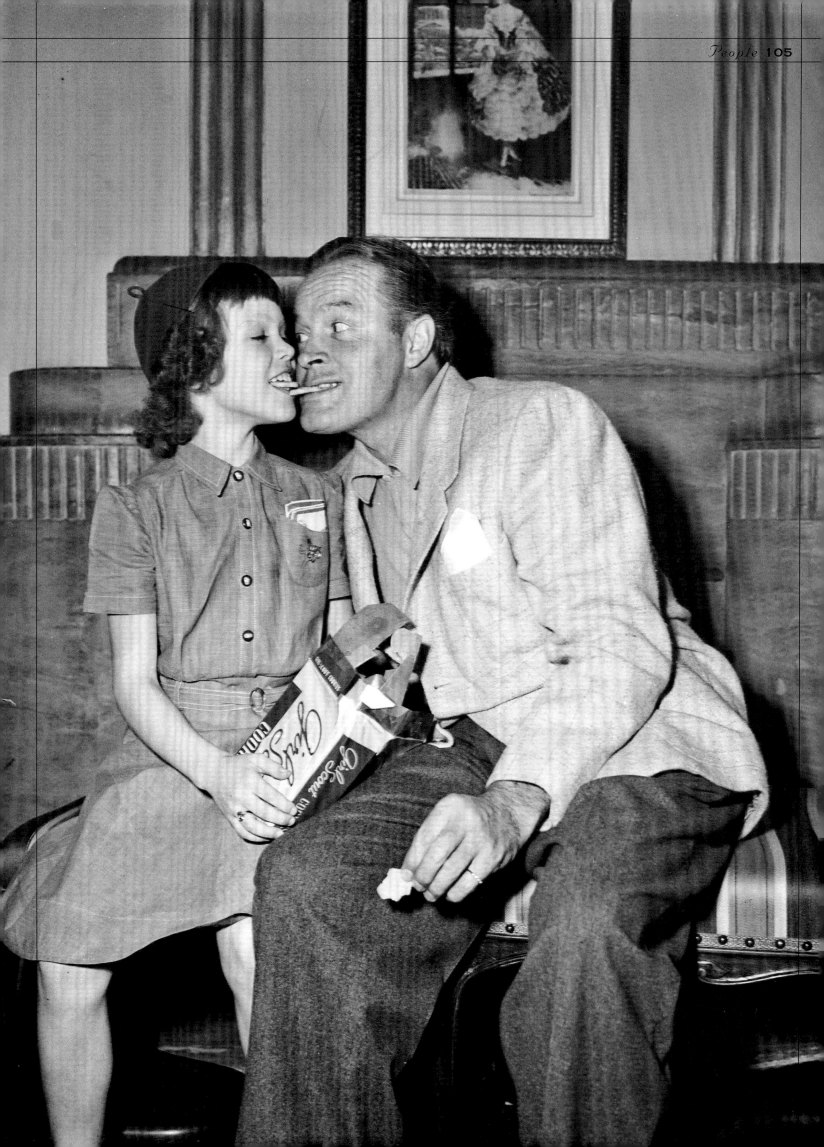

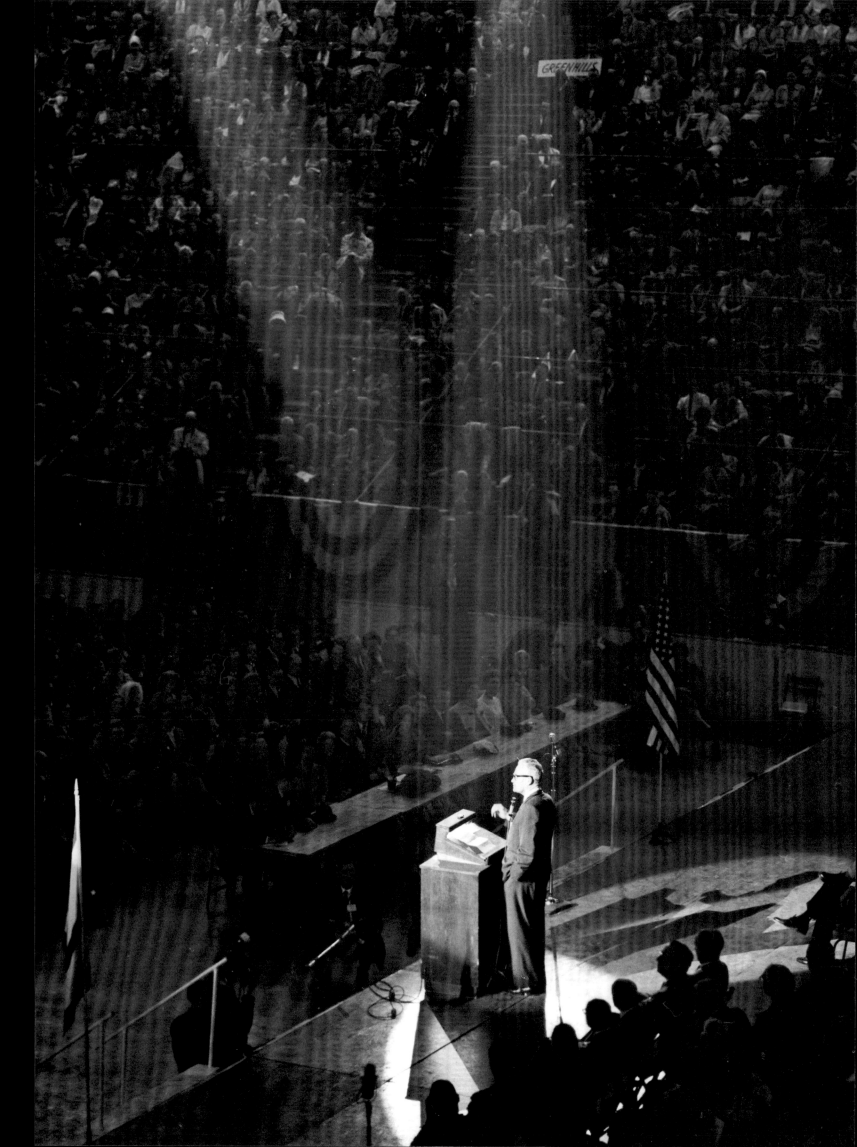

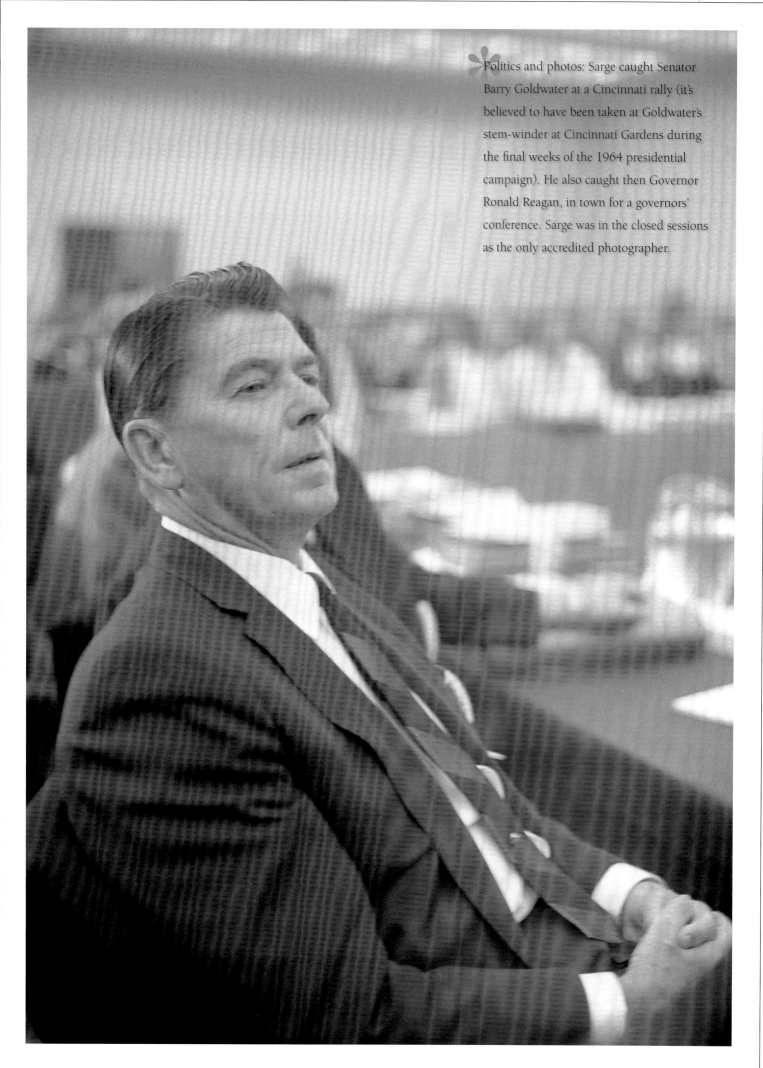

Politics and photos: Sarge caught Senator Barry Goldwater at a Cincinnati rally (it's believed to have been taken at Goldwater's stem-winder at Cincinnati Gardens during the final weeks of the 1964 presidential campaign). He also caught then Governor Ronald Reagan, in town for a governors' conference. Sarge was in the closed sessions as the only accredited photographer.

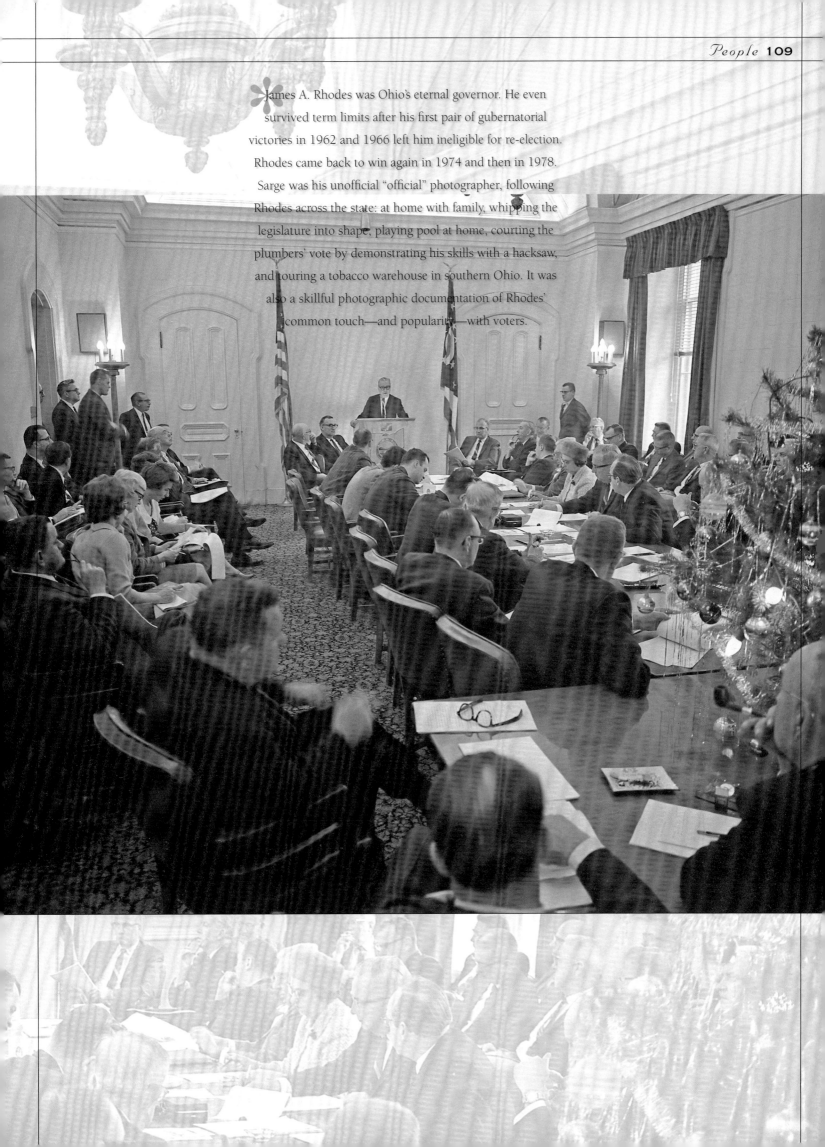

James A. Rhodes was Ohio's eternal governor. He even survived term limits after his first pair of gubernatorial victories in 1962 and 1966 left him ineligible for re-election. Rhodes came back to win again in 1974 and then in 1978. Sarge was his unofficial "official" photographer, following Rhodes across the state: at home with family, whipping the legislature into shape, playing pool at home, courting the plumbers' vote by demonstrating his skills with a hacksaw, and touring a tobacco warehouse in southern Ohio. It was also a skillful photographic documentation of Rhodes' common touch—and popularity—with voters.

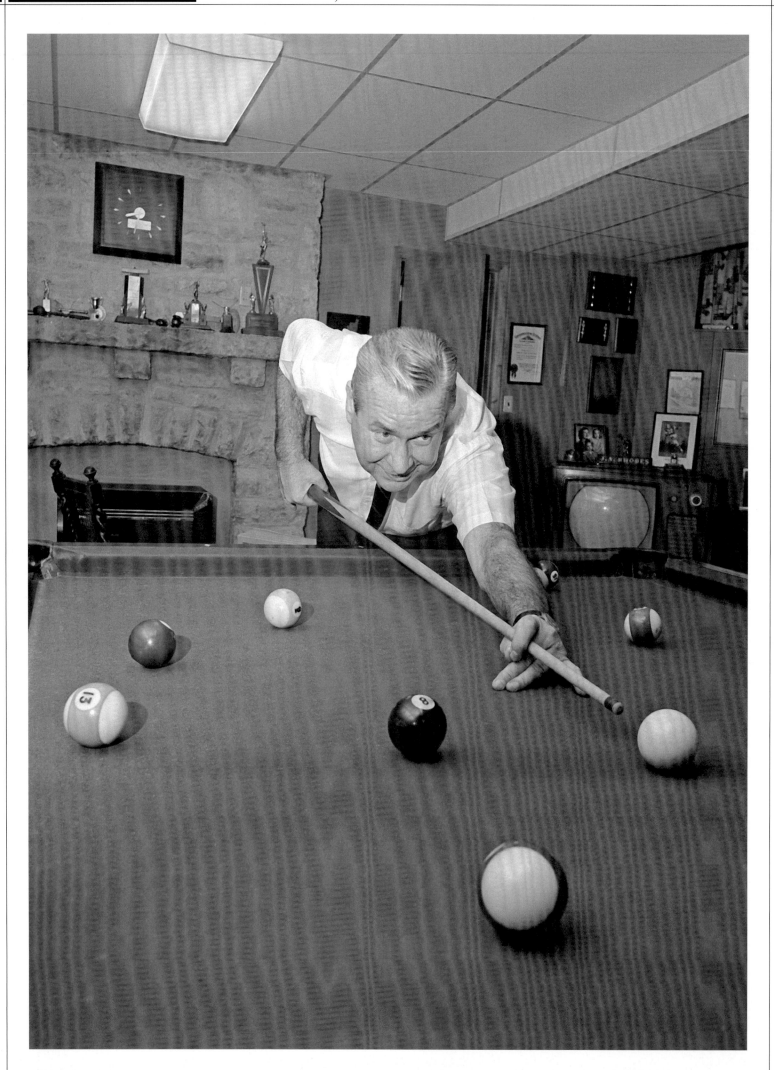

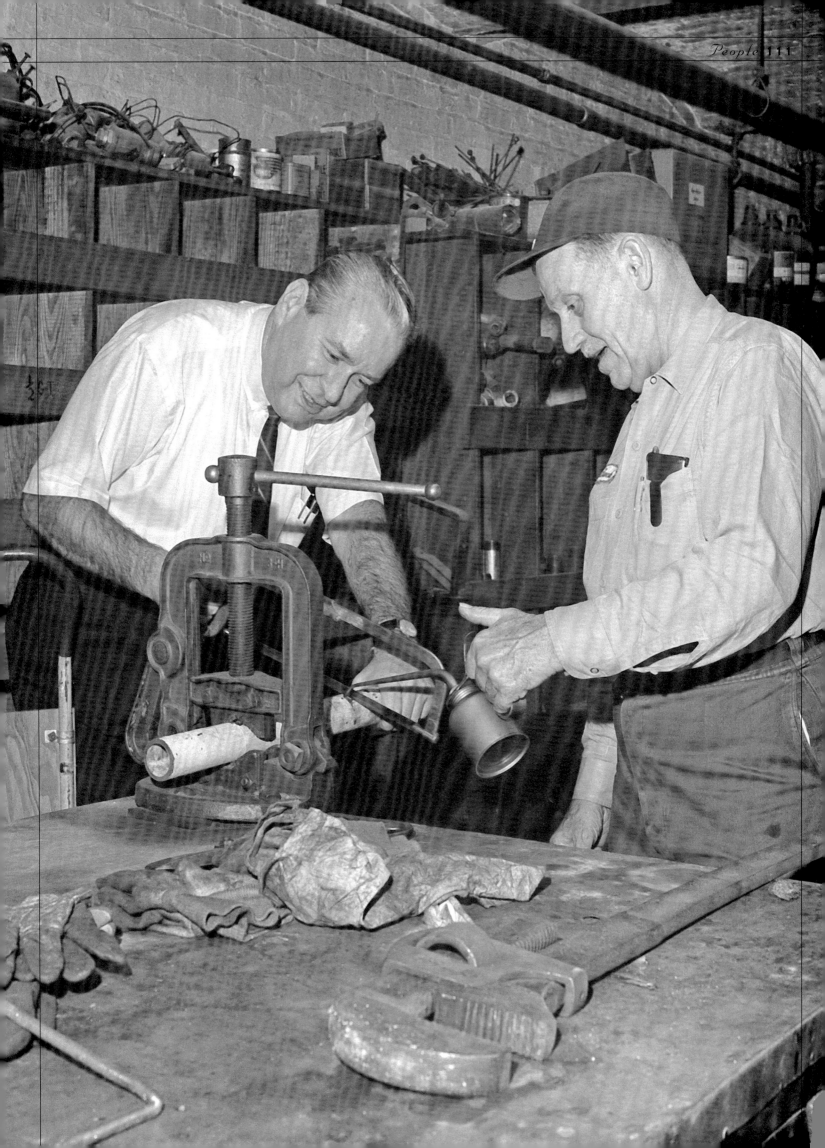

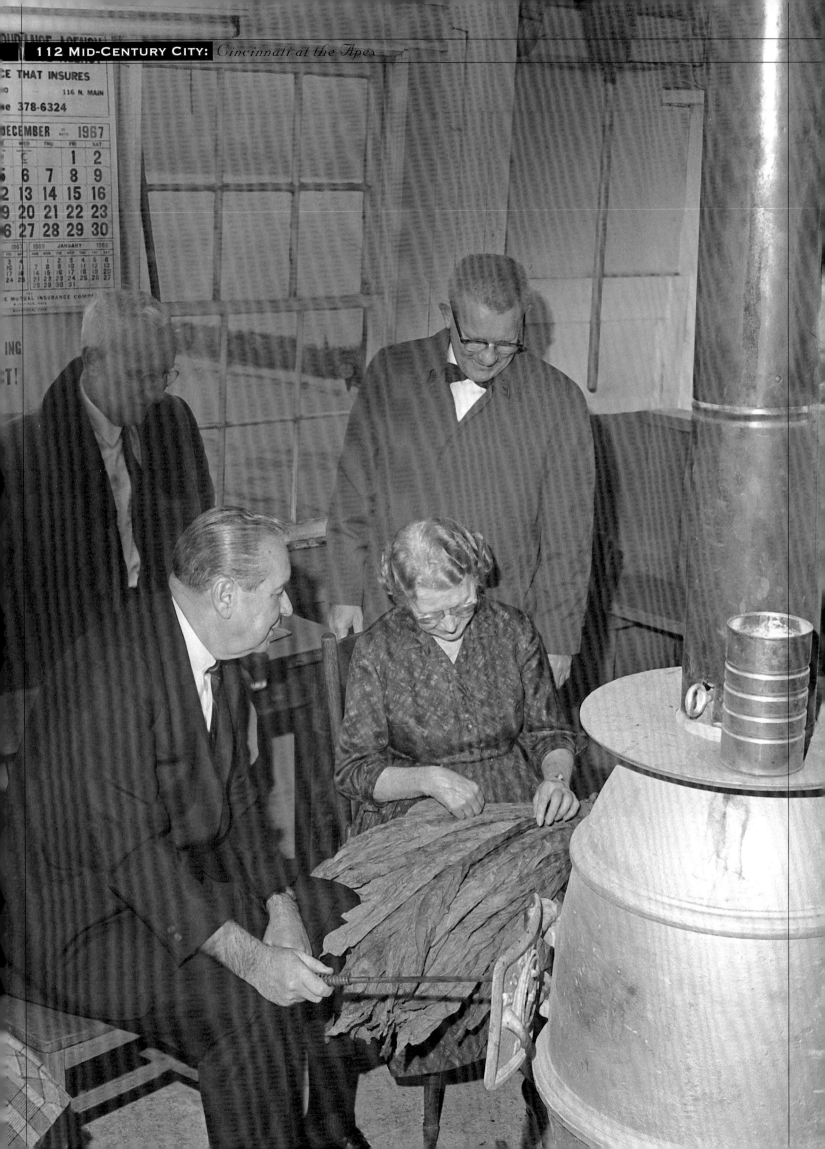

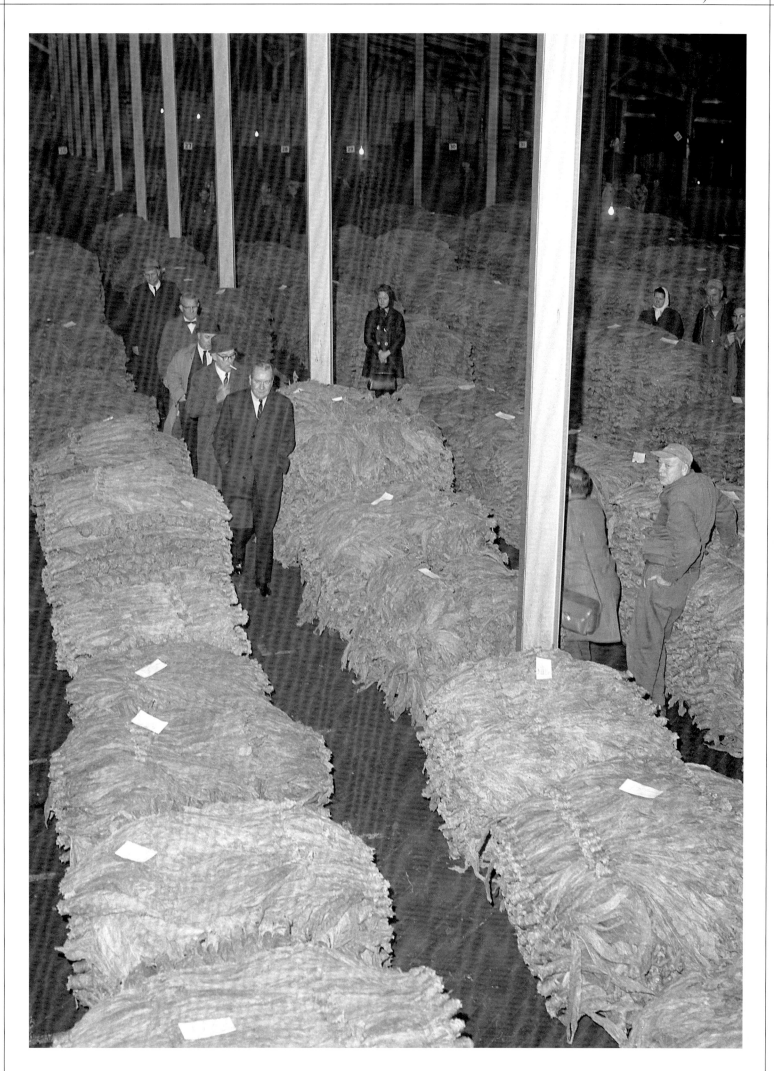

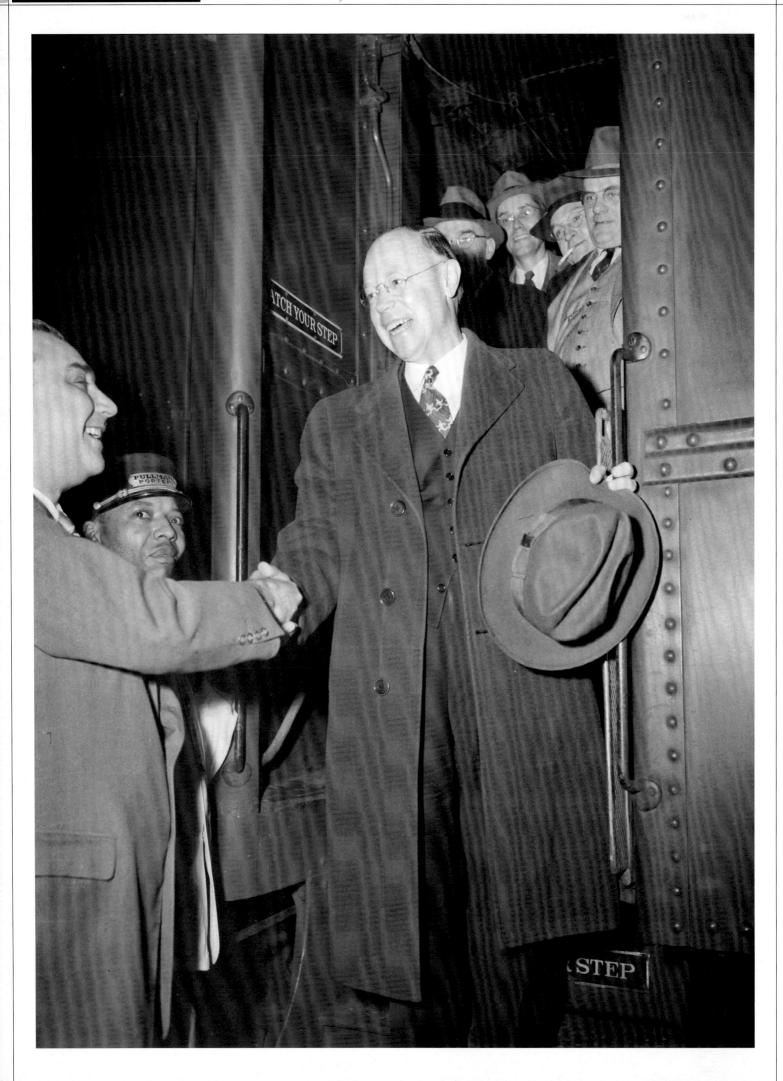

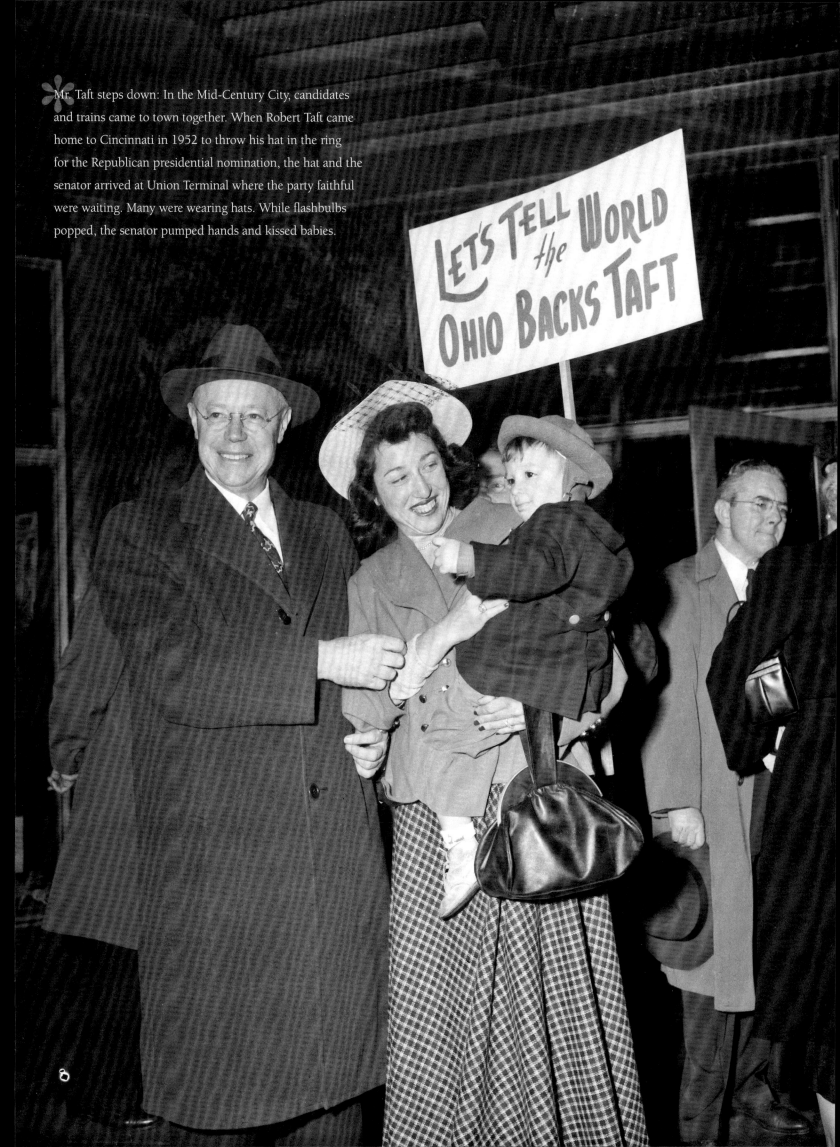

Mr. Taft steps down: In the Mid-Century City, candidates and trains came to town together. When Robert Taft came home to Cincinnati in 1952 to throw his hat in the ring for the Republican presidential nomination, the hat and the senator arrived at Union Terminal where the party faithful were waiting. Many were wearing hats. While flashbulbs popped, the senator pumped hands and kissed babies.

LET'S TELL *the* WORLD OHIO BACKS TAFT

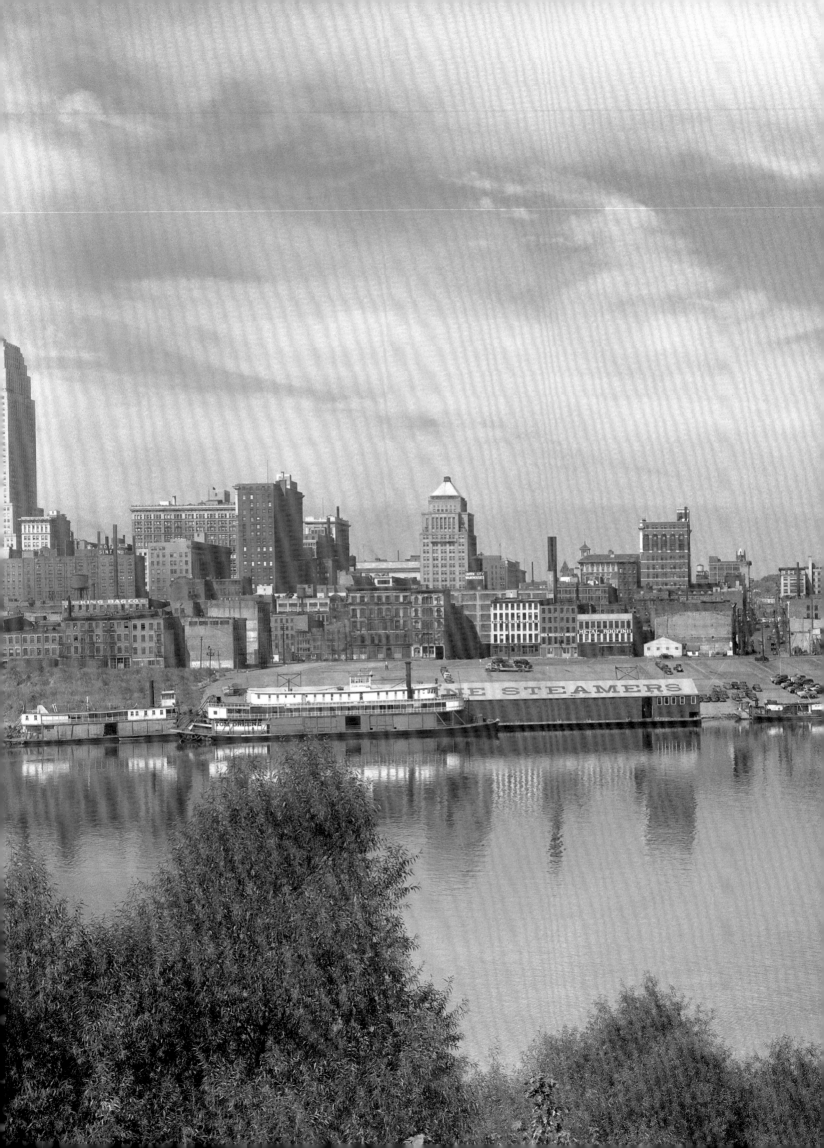

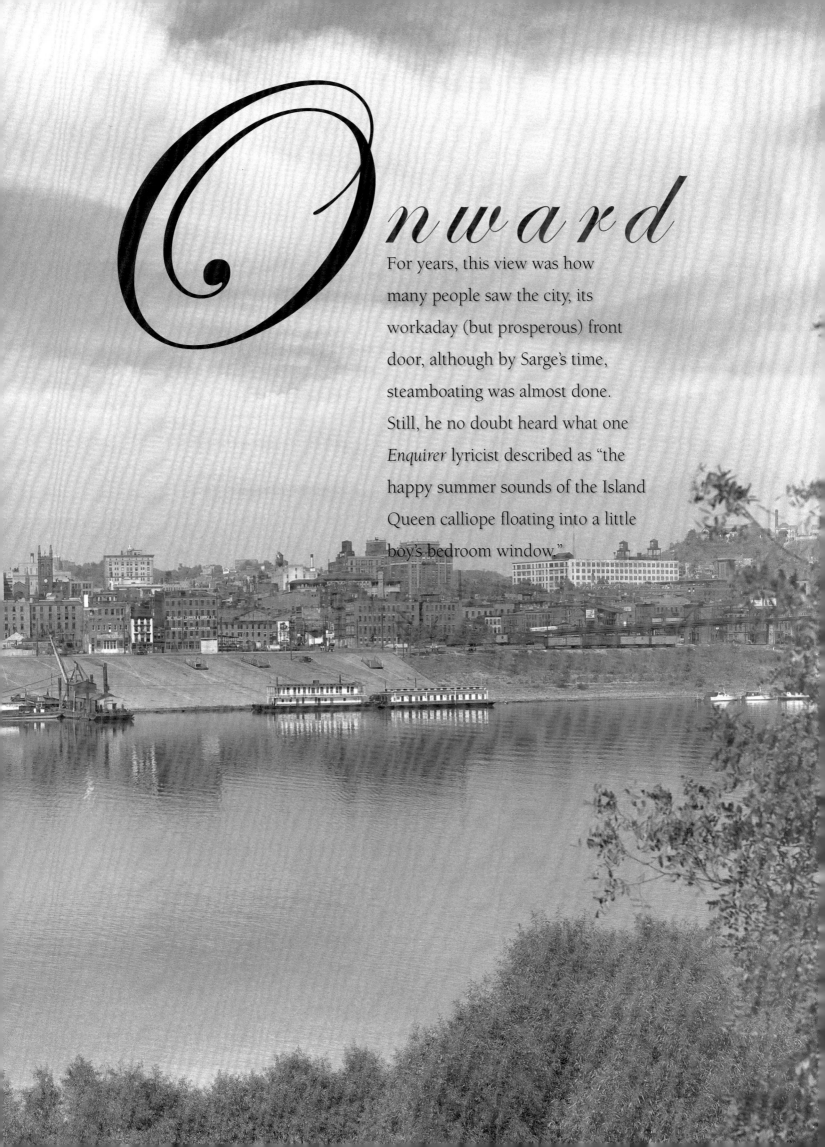

Onward

For years, this view was how
many people saw the city, its
workaday (but prosperous) front
door, although by Sarge's time,
steamboating was almost done.
Still, he no doubt heard what one
Enquirer lyricist described as "the
happy summer sounds of the Island
Queen calliope floating into a little
boy's bedroom window."

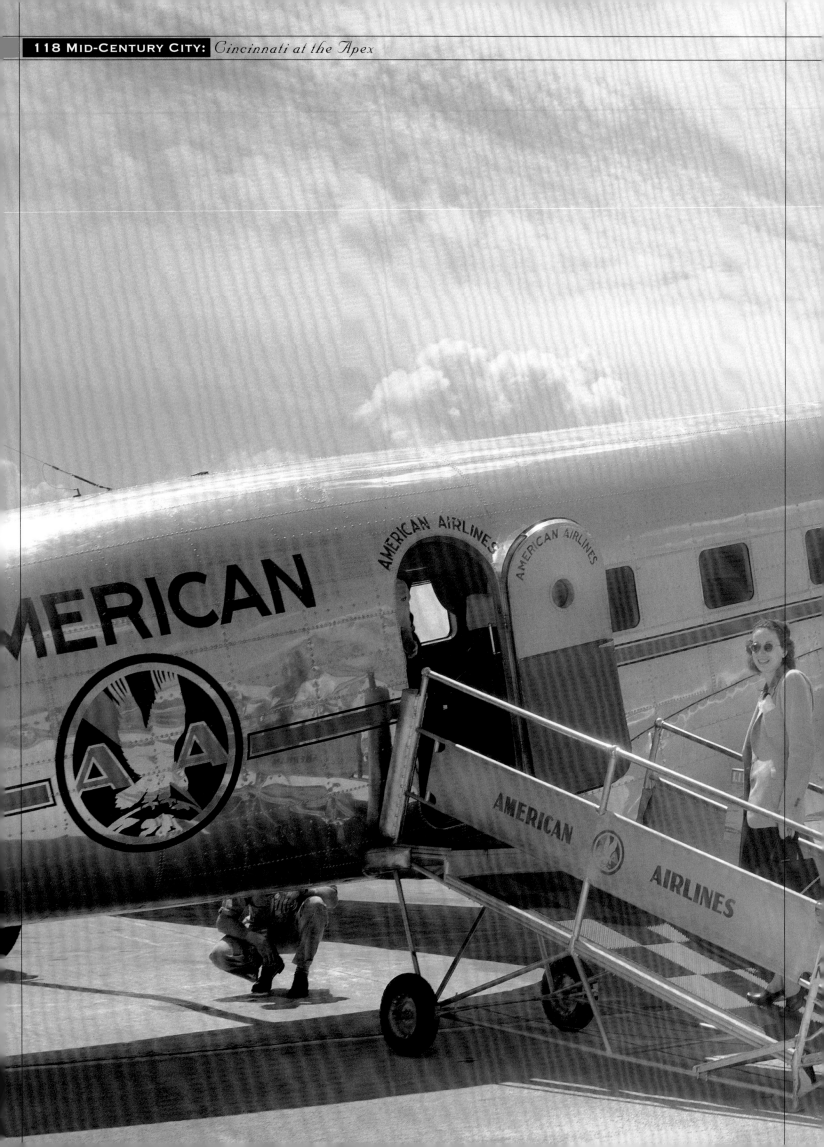

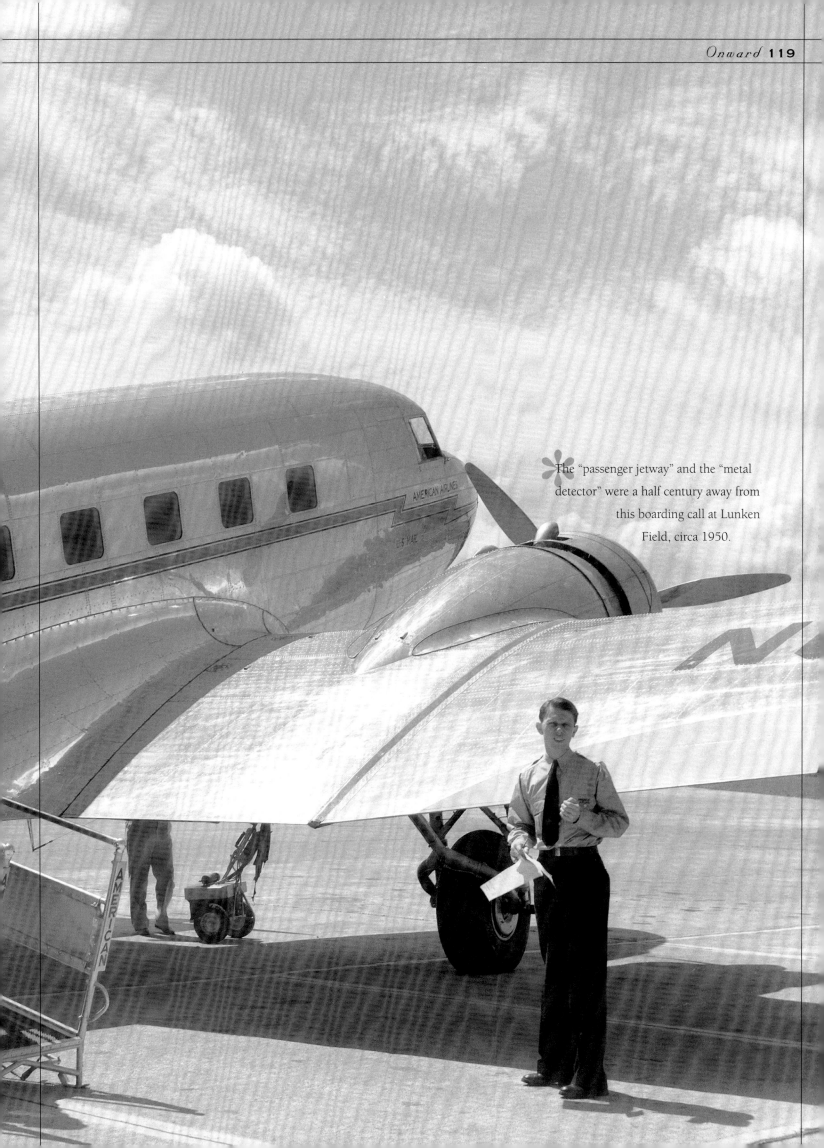

The "passenger jetway" and the "metal detector" were a half century away from this boarding call at Lunken Field, circa 1950.

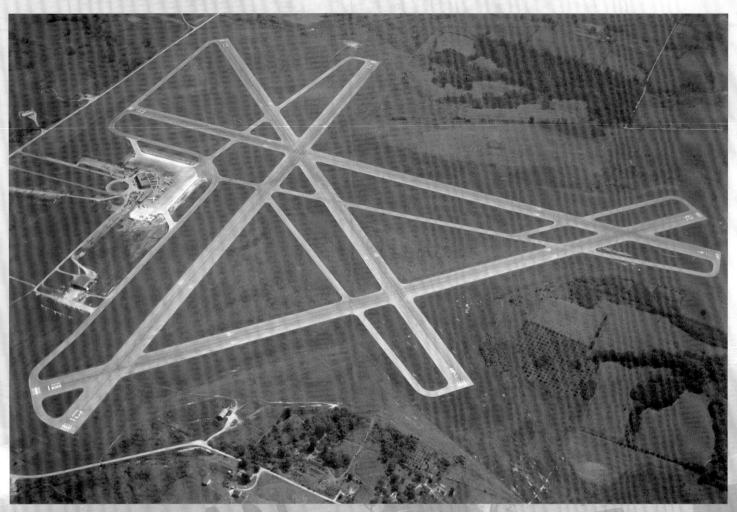

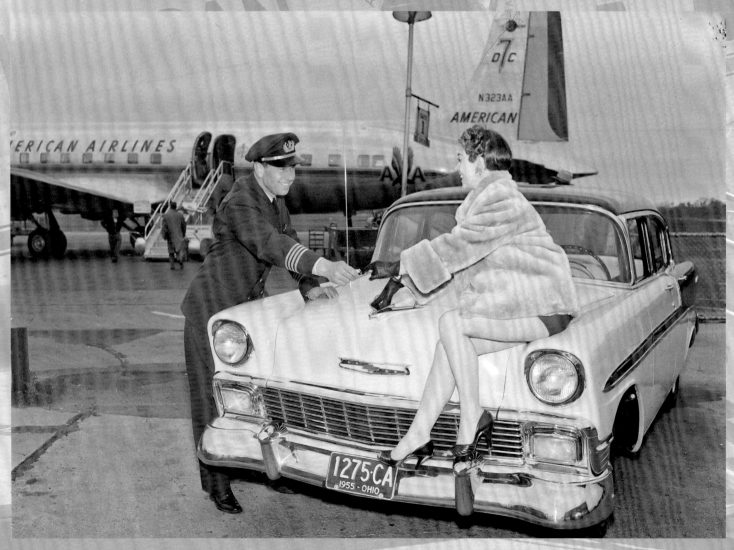

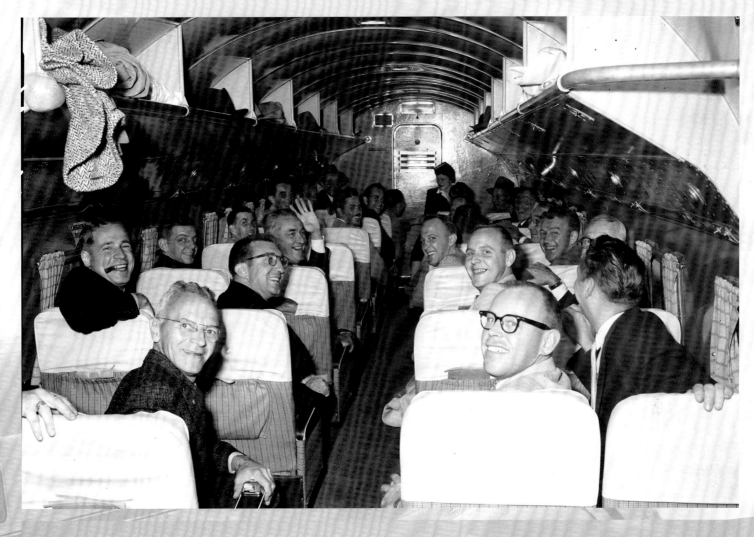

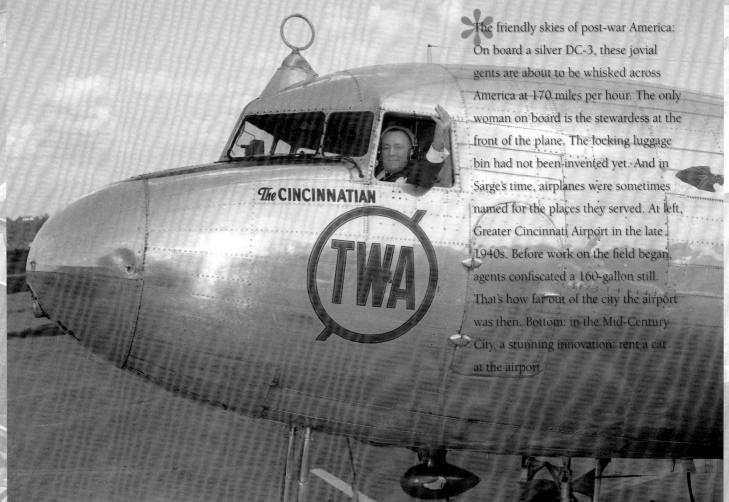

The friendly skies of post-war America: On board a silver DC-3, these jovial gents are about to be whisked across America at 170 miles per hour. The only woman on board is the stewardess at the front of the plane. The locking luggage bin had not been invented yet. And in Sarge's time, airplanes were sometimes named for the places they served. At left, Greater Cincinnati Airport in the late 1940s. Before work on the field began, agents confiscated a 160-gallon still. That's how far out of the city the airport was then. Bottom: in the Mid-Century City, a stunning innovation: rent a car at the airport.

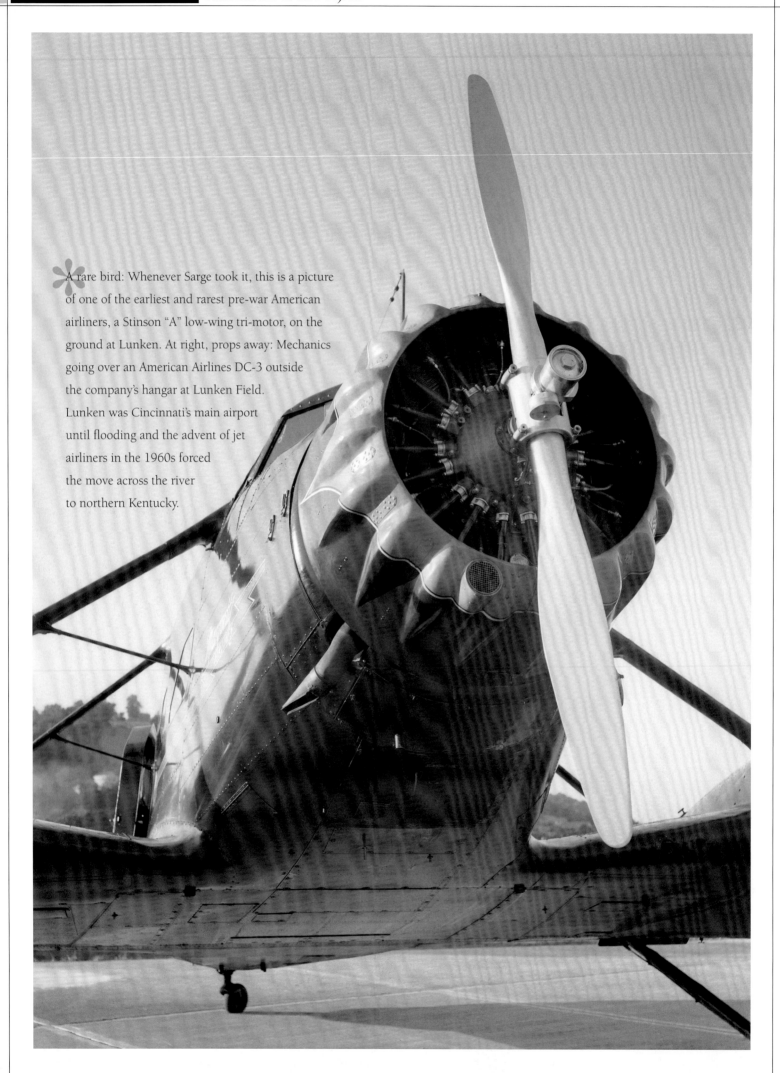

A rare bird: Whenever Sarge took it, this is a picture of one of the earliest and rarest pre-war American airliners, a Stinson "A" low-wing tri-motor, on the ground at Lunken. At right, props away: Mechanics going over an American Airlines DC-3 outside the company's hangar at Lunken Field. Lunken was Cincinnati's main airport until flooding and the advent of jet airliners in the 1960s forced the move across the river to northern Kentucky.

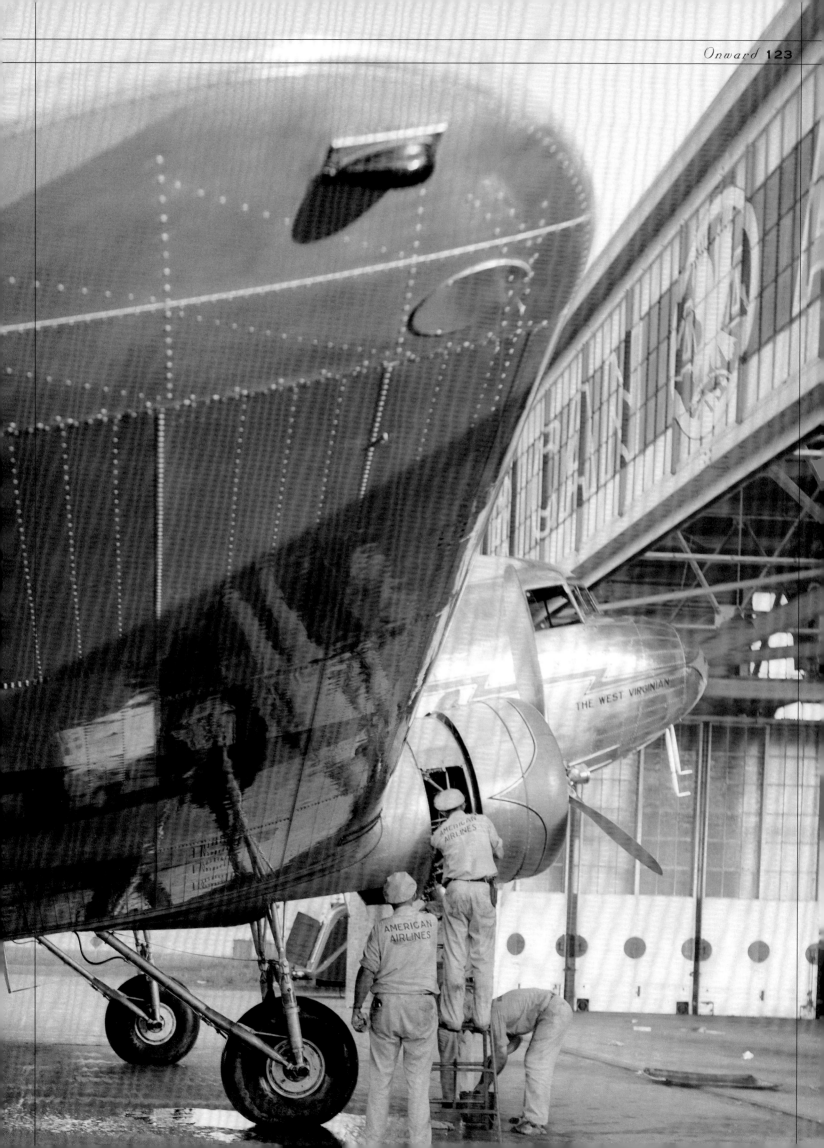

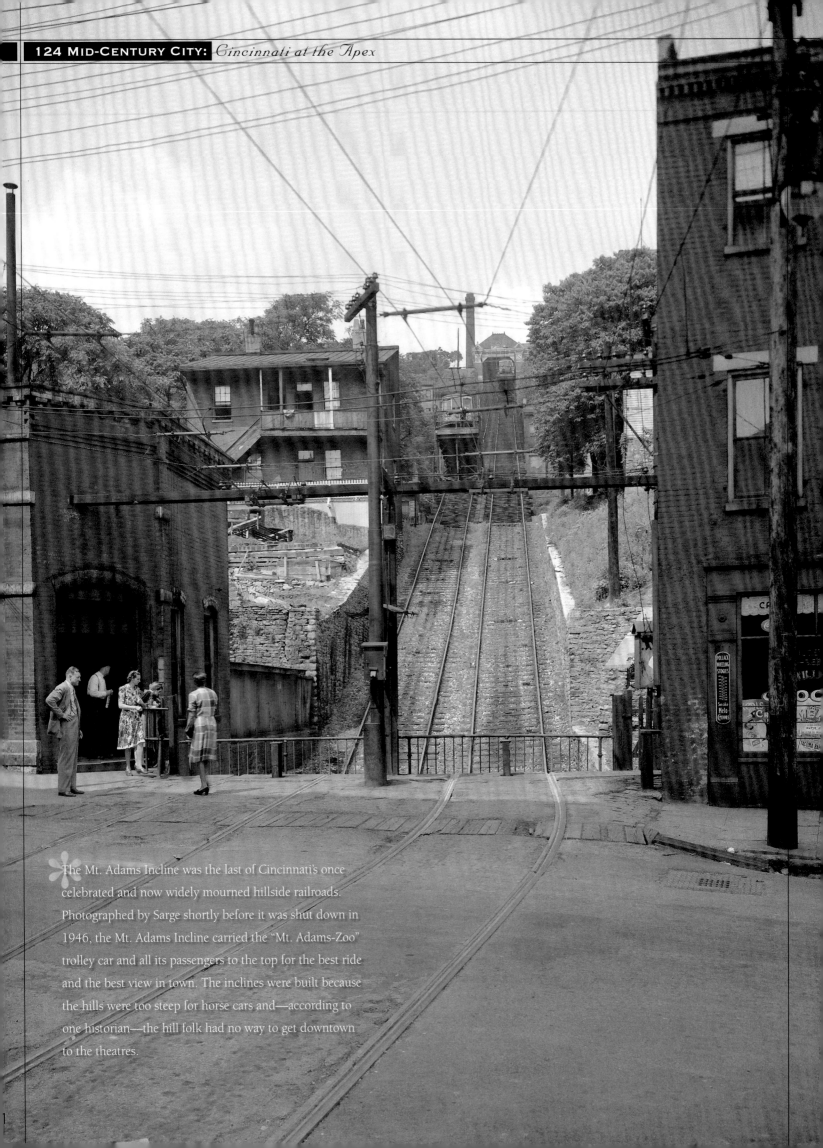

The Mt. Adams Incline was the last of Cincinnati's once celebrated and now widely mourned hillside railroads. Photographed by Sarge shortly before it was shut down in 1946, the Mt. Adams Incline carried the "Mt. Adams-Zoo" trolley car and all its passengers to the top for the best ride and the best view in town. The inclines were built because the hills were too steep for horse cars and—according to one historian—the hill folk had no way to get downtown to the theatres.

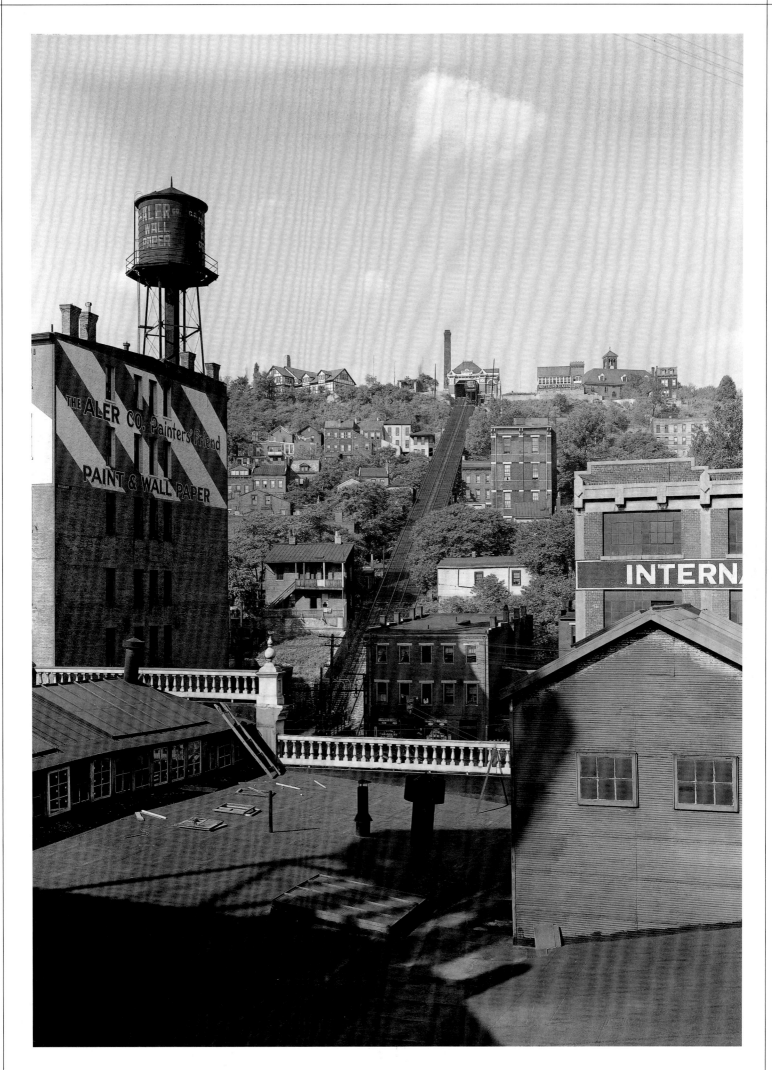

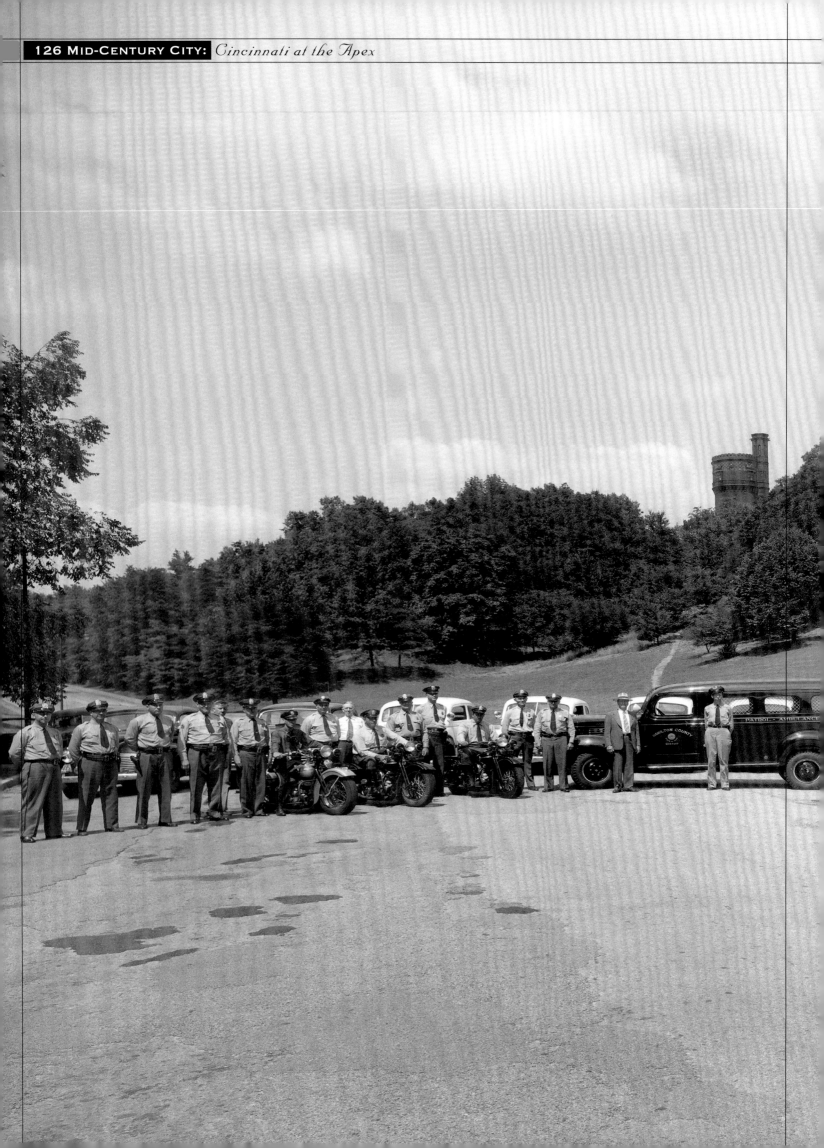

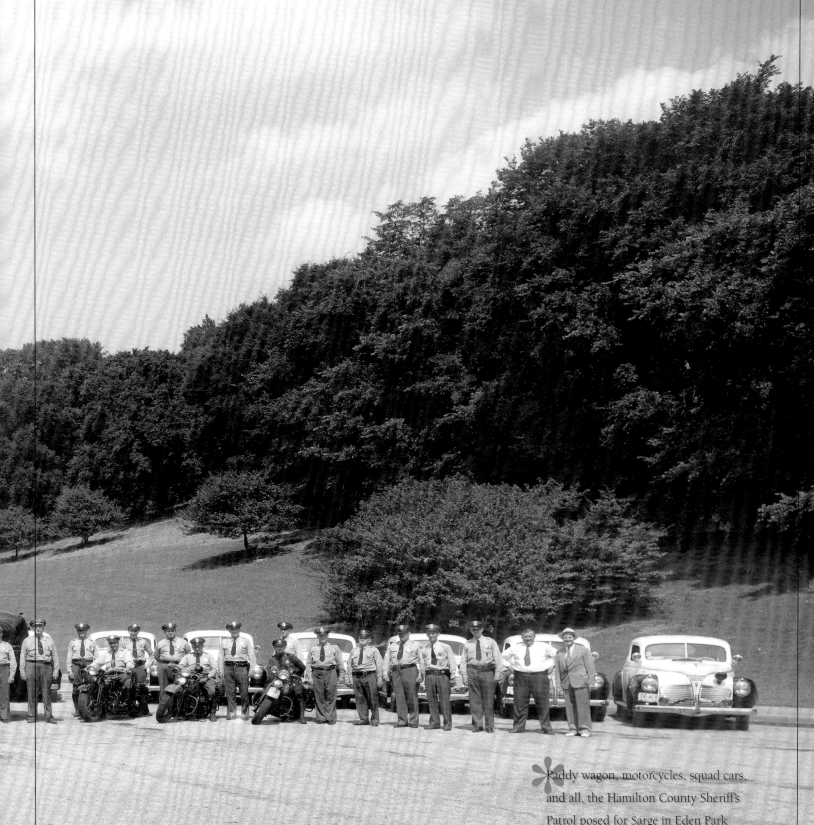

Paddy wagon, motorcycles, squad cars, and all, the Hamilton County Sheriff's Patrol posed for Sarge in Eden Park in the 1940s.

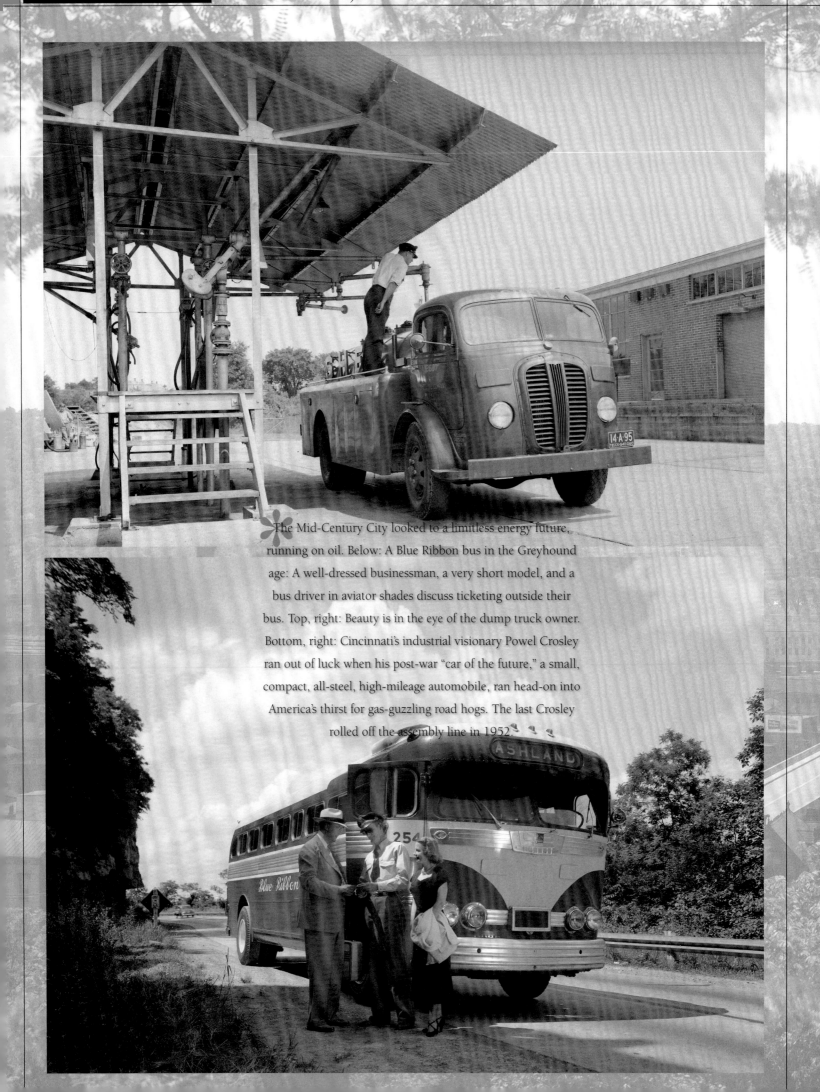

The Mid-Century City looked to a limitless energy future, running on oil. Below: A Blue Ribbon bus in the Greyhound age: A well-dressed businessman, a very short model, and a bus driver in aviator shades discuss ticketing outside their bus. Top, right: Beauty is in the eye of the dump truck owner. Bottom, right: Cincinnati's industrial visionary Powel Crosley ran out of luck when his post-war "car of the future," a small, compact, all-steel, high-mileage automobile, ran head-on into America's thirst for gas-guzzling road hogs. The last Crosley rolled off the assembly line in 1952.

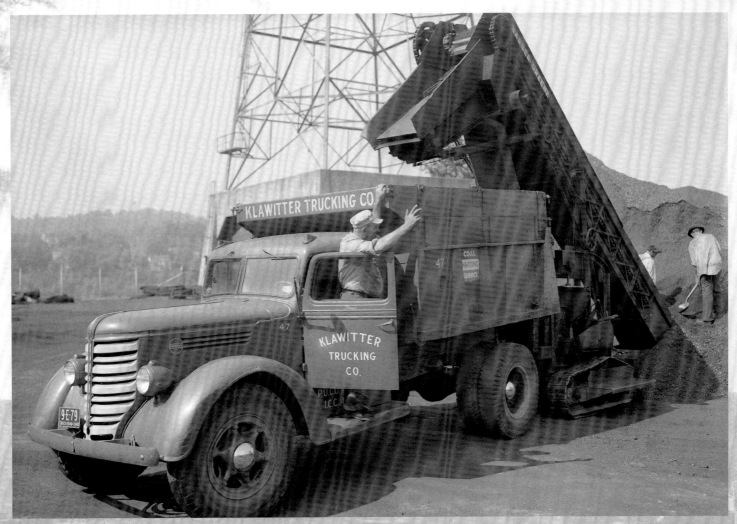

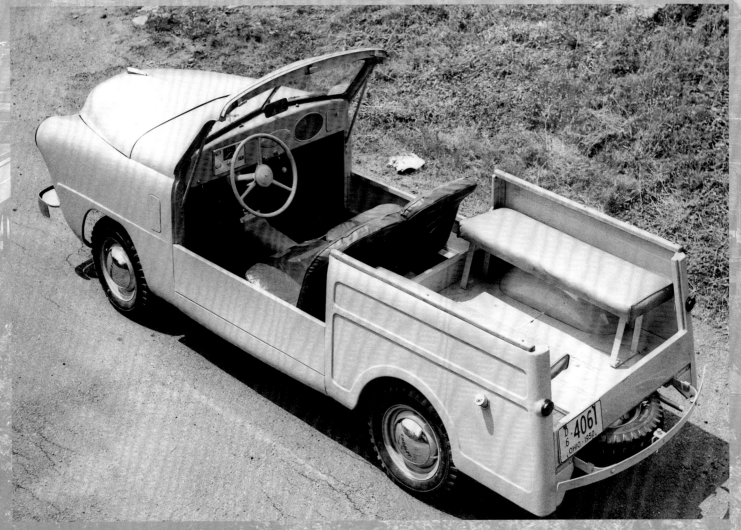

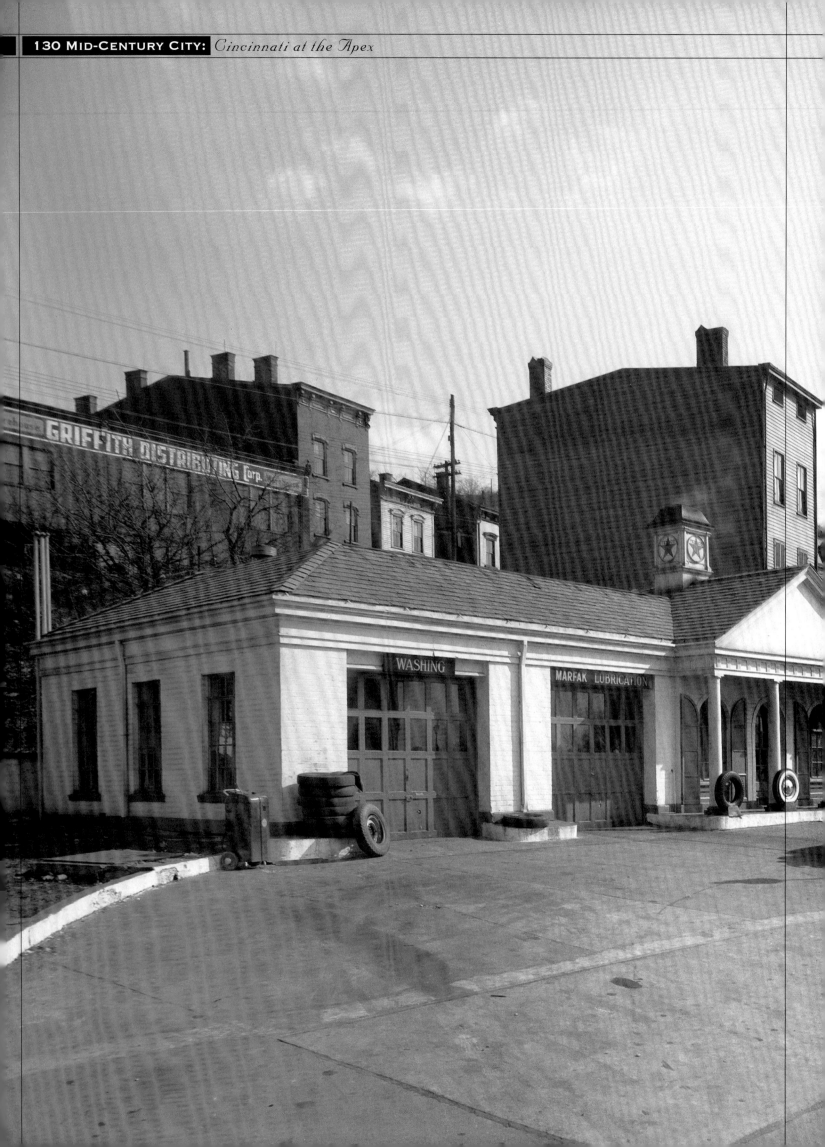

TEXACO

REST ROOM

Check your oil, ma'am? The Mid-Century City had
service stations, that is, with service. For the uninitiated—
which means anyone under 50—"service" meant a man
(in Sarge's prehistoric time, men still did the "servicing")
came out to your car and checked it over.

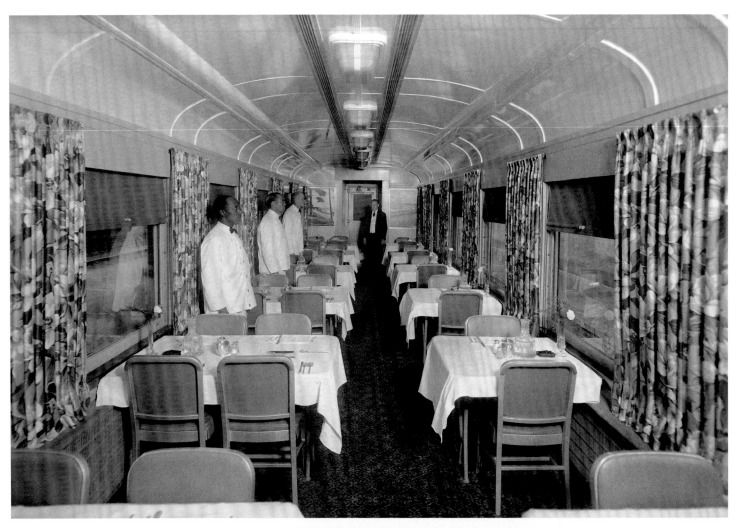

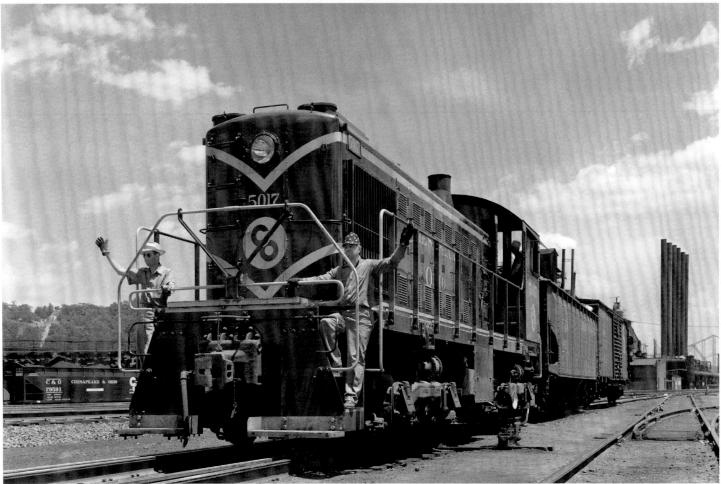

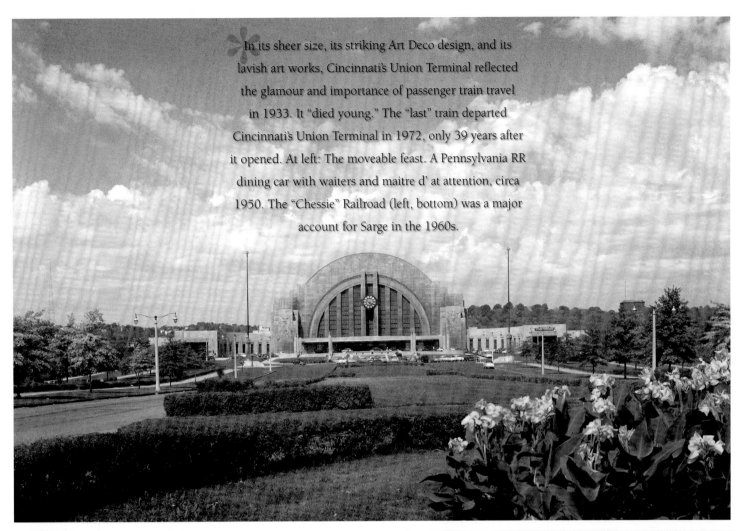

In its sheer size, its striking Art Deco design, and its lavish art works, Cincinnati's Union Terminal reflected the glamour and importance of passenger train travel in 1933. It "died young." The "last" train departed Cincinnati's Union Terminal in 1972, only 39 years after it opened. At left: The moveable feast. A Pennsylvania RR dining car with waiters and maitre d' at attention, circa 1950. The "Chessie" Railroad (left, bottom) was a major account for Sarge in the 1960s.

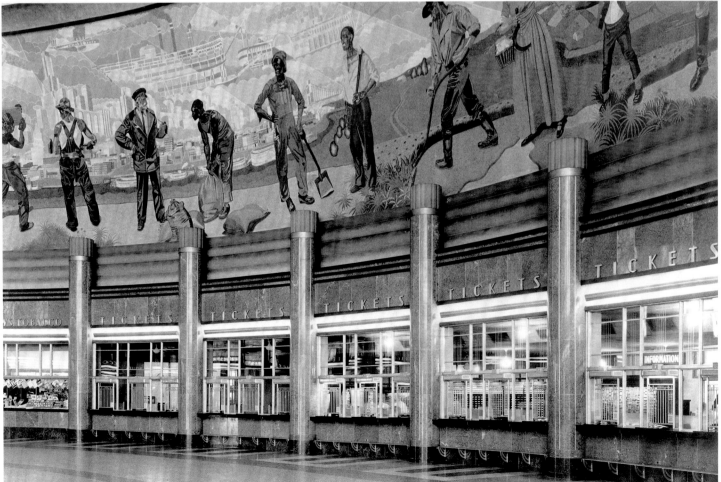

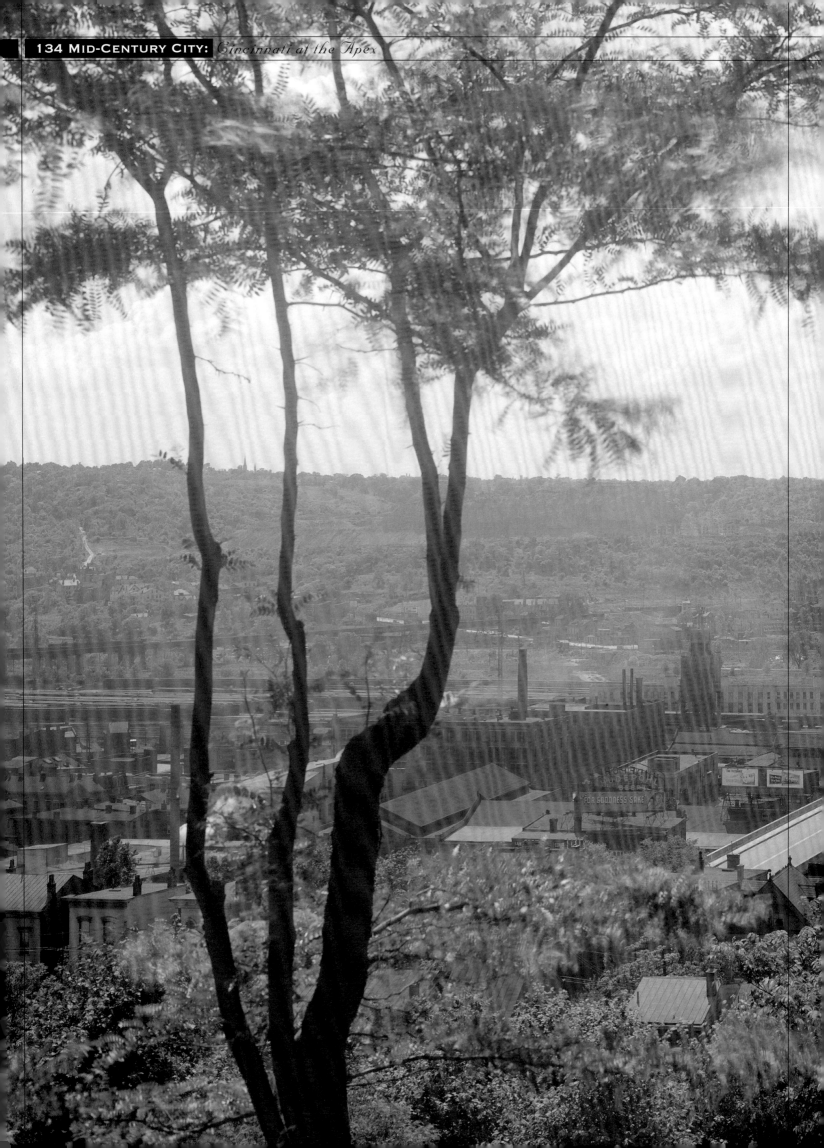

For a city in the flat Midwest, Cincinnati has always struggled with its troublesome sharp-hills and wide-valleys topography. In 1932, the Western Hills Viaduct was a bold attempt to span the Mill Creek Valley with a 3,300-foot-long bridge to the West Side. It's the longest viaduct in the city, and it was built by McDougal Construction and Folwell Engineering under the supervision of the Union Terminal Company, which from 1929-1933 was building Union Terminal itself, hence the viaduct's Art Deco style. Sarge took this photograph looking west.

John Fleischman is the author of *Phineas Gage: A Gruesome but True Story about Brain Science* (Houghton Mifflin) and other books, including *Free & Public, One Hundred and Fifty Years at the Public Library of Cincinnati & Hamilton County* (Orange Frazer Press). He spent most of 2006 in Italy on a Guggenheim Fellowship, writing a children's book about genomes. He has been a science writer for Harvard Medical School, a science broadcaster at WGBH Boston, and a contributor to *Air & Space Smithsonian, Discover, Preservation*, and the *Harvard Health Newsletter*. He and his wife, Mary, live in Cincinnati, on the edge of Sarge Marsh's Mid-Century City.

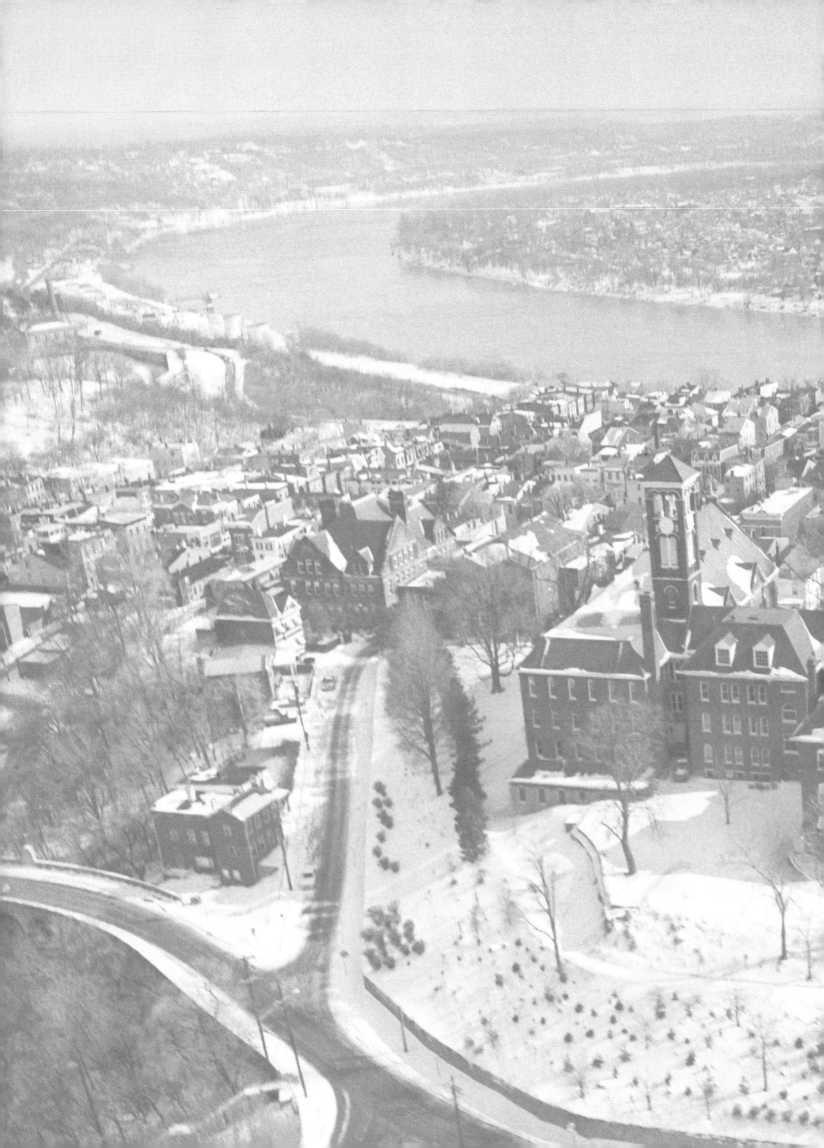